Reparative
Aesthetics

ALSO AVAILABLE FROM BLOOMSBURY

Thinking in Film, Mieke Bal
The Curatorial, edited by Jean-Paul Martinon
Eco-Aesthetics, Malcolm Miles
Counter-Memorial Aesthetics, Veronica Tello

Reparative Aesthetics

Witnessing in Contemporary Art Photography

SUSAN BEST

Bloomsbury Academic
An imprint of Bloomsbury Publishing Plc

B L O O M S B U R Y
LONDON · OXFORD · NEW YORK · NEW DELHI · SYDNEY

Bloomsbury Academic

An imprint of Bloomsbury Publishing Plc

50 Bedford Square 1385 Broadway
London New York
WC1B 3DP NY 10018
UK USA

www.bloomsbury.com

BLOOMSBURY and the Diana logo are trademarks of Bloomsbury Publishing Plc

First published 2016

© Susan Best, 2016

British Library Cataloguing-in-Publication Data
A catalogue record for this book is available from the British Library.

ISBN: HB: 9781472529787
 PB: 9781472529862
 ePDF: 9781472534583
 ePub: 9781472525758

Library of Congress Cataloging-in-Publication Data
A catalog record for this book is available from the Library of Congress.

Typeset by RefineCatch Limited, Bungay, Suffolk
Printed and bound in India

Contents

Illustrations

Acknowledgements

It's funny how intellectual debts mount up rather than being defrayed over the years. Hence I'm thanking again many of the same people and reading groups I thanked for my previous book. In the first instance, I owe much to a master class on feminism and psychoanalysis run by the late Margaret Whitford at Macquarie University in 1997. She opened my eyes to the breadth and variety of psychoanalytic approaches. Her interest in art's connection to philosophical issues also helped me to begin the task of analysing art through that prism. I treasure the memories of visiting galleries with her during her brief stay in Sydney.

Three reading groups have been crucial for the further development of my understanding of psychology and psychoanalysis – the Silvan Tomkins Reading Group (Elizabeth Wilson, Gill Straker, Anna Gibbs, Melissa Hardie, Maria Angel and the late Doris McIlwain); the 'Mrs Klein group' (Elizabeth Wilson, Gill Straker, Kylie Valentine, Robert Reynolds) and the 'Controversial Discussions group' (Kylie, Eliz and Gill). Another ongoing debt is to Liz Grosz, who is a fabulous friend and mentor whose advice and great kindness I have relied upon over the years.

This project required research trips to see in the flesh the art that I discuss, and this was made possible by generous funding from the Australian Council for the Arts. Without those trips, this book simply wouldn't have been possible. On those trips, I have managed to catch up with friends, colleagues and ex-students scattered around the world who have told me what art I have to see in their cities: Alex Alberro, Nick Croggan, Fer Do Campo, Lisa Blas, Thierry de Duve, Alicia Haber, Alicia Ritson, Charlotte North, Dom and Dan Angeloro. In particular, seeing *The War* series by Otto Dix at MOMA in New York with Jean Franco and Nicole Fermon in 2011 helped to crystallize some of my early ideas.

Friends and colleagues have very generously read sections along the way and given me fantastic feedback: Gill Straker, Ann Stephen, Andrew McNamara, Eliz Wilson and Linda Daley. I want to especially thank Gill Straker, whose close reading of the whole manuscript has been invaluable. I am very grateful for the way she so generously shares her breathtakingly brilliant readings of psychoanalysis, grounded in its practice. I would never

have realized the importance of concordant identification without her help. Thanks also to the colleagues and friends who invited me to talk about this research and for the invaluable feedback that resulted: Maryanne Dever, Simon Marsh, Karike Ashworth, Aaron Lister, Elizabeth Caldwell and Tom O'Regan.

. My profound thanks also goes to my friends who have buoyed me up at a very difficult time in my life. I can't thank them enough for their kindness, good humour and unstinting support: Gill Straker, Eliz Wilson, Liz Grosz, Toni Ross, Joan Grounds, Ann Stephen, Tim Laurence, Claire Armstrong, Katherine Moline, Eva Rodriguez Riestra, Gillian Fuller, Nicole Fermon, Glenn Wallace, Natalya Hughes, Mikala Dwyer, Anne Ferran, Les Blakebrough, Suzannah Biernoff, Meredith Morse and Judy Annear. I also want to acknowledge my new colleagues in Brisbane at the Queensland College of Art, who have made me feel so very welcome, and given me a sense of belonging, which is so essential for teaching and intellectual work. In particular, I thank the very welcoming (and often hilarious) fine art crew: Julie Fragar, Pat Hoffie, Ross Woodrow, Donna Marcus, Sebastian Di Mauro, Debra Porch, Russell Craig, Rosemary Hawker and Jess Berry. I especially want to thank Elisabeth Findlay for crucial support and Rosemary Hawker and John Macarthur for their *joie de vivre* and extraordinary hospitality and kindness to a migrating southern. I am also deeply grateful to Angela Goddard, Andrew McNamara, Lydia Rusch and Rosemary Hawker for looking after me during an extended period of illness soon after my arrival in Brisbane. Special thanks to my masters student, Brazilian art historian Mariana Pagotto, for introducing me to the work of Rosângela Rennó and for organizing the photograph of *Os Candangos*. In this regard, thanks are also due to Bruno Cunha for allowing me to reproduce his stunning image.

To the four artists I'm especially indebted, first for their inspiring work, and second their hospitality when I visited each of them. I didn't have to go far to visit Anne Ferran, as at the time I was researching and writing this book I was living in Sydney. She is an inspirational Australian artist whom I am pleased and proud to call a friend. In relation to the historical context of Anne's work, Lucy Frost of the Female Convict Research Centre in Hobart has been incredibly helpful, answering queries about convict women and clarifying dates of the refurbishment of the historic sites in Tasmania. Fiona Pardington has also become a friend, my firm friend across the ditch in New Zealand, whose Facebook updates never fail to amuse and engage. I have to confess I had one of the most successful shopping trips of my life with Fiona in Auckland. My thanks also to Kriselle Baker for organizing access to the life casts at the Auckland War Memorial Museum – the real reason for the trip. My heartfelt thanks also to Rosângela Rennó and Milagros de la Torre for their

hospitality and generosity in Rio and New York respectively, and for taking the time to talk to me about their work.

Thanks always to my brilliant editor at Bloomsbury, Liza Thompson. This is my second book with her and I hope it will not be my last! I'm very lucky to have her enthusiastic interest in my work. This book is dedicated to Gill Straker and Joanna Barnes, my chief repairers.

Introduction

Shame, writes psychoanalyst Léon Wurmser, has three main meanings: shame as anticipatory anxiety about potential humiliation; shame as preventative (a dispositional orientation to the world that seeks to avoid disgrace); and then finally the actual experience of shame – the real or imagined feeling of being exposed or looked at with disapprobation by others.[1] The fact that Wurmser lists not one but two meanings of shame whose sole function is to avoid actually being ashamed speaks to how little we want to experience it directly.

The experience of shame, as psychologists and cultural theorists repeatedly remind us, is deeply disturbing and disorganizing. For example, American psychologist Silvan Tomkins avows that, of all the negative affects, 'shame strikes deepest into the heart of man'.[2] According to him, it is 'felt as an inner torment, a sickness of the soul'.[3] While, for queer theorist Eve Kosofsky Sedgwick, pain and volatility are the leitmotifs of shame: it causes a double movement 'toward painful individuation, toward uncontrollable relationality.'[4] Thrown back on the self in torment, yet exposed to the disapproving gaze of potentially limitless others, in her view, shame is both 'contagious' and 'potentially paralysing'.[5] The strange reliance on metaphors of disease and infirmity – sickness, contagion – to describe what both Tomkins and Sedgwick regard as an innate affect, underscores the magnitude of the aversion to shame. Given these descriptions, the existence of hypervigilant defences against feeling shame are more than understandable.

How, then, do we confront shameful events in national histories without stirring up the many defences that this potentially toxic affect can marshal? This book examines the work of four women photographers from the southern hemisphere who achieve exactly that. The artists are: Anne Ferran (Australia), Fiona Pardington (New Zealand), Rosângela Rennó (Brazil) and Milagros de la Torre (Peru). Collectively, they are pioneering what I am calling a reparative approach to the representation of shameful histories. In other words, their work attenuates shame while also bringing to light difficult and disturbing issues such as: the harsh and unjust treatment of indigenous peoples; the

cruel institutionalization of vulnerable groups; the disappearance of dissidents; and the carnage of civil war.

The success of these artists' work can be partly attributed to the way in which they make a radical break with the dominant anti-aesthetic approaches to political art.[6] The anti-aesthetic tradition privileges critique over aesthetic engagement and rejects the importance of traditional aesthetic concerns such as beauty, feeling, expression and judgement. In contrast, these artists use a range of complex aesthetic strategies to engage audiences with these histories and to temper, and at times transform, the feelings of shame that would normally accompany them. These strategies will be analysed in detail in the following chapters.

The book as a whole is situated at the juncture of four emerging areas of scholarship: contemporary art practice concerned with traumatic, disturbing and shameful events; the recasting of the viewer as a witness in response to this art of real events; debates about the cultural significance of affect, guilt and shame; and the reconsideration of the importance of aesthetics for political art. Taking the last area first, the need to rethink the rejection of aesthetics has been broached by philosophers as diverse as Arthur Danto, Jacques Rancière, Elaine Scarry, Robert Pippin and Michael Kelly.[7] Despite the now substantial body of scholarship, the anti-aesthetic tradition still dominates modern art history and theory. This book aims to connect the art historical study of political art with the rethinking of aesthetics, and in particular with affect theory, which has revivified the traditional aesthetic category of feeling.

Political art, and analyses of it, have now assumed centre stage in writings on contemporary art. Indeed, the upsurge of art about shameful histories, which begins in the 1990s, takes place within the context of an important return in international contemporary art towards picturing or addressing worldly affairs. Increasingly artists are working with documentary and ethnographic protocols and examining major historical and contemporary events such as 9/11, the genocide in Rwanda and the Lebanese Civil War.[8] There are a number of different strands of art practice that comprise this art of real events. For example, leading art historian Hal Foster has identified an 'ethnographic turn' and an 'archival turn'. He characterizes these shifts in contemporary practice as an engagement with the under-represented position of marginalized people in the case of the ethnographic turn, and neglected historical events in the case of the archival turn.[9]

The archival turn is most pertinent to this book. In his article of 2004, 'An Archival Impulse', Foster identifies the emergence of art focusing on archives, which demonstrates the pursuit of a kind of 'counter-memory'; that is, artistic practices that seek to retrieve and represent what he terms 'alternative knowledge'.[10] The archival art that he highlights in this essay, like art that exemplifies the ethnographic turn, continues the critical enterprise of

documenting and recovering neglected or marginalized knowledge, but this time with an emphasis on history and historical records. As these examples should indicate, Foster's work on contemporary art is acutely attuned to the shifting ways in which political art is refigured; he continually extends the critical tradition of the western avant-garde through into the present in order to diagnose the current state of 'advanced art on the left'.[11] Yet this critical lineage has its drawbacks, it tends not to be reparative.

As the astute reader may have already guessed, my interest in a reparative approach to political art is deeply indebted to Sedgwick's early theorization of reparative reading practices. Sedgwick, in turn, borrows the idea of a reparative position or orientation from psychoanalyst, Melanie Klein, for whom the term signifies a capacity to deal with ambivalence, and to incorporate both positive and negative feelings. The reparative position is not, then, simply about undoing or reversing damage; ambivalence precludes that wholly positive orientation. For Sedgwick, a reparative motive seeks pleasure rather than the avoidance of shame, but it also signals the capacity to assimilate the consequences of destruction and violence. Sedgwick advocates reparative interpretations of cultural material in place of the much more common 'paranoid' interpretations (another key Kleinian term). She explains that paranoid interpretations routinely adopt a posture of suspicion and operate as a kind of 'exposure' of traces of oppression or injustice.[12] Crucially, she argues paranoid suspicion is central to critical practice in the humanities and that it is propelled by the desire on the part of theorists and critics to avoid surprise, shame and humiliation.

In contemporary art, this approach is typical of the anti-aesthetic tradition and identity politics art, which also favour critique and the exposure of wrongdoing. The anti-aesthetic tradition, as I mentioned earlier, is one of the dominant approaches to political art. Generally seen as the legacy of Marcel Duchamp, anti-aesthetic tendencies can also be discerned in much earlier art.[13] Identity politics art has a clearer provenance; it came to prominence in the 1970s with feminist-inspired practices, and continues to the present as a mode of self-representation by subaltern groups and individuals. In the 1960s, 1970s and 1980s, these frequently overlapping strands or traditions of art making are often associated with conceptual art and conceptualism, institutional critique, feminist and critical postmodern practices. Artists like Allan Sekula, Adrian Piper, Martha Rosler, Victor Burgin, Hans Haacke, Krzysztof Wodiczko, Jenny Holzer, Andrea Fraser, Lorna Simpson and Barbara Kruger are representative of this type of art.

Rosler is a particularly good example to consider here as she combines conceptual anti-aesthetic allegiances with feminist politics. For instance, her video, *Vital Statistics of Citizen, Simply Obtained* (1977), is presented in the deadpan mode favoured by conceptual art, with the typical low-tech DIY look indicative of an anti-aesthetic orientation. In short, there is nothing visually

interesting or perplexing to distract from the fairly straightforward didactic message. The video shows a team of white-coated scientists measuring Rosler's body, pronouncing parts of it standard, above standard, and below standard via various keyed sounds, such as a whistle and a claxon. In other words, she 'exposes' the oppressive classification of women's bodies by these white-coated men. Yet, it's hard to imagine that any woman watching this film then or now was actually surprised by this revelation. What exactly is the function, then, of 'exposure' when the issue is already known? In this instance, the role of paranoid suspicion for both the artist and the female audience is perhaps to avoid any kind of surprise whether aesthetic, affective, political or ideological. If the oppressive patriarchal categorization of women's bodies is truly surprising, and implicates the viewer (a man, perhaps), it will most likely trigger shame, or one of its defences: denial, evasion, anger. In other words, such works preach to the converted, while potentially alienating perpetrators.

More recently the work of Fred Wilson, Coco Fusco, Kara Walker, Taryn Simon, Renée Green, Emily Jacir, James Luna, Regina Jose Galindo, Tanja Ostojic, Santiago Sierra, Boris Mikailov, Catherine Opie, Fiona Tan, Alfredo Jaar, along with many, many others, can also be understood in these terms. I don't want to suggest here that these artists are making bad art because they adopt an emphatically political stance; these artists are extremely well known internationally for precisely that reason. Rather my point is that paranoid art has become almost synonymous with political art. As Sedgwick explains for cultural criticism, 'it seems to me a great loss when paranoid inquiry comes to seem entirely co-extensive with critical theoretical inquiry rather than being viewed as one kind of cognitive/affective practice among other, alternative kinds'.[14] In this spirit, I suggest that alongside the longstanding tradition of making paranoid political art there is also an alternative – the reparative kind I analyse here.

Sedgwick's interpretation of Klein's reparative position has been widely taken up in queer theory, but has had limited purchase in discussions of contemporary art.[15] A central aim of this book is to consider how Sedgwick's insights can illuminate the achievements of the four women artists discussed. However, one important transposition should be noted; my concern is principally with how artists present historical material reparatively, rather than how critics or viewers interpret that material. Although, the methods artist adopt, of course, crucially determine what positions are available to the viewer.

Curiously, a substantial change in the viewer's position is already signalled in the scholarly literature but it is not connected back to significant changes in artists' modes of production. When the position of the viewer of political, memorial or testimonial art, literature and media is discussed, very frequently it is theorized as a form of witnessing. Here, however, the issue of shame is not broached; instead, trauma is more usually in the ascendancy as the

pertinent psychological rubric. In the visual arts, the term witnessing is frequently applied to the so-called indexical arts such as photography, film and video.[16] My decision to focus on photographic practices in this book was guided by photography's traditional role of bearing witnessing to events, as well as an interest in the transformation of that documentary project in contemporary practice. The work of these four photographers can be understood to continue the documentary 'traditions of dissent and resistance' that John Roberts argues have all but disappeared in contemporary practice.[17]

In the broader domain of contemporary art practice, witnessing signals: a link to documentary and testimonial protocols; artists' efforts to present a truthful representation of events; and a juridical or therapeutic role for art. To understand the reparative role of witnessing, however, the feelings of guilt and shame evoked by histories of injustice and inequality need to be considered. To date this has not occurred.

The first book-length study of witnessing in the visual arts by Jane Blocker is typical of the paranoid approach described by Sedgwick.[18] For Blocker, witnessing refers to the personal testimony of the artist. Instead of considering 'how' to bear witness to trauma – which she argues preoccupies the scholarly field – she stresses 'who' has the right or moral authority to represent such events.[19] In this way, the art of witnessing seamlessly joins with the project of identity politics, and testimony is the mode of art practice favoured. Given that the artist is either traumatized or directly affected by traumatic events, such art is difficult to criticize. Thus, the beholder has a relatively passive role of receiving that testimony; debate, discussion and disagreement tend to be precluded. Instead, the therapeutic or the pedagogical role of art is emphasized. For example, E. Ann Kaplan emphasizes the role of witnessing in developing an ethical consciousness and a sense of responsibility for injustice.[20]

In the case of art dealing with historical events, the viewer's position is described by Ulrich Baer as 'secondary witnessing'.[21] He uses this expression, which is already well established in the Holocaust literature, in a highly novel way to describe the kind of belated relation to events that characterizes the artists in this book. Referring specifically to recent photographs of Holocaust sites, Baer argues that when contemporary viewers are made aware of seeing things that, as he puts it, 'no one ever wanted to know about', they are positioned as secondary witnesses.[22] Such images, he continues, make us 'as much spectators as seekers of knowledge'.[23] Baer does not discuss secondary witnessing in any detail, however it is an enormously suggestive idea that signals a shift in modes of beholding. Baer is a recurring figure in this book. At times, I lean on his analysis of the will to ignorance that witnessing attempts to redress; at others, I am more critical. The principal shortcoming of Baer's argument is his failure to consider the aesthetic qualities of images, without which viewers are unlikely to seek further knowledge.

The empty photographs he considers are banal, deadpan, uncompelling images, despite the considerable gravity of the topic. The images he discusses by Mikael Levin are from Levin's book, *War Story* (1997).[24] In this book, they were presented alongside original reports and images of the Holocaust where their affectless quotidian quality served as a counterpoint to these deeply disturbing historical photographs. When taken out of that context, they lack the necessary aesthetic strength and complexity to generate interest. The lack of engaging visual qualities undercuts the provocation to inquire further that Baer suggests is the appropriate response. The artists in this book, on the other hand, demonstrate precisely the kind of visual strength and appeal necessary to give memorable form to the events and issues they address.

Significantly, feeling is not mentioned frequently in the accounts of witnessing in the visual arts: the therapeutic aim of witnessing is sought through the pursuit of knowledge, following the dictates of the anti-aesthetic tradition. While the work of Jill Bennett has emphasized the importance of affect for a consideration of trauma art, and Erika Doss has examined the role of feeling in relation to public memorials, these are still the exceptions in art history rather than the rule.[25] In the narrower field of photographic theory, the importance of feeling has been broached by Margaret Olin, Sharon Sliwinski and Barbie Zelizer in relation to photo-journalism, documentary and vernacular photography, but largely this has not occurred in discussions of art photography.[26] The 'affective turn', which has swept through other disciplines in the humanities and social sciences, still has limited purchase in art history.[27]

In one of the most important recent texts on photography that addresses the problem of witnessing, feeling is, in fact, very deliberately excised. Ariella Azoulay seeks to shed terms like shame, empathy and compassion in her account of our civic duty to attend to photographic images of disaster and catastrophe.[28] She argues that audiences should 'watch' such photographs rather than merely looking at them, thereby enacting what she calls the civil contract of photography.[29] Her argument will be examined in greater detail in Chapter 2. Azoulay is another key figure in my analysis; her idea of watching, and the stress on duration and attention it implies, are crucial for the reception and digestion of shameful histories.

However, in her account of the obligation to 'watch' photography, Azoulay does not consider how an emphasis on wrongdoing may serve to shame the viewer and thereby discourages interest in the broader social and political issues at stake. While the viewer's indifference and compassion fatigue are the difficulties repeatedly addressed in the photo-theory literature, little has been said about the elicitation of shame in response to contentious, troubling or upsetting issues in art photography.

The affect of shame usually terminates interest and thereby forecloses on attention and any possibility of prolonged viewing. In Silvan Tomkins' account

of shame, the incomplete reduction of interest precipitates shame.[30] A shamed listener is self-conscious rather than being able to properly hear or respond to injustice. Artists dealing with shameful histories thus need to contend with indifference, compassion fatigue and shame. Shame needs to be attenuated in order to make viewers into secondary witnesses who can 'watch' depictions of disturbing or difficult histories. In short, shame is a crucial (if unacknowledged) aspect of that art's reception.

With this in mind, in the following chapters the analysis of each artist's work carefully considers how the viewer is positioned. Considering spectatorship will be intertwined with the analysis of affect. In my previous book, I developed an art historical method for analysing affect, which I draw upon here. Briefly, I conceive of affect as a component of the work of art rather than an expression of the artist's feelings. More specifically, affect is one aspect or part of the expressive dimension of art; it provides the tone of the work, which is an important source of orientation for the viewer, shaping and comprising aspects of the work's psychological address.

To analyse the affective dimension of art in all its complexity, I contend, requires recourse to a broad range of psychological theories, including but not limited to psychoanalytic theory, psychology and affect theory. In this book, I draw on a variety of theorists to analyse the reparative, affective and psychological dimension of art: Freud, of course, Sándor Ferenczi, Melanie Klein, Heinrich Racker, Jacques Lacan, Jean Laplanche, Silvan Tomkins, Lauren Berlant, Eve Kosofsky Sedgwick, Ignacio Matte-Blanco, Elisabeth Roudinesco, Sianne Ngai and Ruth Leys.

The remaining issue to clarify is the selection of artists. As a feminist art historian with a commitment to the work of French philosopher Luce Irigaray and her project of highlighting and bringing into being sexual difference, I am always on the look out for the ways in which women artists might be doing things differently. This project pursues that aim by bringing to light the distinct contribution of women artists to the archival turn and politically engaged contemporary art – their reparative approach. There are, no doubt, more artists pursuing this strategy than I have identified here. My point is not to exhaustively survey the field, although I have certainly examined a wide range of contemporary photography to select my final examples. Rather, I aim to provide a way of thinking about the particular works the artists have produced, and the important political and methodological issues they raise.

There may also be male artists who could be fitted into this category of practice, although I have to confess that I have not found any to date. The de-colonial aesthetics project, with its commitment to rethinking and remaking colonial history, certainly advocates for repair and promises to generate a form of art that is similarly oriented by post-identity politics.[31] During my research for the current project, the work of one male artist did especially pique my

interest: the French Algerian artist, Kader Attia. He is an intriguing example of someone who directly references the idea of repair, but whose work does not seem to me to be reparative in the sense that Sedgwick uses the term. It is worth a brief digression to consider his exclusion from the reparative mode, as it may help to clarify the limits of my argument.

In the installation, *The Repair: From Occident to Extra-Occidental Cultures* (2012) for dOCUMENTA 13, Attia's use of shock and humour are without doubt a departure from the typical strategies of political art that seek to uncover the negative effects of colonialism. His display of surprising, endearing and at times almost absurd, historical objects crafted from colonial and wartime artefacts – bullets, hats, coins, artillery shells – certainly spoke to the inventive cultural agency of colonized subjects and World War I soldiers in the trenches. Similarly, the slide component of this installation, which juxtaposed the damaged and repaired faces of World War I veterans with African body modifications and the repair of African artefacts, drew previously inconceivable parallels between different types of practices, all now conceived as evidence of repair. Showing the mutilated veterans was almost sadistic, so extreme were the images of cranial and facial devastation; viewing was rendered tolerable only by the short time of exposure to each slide and the periodic reprieve granted by benign and less brutal images.

Linking the occidental and extra-occidental worlds in this fashion, created an extremely strange continuity between the making-do practices of extreme trench warfare, the surgical solutions to its aftermath, and peaceable African practices of routine repair and bodily transformation. *The Repair* seemed to answer back to the empire: we too manipulate faces; we likewise repair; we also re-appropriate, repurpose and recycle objects. To me, this is a very important reassertion of agency in the mode of Frantz Fanon and Oswald de Andrade, whom Attia cites as guiding influences.[32] As such, his approach is more correctly identified as part of what Sianne Ngai calls the uplift aesthetic, which counters or replaces negative stereotypes with positive ones.[33] To be reparative in Sedgwick's sense would require deeper and closer attention to that refuted negativity. A more masculinist, combative form of repair, perhaps, is in evidence.

Alongside the investigation of reparative strategies, the book has two main aims. First, by examining four prominent women artists from the southern hemisphere, I aim to redress the omission of their perspectives from the international literature on witnessing and the archival turn. The neglect of whom has seriously curtailed a genuinely broad-ranging, international discussion of the topic. There are two rather obvious reasons for this oversight, which are nonetheless worth restating, if only to head off the constant claims that women artists require no special pleading. As feminist art historians have consistently shown, women artists are still radically under-represented in art

criticism, art history, museum collections and exhibitions.[34] Also, the literature on the archival turn is dominated by art from the northern hemisphere.[35] As a consequence of these typical prejudices, the different approach of these four artists has been overlooked.

Second, I address a major problem in shame and affect studies by proposing a new way to combine the key antithetical approaches to shame that have emerged in literary and cultural theory. Currently, one of the main fault-lines in the debates about shame lies between the approach of Eve Kosofsky Sedgwick and her followers, which combines the work of the American psychologist Silvan Tomkins with performative approaches to identity, and the recent critiques of Sedgwick and Tomkins by Ruth Leys, whose work is more psychoanalytically inclined. Chapter 1 provides a close analysis of their positions.

To briefly explain the dispute here, it turns not so much on how affect is understood, although there are substantial differences between the two theorists, but on the way in which identity is understood. Sedgwick suggests shame can provide the energy for the transformation of oppressed and oppressive cultural identities.[36] Leys views the anchoring of identity in the expression of feelings, such as shame, as a reductive account of subjectivity; the corollary of which is an avoidance of discussion about identity claims, principally because how we feel is not subject to debate. She argues for the importance of moral feeling in the form of guilt and responsibility for action, characterizing the rise of shame and the eclipse of guilt as a shift from a concern about 'what you do' to a solipsistic focus on 'who you are'.[37] While the two theorists clearly have very different approaches to affect and identity, they are not incompatible. In what follows I combine their concerns by thinking about guilt *and* shame, responsibility for actions *and* the possibility of change and transformation.

My aim in this book is to show that the representation of shameful issues in art can transform the affective tenor of the subject matter (Sedgwick) *and* facilitate attention to the wrongful actions and disturbing events depicted (Leys). For this to happen, however, the audience needs to be engaged rather than shamed. Art practices that use experimental aesthetic strategies to frame distressing issues enable shame to be worked through rather than transmitted to the audience, or more forcefully and traumatically, introjected into them. A synthesis of Sedgwick's performative account of identity with Leys' more psychoanalytic approach yields a much more complex and useful account of shame and guilt.

* * *

The book is divided into three sections. The first section, comprised of two chapters, establishes the theoretical framework for the subsequent case

studies. Chapter 1 focuses on the affect theory debate and seeks to effect a rapprochement between Leys and Sedgwick by looking more carefully at their shared theoretical commitments. Both are indebted to deconstruction and psychoanalysis but, more surprisingly and significantly, both are highly critical of aspects of identity politics. Their analyses support a re-examination of the current and ongoing theoretical approaches of much critical and cultural theory: the pertinence of ideology critique in the case of Sedgwick, and materialist approaches to ontology that are very much in the ascendency, in the case of Leys.

In Chapter 2 I examine what I am calling witnessing fever, namely the idea that in our highly connected world we are all witnesses to world events simply by watching them via mediating technologies. This hyperbolic inflation of witnessing is an interesting symptom of a desire for greater involvement in world events, even if, as I argue, it renders witnessing virtually meaningless. The chapter contextualizes Ulrich Baer's art-historical approach to witnessing by looking at the broader trend in media theory and the new field of witnessing studies. Drawing on Caroline Wake's idea that emotional co-presence can be evoked by watching video testimony, I introduce a more complex account of the role and meaning of identification – a much-neglected term in art history.[38] Specifically, I introduce the idea of complementary identification from the psychoanalytic trauma literature, alongside the more typical reliance upon concordant identification, usually understood as empathy.

The second section focuses on nineteenth-century colonial histories in Australia and Oceania. Chapter 3 examines Anne Ferran's series *Lost to Worlds* (2008), which is part of her suite of works on convict women in colonial Australia. Founded as a British penal colony, Australia is often perceived as tainted by the shame of convict origins. Certainly, the British like to use this perceived slur in international test cricket matches: they frequently refer to the Australian side as 'the convicts'. Contemporary Australians prefer to view these origins as a source of pride, yet this does not entirely square with the views of historians or the way in which the convict legacy is discussed in the media.

Despite the acknowledged importance of convict history for Australian identity, the image of the convict woman is largely absent from the cultural imaginary. There have been some film and television treatments of the topic, however documentary and high art images of the convict woman are few and far between. Ferran, struck by this absence, began to explore the few remaining material traces of female convict heritage in Tasmania, an island-state to the south of the Australian mainland. The paucity of visual records underscores the limits of the archive: some histories and particularly women's history are incompletely or improperly recorded. While some of Ferran's previous works use archival images and artefacts, in *Lost to Worlds* her challenge was to

resuscitate or depict the history of convict women, while also honouring the gap in visual records. Her series of photographs focused on the ground at Ross, a former site of female incarceration, conjure that forgotten history from very meagre remains in a way that incorporates both shame and pride. Ferran thereby puts into play Melanie Klein's idea of the reparative or 'depressive' phase of human development, which can tolerate such ambivalence.[39]

Fiona Pardington's series, *The Pressure of Sunlight Falling* (2010), is the focus of Chapter 4. This ravishingly beautiful sequence of photographs shows some of the fifty life casts of the people of Oceania taken in the early part of the nineteenth century on one of the last European so-called voyages of discovery. The highly poetic title of the series makes one think of the photographic process that requires the action of light, the pressure of the plaster on the sitter's head that does the work of light in this proto-photographic procedure, and perhaps after the cold, dark ordeal of wet casting the newly appreciated comfort of warm sunlight on skin.

The casts are now archival objects, held in French ethnographic museums, but they were originally intended to illustrate a hierarchical and deeply racist classification of the peoples of the Pacific. Pardington transforms these colonial artefacts into vibrant portraits of the original sitters that emphasize a living relation to the dead ancestral figures. She adopts an 'animistic' Māori perspective on these anthropological artefacts that might otherwise be regarded as embarrassing or shameful relics of colonial thinking. The series has a deeply personal resonance for Pardington, included amongst the images are some of her Māori ancestors from her iwi or tribe Ngāi Tahu. The series does not occlude the traumatic past by asserting these personal and living relations. Her oblique restaging of the traumatic contact between the explorers and the sitters is a powerful form of witnessing that will be discussed using the idea of religious witnessing drawn from the work of John Durham Peters.[40]

The third section examines more recent events from twentieth-century Latin American history. The focus of Chapter 5 is the work of Brazilian artist Rosângela Rennó, and in particular a photographic series titled *Corpo da alma* [*Body of the Soul*] (1990–2003) and a photo-installation *Imemorial* [*Immemorial*] (1994). *Imemorial* brings to light a forgotten part of Brazilian history: the shameful labour practices that underpinned the construction of Brasília, the so-called 'capital of hope'. Her project of resuscitation is not redemptive; she simply makes such memories 'tolerable', to use her expression.[41] Her reparative method thus has a carefully calibrated aim to make us look at, rather than look away from, signs of oppression, injustice and negligence.

Body of the Soul is one of the most complex and difficult works in Rennó's oeuvre. It radically recontextualizes the infamous human rights abuses in South America, namely the state-sanctioned murder or 'disappearance' of

dissidents. In South America, a significant number of artists are grappling with the question of how to adequately represent the disappeared; the most well-known examples working with lens-based media are Oscar Muñoz, Juan Manuel Echavarría and Marcelo Brodsky.[42] Photographs, and in particular portraits, are a favoured means for remembering and honouring these people who have been so shamefully treated by different regimes across the continent. Rennó also uses portraits, but crucially in her images there is always someone holding the photographic portrait so that it is the reaction to disappearance that is emphasized. Her series is thereby placed in a more immediately emotional register, which she then strives to contain and cool down. In contrast, Brodsky and Muñoz use less emotive images that struggle to register the intense pain and grief of loss.

For example, Brodsky's work on the disappeared in Argentina, *Buena Memoria* (1996), as I have argued elsewhere, has a peculiarly deadpan and unaffecting quality.[43] His identification of the disappeared in his class photo from 1967, via colour coding and diacritical marks, is numbing and perhaps deliberately unsensationalized (Figure I.1).

Similarly, Muñoz's work distances the viewer by stressing the technology of appearance and disappearance. In *Aliento* [*Breath*] (1996–1997), he requires the viewer to blow on photographs of the disappeared printed on mirrors

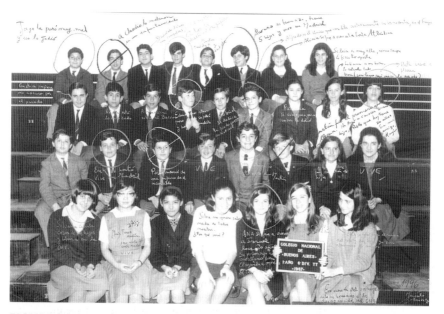

FIGURE I.1 Marcelo Brodsky, *The Class Photo*, from *Buena Memoria*, © Marcelo Brodsky, Buenos Aires, 1996.

(Figure I.2), allowing only a glimpse of the face before it returns to oblivion; while in *Proyecto para un Memorial* [*Project for a Memorial*] (2005) his video installation of portraits being drawn with water, we watch the images evaporate before they are even finished. With the stress falling so heavily on the difficulty of recalling the past, frustration is the abiding feeling evoked by these two works. His work thereby conforms to the repertoire of motifs that stress 'an ever elusive past' identified by Lisa Saltzman in her study of mostly European and North American art concerned with remembrance.[44] She notes the recurrence of various 'post-indexical' visual strategies (the use of shadows, silhouettes, projections, casts and voids) that rely on the idea of an indexical sign while also questioning the sign's capacity to adequately represent an event.[45] In Muñoz's case the stress on inadequacy overwhelms other meanings.

The photographs of Echavarría of broken mannequins, tombs of the anonymous dead and bones assembled into flowers are similarly unaffecting; a professional writer with no formal art training, his photographs lack the visual complexity and attention to the psychology of viewing demonstrated by the artists in this book. However his video, *Bocas de Ceniza* [*Mouths of Ash*] (2003–2004), is a very moving portrait of eight survivors of mass killings in Colombia, shown in tight close-up singing *a capella* about what they have endured.[46] These simply rendered testimonies expose suffering, but also contain and frame it through the fact of survival and the distancing mechanism of song. Video art with inbuilt duration and the possibility of engaging narrative form is already situated in the domain of watching, and perhaps as a consequence has an easier claim on the reparative.

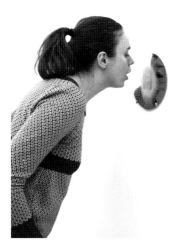

FIGURE I.2 Oscar Muñoz, *Aliento* [*Breath*], twelve metallic discs, screenprint on grease film, 20 cm diameter each, 1995. Installation shot OK Centrum für Gegenwartskunst, Linz, Austria. Courtesy of the artist and Sicardi Gallery.

In *Body of the Soul*, by constructing an archive of photographs of people holding photographs of people, Rennó shifts the meaning of the disappeared from a specifically Latin American phenomenon to a more global encounter with precarity, as well as showing the peculiar power of photographs to conjure an absent body for a much broader range of purposes. Here too her reparative approach is in evidence, her very surprising (but not shocking) representation of a familiar Latin American topic makes us 'look for' photographic meaning, rather than merely look at images. She thereby combines the positive affect of interest with a very thoughtful consideration of the private and public emotions stirred up by the photographic portrait.

The final chapter examines the photographic series, *Los pasos perdidos* [*The Lost Steps*] (1996) by New York-based Peruvian artist, Milagros de la Torre. The chapter focuses on her oblique representations of violence in this series. De la Torre does not show violence *per se*; rather, her work is part of the emerging genre of aftermath images. In her case, it is not past sites of historical violence that she photographs, but rather poignant objects. Like Pardington's work, the series is based on archival objects; in de la Torre's case they are objects that were used as evidence in criminal trials now held in the museum collection at the Palacio de Justicia de Lima, the Courthouse in Lima, Peru.

In *The Lost Steps*, her reparative strategy is to include objects from the Peruvian civil war – a flag confiscated from the terrorist group, Shining Path and a journalist's shirt from the Uchuraccay Massacre – alongside other objects involved with violent crime, such as an incriminating letter sent by a prostitute to her lover. This inclusive arrangement demonstrates de la Torre's interest in illuminating what she calls 'the dark side of human nature'.[47] In this phrase she invites us to share in the psychology that enacts violence rather than judging it from the outside. Our dark side is a phrase also used by Elisabeth Roudinesco to consider the history of perversion. She notes the disappearance of this term in psychiatric manuals, arguing it is a useful and necessary psychological category to describe all types of transgressive behaviour whether inventive or destructive, positive or negative.[48] Most importantly, for Roudinesco, perversion illuminates our shared negativity and destructive instincts. Viewing violence as a shared capacity orients de la Torre's series towards reconciliation and forgiveness, rather than polarizing the world into good and evil, colonizer and colonized, oppressor and oppressed.

By carefully looking at the work of these four artists and their different ways of approaching the archival turn, a new way of thinking about the contribution of women artists to this global trend is opened up. Their very moving and aesthetically complex works regenerate political art and the paranoid postures that are routinely adopted, while also generating insights into their particular national concerns. Their work highlights disturbing and

difficult issues from the past that have the capacity to haunt national consciousness if repressed or unresolved. By integrating the negative parts of history, they seek to facilitate the acknowledgement and working through of such issues and to contribute to a reparative national self-image, which can tolerate ambivalence. Perhaps most importantly, making reparative rather than paranoid works of art, these four artists show the importance of hope – the hope for a progressive society in the future that does not disavow or deny its less than promising past.

1

Guilt and Shame

Current Debates in Affect Studies

Just as contempt strengthens the boundaries and barriers
between individuals and groups and is the instrument par
excellence for the preservation of hierarchical, caste and class
relationships, so is shared shame a prime instrument for
strengthening the sense of mutuality and community
whether it is between parent and child, friend and friend,
or citizen and citizen.[1]

SILVAN TOMKINS

The affect of shame has become the touchstone for the recent debates about the affective turn in the humanities and social sciences. It is perhaps no accident that this 'prime instrument' of bonding should attract such attention at this time. As we look back over the last century of war, strife and terror, shared shame at the violence and destructiveness of humankind might seem the only fitting response. Or, thinking more locally, a deep sense of shame could describe the bad feelings many of us have about ongoing national injustices. In my case, it would be the Australian government's inaction on climate change, growing social inequalities, the treatment of refugees, the stalled process of reconciliation with Aboriginal and Torres Strait Islander peoples, as well as innumerable other issues I could mention. To live in the western world today with a social conscience, one is bound to be shame prone. I need look no further than my own profession. While I have an ongoing job (at least for the time being) the casualization of the university work force is a ruthlessly exploitative system of which I am an inadvertent beneficiary. These social, political and economic factors give shame its strong currency – shame

rather than guilt is in the ascendancy as one of its foremost critics, Ruth Leys, laments.

The common way of distinguishing between the closely related feelings of shame and guilt is to point to the way in which guilt is triggered by something we have actually done, whereas shame is more self-reflexive: we feel bad about ourselves, our profession or country. The bad feeling requires prior investment or identification – interest, to use American psychologist Silvan Tomkins' idea – that is then curtailed, or compromised by a shortfall from our personal ideals.[2] Guilt, on the other hand, does not necessarily rebound on the sense of self as a whole – it is more piecemeal in character, limited to specific acts or omissions. This distinction suggests that shame is socially isolating, which of course it is. According to Silvan Tomkins, we break contact when we are shamed: literally or metaphorically looking down, blushing or flushed with shame. Yet this break in social contact, he asserts, curiously also forges social bonds of community and mutuality. As he puts it 'to be ashamed rather than to show contempt strengthens any social group and its sense of community'.[3] Turning inwards towards the self in response to injustice seems an unlikely way to forge social bonds. Eve Kosofsky Sedgwick, a key interpreter of Tomkins, argues that shame causes a double movement 'toward painful individuation, toward uncontrollable relationality'.[4] In her view, the inward turn is also a turn outward, but this outward turn, if it is uncontrollable, means it is hard to determine or limit whose regard might cause shame. Is this a bond as such, or more like a precondition for sociality? How do we conceptualize, then, the role of shame in strengthening social bonds? This question is a central concern of this book. In particular, I am interested in the ways in which shame currently figures so prominently in the discussion of historical events that we are implicated in, but not responsible for. Why on such occasions is shared shame the response? And most importantly for my project, can shame feed into or enable a reparative approach that facilitates proper attention to these blots or shadows on the social conscience of nations?

While both guilt and shame are classified as self-reflexive moral emotions, psychologists June Price Tangney and Ronda Dearing argue that shame commonly leads to evasion and inaction manifested by a desire to escape, retaliate or blame others, whereas guilt is more likely to result in remorse, apology and reparative action.[5] This distinction suggests shame alone is not sufficient to confront injustice and wrong-doing. Is guilt necessary, then, to facilitate repair?

To think about these questions, this chapter examines the debate initiated by Ruth Leys on the contrast between guilt and shame. These different affects signal different theoretical commitments, respectively psychoanalysis and affect theory, both of which are a central concern in this chapter. Leys' work traces the changing fortunes of these affects and the theoretical models that

underpin them. Her work throws light upon a dramatic shift in the psychological and psychiatric literature on trauma from considering survivor guilt to the current focus on survivor shame. While Leys' analysis concentrates on the feelings of the victim, it has broader implications for thinking about the various subject positions generated by instances of violence or injustice: perpetrators, bystanders and beneficiaries. These subject positions will be discussed in greater detail in the chapters that follow.

The current debate: shame and anti-intentionalism

Although affect studies is now dominated by approaches that favour the work of Gilles Deleuze and its broadly anti-psychological remit, to me the most interesting part of the current field is the difference between the approach of literary theorist Eve Kosofsky Sedgwick and that of historian of science, Ruth Leys.[6] The first salvo, in what is now an ongoing debate, was launched by Ruth Leys in her book *From Guilt to Shame: Auschwitz and After* published in 2007.

As the title suggests, Leys' initial focus in this book is the advent of a different diagnosis of the affective response of survivors of the Holocaust. Her analysis broadens in the third chapter to consider how this shift from guilt to shame is also reflected in current psychiatric evaluations of Post-Traumatic Stress Disorder (PTSD). It is the fourth chapter, 'Shame Now', that is crucial for the affect theory debate. Here, her argument moves into another register all together, considering how shame features prominently not just in trauma studies, but also in cultural analysis more generally. In 'Shame Now' Leys mounts her first critique of affect theory, focusing in particular on the work of Eve Kosofsky Sedgwick and Silvan Tomkins. She has amplified this initial criticism in a series of interviews and articles, most notably her article, 'The Turn to Affect: A Critique', published in *Critical Inquiry* in 2011, which generated a range of responses from followers of both Silvan Tomkins and Gilles Deleuze – her key theoretical targets in the article.[7]

Her chief complaint about the current approaches to affect theory is that the affects are conceived as non-intentionalist or anti-intentionalist, as Leys puts it: 'affective processes occur independently of intention or meaning'.[8] She continues: 'In contrast to Freud . . . for whom emotions are embodied, intentional states governed by our beliefs, cognitions and desires, Tomkins and his followers interpret the affects as non-intentional, bodily reactions.'[9] More importantly for her argument, the affect system is not only corporeal, it is fundamentally separate from cognition, as she puts it: 'affect and cognition are two separate systems'.[10] She underscores the 'constitutive disjunction'

between affect and cognition by pointing to Tomkins' claim that there is a 'radical dichotomy between the "real" causes of affect and the individual's own interpretation of these causes'.[11]

Causality is consistently complicated by Tomkins, for example, he characterizes the relation between affects and objects as profoundly fluid: affects either find an object for expression, or are triggered by an object or external event.[12] The common assumption that affect is primarily a reaction to something is questioned here by the counterintuitive claim that affect may *find* an object for expression. In this account, the affect system begins to sound like it has a life of its own, seeking out opportunities for expression.[13] Certainly, in Leys' interpretation of Tomkins, the affects are presented as an autonomous closed-off system over which we have little control and that offer little by way of accurate knowledge about our reactions, motivations and feelings. As Leys puts it, citing Sedgwick, affects 'can be autotelic', that is, they have no external goal or purpose; they are an end in themselves.[14]

As someone deeply committed to the work of Tomkins and inspired to study his work by Sedgwick, I initially resisted the anti-intentionalist characterization of his work. My feeling was that this characterization of affect theory perfectly describes the theoretical investments of Deleuzian followers, such as Brian Massumi and Nigel Thrift, but it did not encompass the more psychologically attuned work of Sedgwick and Tomkins. Leys' central point, however, is that *both* strands of affect theory share a commitment to anti-intentionalism. While this positioning of affect outside the reach of reason and cognition is very actively and explicitly embraced by the followers of Deleuze, it is not as easy to detect this theoretical investment in the work of Sedgwick and Tomkins. After looking very carefully at Leys' criticisms, I have to concede that Tomkins' theory of the *inherited* affects is anti-intentionalist and that this conception of affect is fundamental to Sedgwick's highly creative use of him.

Whether Sedgwick's work as a whole can be reduced to this anti- or non-intentional formulation, however, is another question. After all, Tomkins is just one of many theorists Sedgwick uses in her highly syncretic style of writing and theorizing. I will return to this reservation in the next section. Before considering Sedgwick's work in greater depth, let me backtrack slightly to outline my initial objections to the anti-intentionalist diagnosis of Tomkins-inspired work and to highlight one part of Leys' analysis that I believe is incorrect.

First, that Tomkins' affect system is innate and biological is not a surprising revelation; it is emphasized by Sedgwick and Adam Frank in their introduction to the Tomkins Reader, *Shame and its Sisters*, published in 1995. They specifically question the very common idea in humanities research that a 'discursive construction' of affect is necessarily preferable to a 'natural' or biological theory of affect.[15] Why, they ask, does theoretical work in the humanities so often

assume that a biological explanation is something to reject as wrong-headed scientism, to be displaced by a social or cultural explanation? Their resuscitation of the work of Tomkins very deliberately questions the longstanding tenet in humanities scholarship that there are two mutually exclusive approaches to ontology, respectively: biologism (presumed to posit fixed essentialist entities) versus social determination (which counters essentialism with the idea that everything is contingent and subject to the vagaries of cultural construction). In much contemporary theory, asserting the discursive construction of emotion – or any another concept (sex, gender, race) – is still frequently supposed to dispel the fixities of essentialism. Despite innumerable attempts to show that essentialism is inescapable – by theorists as diverse as Elizabeth Grosz, Diana Fuss and Gayatri Spivak – the assumption remains that contingency best characterizes our selves, our world and our relation to the things in it.[16] Significantly, Sedgwick and Frank embrace both contingency *and* the idea of a biological given innate system of affects.[17] The pointed refusal of the typical one-sided approach to theoretical endeavours is indicative of Sedgwick's deconstructive method, a commitment that also characterizes the work of Leys – more on that shortly.

Countering the routine rejection of science, biology, nature and the natural, Sedgwick and Frank point out that a high degree of complexity is generated by Tomkins' relatively simple system of eight, then nine affects, that are, as they put it: 'hardwired into the human biological system'.[18] The nine affects are described by Tomkins according to a sliding scale of intensity: interest–excitement, enjoyment–joy, surprise–startle, distress–anguish, fear–terror, shame–humiliation, contempt–dissmell, contempt–disgust and anger–rage. Tomkins presents these innate affects as a motivational system; for example, the affect of interest is necessary for sexual interest, thus displacing the primacy of the drives in Freudian theory.

At first sight, the concepts of interest and motivation might suggest the involvement of cognition and thus promise a way to complicate the charge of anti-intentionalism. Interest, in Tomkins' affect theory, is conceived as an orientation towards novelty, rather like curiosity, making it seem more like a faculty or a capacity rather than a feeling. Conceptualizing interest in this fashion implies a link to reason and cognition. Indeed, adding interest to Charles Darwin's taxonomy of emotion is one of Tomkins' chief innovations in affect theory. However, while to be interested in something necessarily involves conscious awareness of the object, the feeling triggered remains stubbornly within a materialist anti-intentionalist framework.

Motivation suffers a similar fate. It is usually defined as 'giving reason to act', thereby necessarily involving thinking, beliefs and what Leys would call 'higher-order mental processes'.[19] However, Tomkins' description of the goals of the affect system, or General Images as he calls them, is elaborated in

quantitative and hydraulic terms akin to the drives in Freud. Tomkins describes the four goals as follows:

> 1) positive affect should be maximized; 2) negative affect should be minimized; 3) affect inhibition should be minimized; 4) power to maximize positive affect, to minimize negative affect and to minimize affect inhibition should be maximized.[20]

Explained in this way, the motivational aspect of Tomkins' system is barely distinguishable from the pleasure/unpleasure principle in Freudian theory, which regulates the psychic apparatus, and most particularly the drives. The avoidance of unpleasure and the pursuit of pleasure, Freud reminds us, is an 'automatic' mechanism.[21] These General Images, one would assume, then, are like a pre-set thermostat regulating behaviour: protecting us from pain and orienting us towards pleasure. Articulating motivation in this way corresponds to the non-intentional inherited model of affect that Leys defines as the 'rapid, phylogenetically old, automatic responses of the organism that have evolved for survival purposes'.[22] Certainly, the General Images are insufficient to operate as a moral compass or as a guide to moral and ethical action.

Elsewhere, Tomkins in fact describes the affects as something over which most human beings 'never attain great precision of control'.[23] More explicitly, he argues in the same chapter: 'Most of the characteristics which Freud attributed to the Unconscious and to the Id are in fact salient aspects of the affect system'.[24] This comparison is not pursued in any detail; the co-assemblage of affects with the drives is Tomkins' main preoccupation in this particular chapter. However, the analogy suggests a productive way of situating his work relative to psychoanalysis, key aspects of which, Sedgwick notes, he skirts around rather than opposing.[25] To turn his insight around the other way, if the salient features of the affect system are in fact characteristics of the unconscious, then when the goals operate automatically they do not forge a strong link to cognition, and under these circumstances they produce a weak theory of moral or ethical motivation, albeit one that can easily be allied with psychoanalysis. That said, these goals would at times be consciously registered, so it would not be correct to say they are entirely separate from cognition, meaning and intention. For example, we can all imagine occasions when we think about how to avoid negative affect, and similarly times when we consider how to maximize positive affect. We might consciously and mindfully adopt courses of action to avoid anxiety, and seek out opportunities for joy and communion.

One further more important criticism should be added to my broadly sympathetic interpretation of Leys' position: the affect system is not divorced from learning and thinking. Even if the inherited affect system initially operates

for the infant automatically and 'blindly', to use Tomkins' term, feedback and the learning this entails make both the system and the individual affects subject to modification over a lifespan.[26] Experience and memory (whether conscious or unconscious) modify the innate system: affects can be avoided, they can snowball, modify each other, be miniaturized, become monopolistic, made weak or strong, to list just some of the vicissitudes Tomkins describes.

In other words, there are many and varied departures from the blueprint provided by the General Images; whether these are reported via some kind of feedback to the self, or can be even minimally consciously controlled, would no doubt vary from individual to individual. One would imagine that some part of the modification, if not the goals themselves, would be felt and quite possibly known. Does this dispel or complicate the charge of anti-intentionalism? Perhaps not. The kind of motivation described by Tomkins provides little guidance for moral and ethical action, which is ultimately Leys' chief concern. That said, the affects must nonetheless figure in such action, as Tomkins puts it: 'Reason without affect would be impotent, affect without reason would be blind.'[27] While the two systems might be relatively independent in their theoretical articulation, that separation cannot be sustained in everyday life. Indeed, to give Sedgwick the last word, she describes the connection between the various systems in the following way: 'For Tomkins, the difference between the drive system and the affect system is not that one is more rooted in the body than the other; he understands both to be thoroughly embodied, as well as more or less intensively interwoven with cognitive processes.'[28]

Paradoxically, then, affects are autotelic – '[a]ffect is self-validating with or without any further referent' as Tomkins puts it – which suggests they comprise an autonomous, self-referential system, and yet they are not entirely autonomous; they are 'more or less intensively interwoven with cognitive processes'.[29] Similarly, they are anti-intentionalist in conception, and yet contribute to the exercise of reason. These are paradoxes that are a vital part of Tomkins' work that Leys overlooks. While she provides a brilliant analysis of the inherited affect system, which is where her criticisms have the greatest purchase, she pays insufficient attention to Tomkins' extensive phenomenology of the lived affect system, where some of her claims about anti-intentionalism are complicated, if not undercut.

Leys and Sedgwick: points of convergence, psychoanalysis and affect theory

A way forward through this impasse, I believe, is to consider how Tomkins' affect theory can operate within the terms of psychoanalysis, which affords a

much more rigorous account of the interplay between consciousness and the unconscious. Linking Tomkins' affect theory to psychoanalysis promises a thicker description of the role and positioning of the affect system in the psychic apparatus, supplementing the phenomenological descriptions of the vicissitudes of affect, which are the great strengths of Tomkins' work. Using the idea that the goals of the affect system are inherited and thus generally beyond conscious control, we might pose affect as continuous with the unconscious, thereby following the theorization of affect by Chilean psychoanalyst, Ignacio Matte-Blanco.

Against the more typical psychoanalytic belief that affects cannot be unconscious, Matte-Blanco draws attention to the similarities between feeling and the unconscious. Indeed, he goes further, questioning our capacity to separate one from the other. Both, he says, are opposed to thinking. In contrasting thinking and feeling in this fashion, his psychoanalytic understanding of affect aligns with Leys' general criticism of affect theory.

Matte-Blanco points out that we can describe what we are thinking or perceiving 'with precision' whereas descriptions of our feelings are *always hazy*.[30] In other words, he argues that in relation to our own feelings we have none of the clarity or capacity for 'macular vision' that we have with thinking and perception.[31] He suggests that one possible explanation for this haziness about emotions is because they 'seem to have a greater number of dimensions than that with which our self-awareness is capable of dealing'.[32] This explanation aligns feeling with the unconscious; it refers specifically to Matte-Blanco's mathematical account of the unconscious where the space of the unconscious is characterized as having more dimensions than that of perceptions and conscious thinking.

This potential alignment with psychoanalysis is not an issue raised or noted by Leys; her powerful critique illuminates a situation that needs remediation, rather than proposing a solution. More complex thinking about the relationship between psychoanalysis and affect theory, I would suggest, enables remediation. Particularly as Leys' criticism of the rise of affect theory centres on the way it rejects psychology, she argues that it: 'give[s] primacy to the feelings of a subject without a psychology and without an external world'.[33] More specifically, this reduced account of subjectivity results from the rejection of the psychoanalytic understanding of survivor guilt, which presumed unconscious identification with the aggressor. Rejecting this model of internalization underpins the shift from guilt to shame in trauma studies. Leys renames this classic psychoanalytic account of immersive identification as a 'mimetic' response to trauma.

In the current trauma literature, this mimetic model is displaced by an antimimetic model that rejects internalization and favours a performative relation to events and feelings of shame. Disidentification in the antimimetic

model, psychologists claim, enables the victim of violence to stand apart from the aggressor. Any imitation of the aggressor is argued to be only a performance, a 'dissimulation' as Leys puts it, glossing the views of Ernest A. Rappaport.[34] Shame, it is then argued, is a self-aware and self-conscious response, which is triggered by the sense of being observed or judged for this apparent compliance; as one proponent of shame puts it: 'the thought of being seen by another is a catalyst for the emotion'.[35] The victim is described as psychically outside the event, only returned to his or her skin by the gaze of another.

Leys argues strongly against the current trend to privilege the performative and the antimimetic understanding of trauma. However, the most interesting conclusion Leys draws from this bifurcation in the field is that the immersive and antimimetic are inseparable. This deconstructive move, which refuses the either/or of binary logic, is most clearly outlined in her earlier book, *Trauma: A Genealogy*. Here, she first identified and explained the imbrication of the two theories of trauma:

> My goal in this book has been not so much to associate individual interpretations of trauma with one or other of the two theories, though to some extent that has been inevitable, as to show that from the turn of the century to the present there has been a continual oscillation between them, indeed the interpenetration of one by the other or alternatively the collapse of one into the other has been recurrent and unstoppable.[36]

This insight, suggestive of a deconstructive account of mimetic and antimimetic responses, could be extended to consider how affective responses such as guilt and shame also alternate, interpenetrate and combine. Again, this is not the direction Leys pursues, she is not concerned with how the two might be brought together deliberately, rather she traces the profound consequences of ignoring the imbrication, instead focusing only on shame.

Leys argues that the concentration on shame generates a politics of difference without ethics, responsibility, or the possibility of dispute. Or, as she describes this drastic curtailment of the complexity of subjectivity and its external relations, the concentration on shame leads to what she calls the 'primacy of personal differences'.[37] She explains this retreat to the personal, by contrasting the anti-intentionalist approach of Sedgwick with the critique of such positions by Walter Benn Michaels. According to Leys, in his book, *The Shape of the Signifier: 1967 to the End of History*, Michaels identifies a widespread theoretical tendency that favours the materiality of the text, and the identity and subject positions of the reader over the intentions of the author. She explains how this leads to a shift away from discussion and debate: 'Differences become intrinsically valuable because a concern with

disagreements over beliefs and intentions is replaced by a concern with differences in personal experience. The result is that when people have different experiences or feelings, they don't disagree, they just are *different*.'[38]

Michaels, she points out, stresses that while we may have ideological disputes – conflicts about beliefs, and disagreements about what is true – what we feel is generally not subject to public debate.[39] While it is possible to debate how and what we feel in relation to both art and events it is nonetheless not currently customary, despite the fact that much contemporary political discourse is highly emotive and appeals to what Joshua Greene calls our 'tribal emotions'.[40] For example, we could argue about over-reactions, perceived failures to react properly, misapplied emotions, projected feelings and so forth, but in public life curiously we do not. The situation described by Leys as 'disarticulating difference from disagreement' militates against debate and discussion.[41]

The quelling of debate, I would argue, is as much a result of decades of identity politics, as it is the more recent affective turn. And significantly, the failure to debate identity claims that are based on the personal experience of disenfranchised groups or individuals, whether expressed in art or cultural theory, is often the result of the feeling of shame on the part of beneficiaries of the same system of inequality. While in such instances one would expect the feeling to be consciously registered or felt, shame can easily transmute into evasion or aggression, as Tangney and Dearing suggest. If it is displaced or outpaced in this fashion, shame may barely register as the underlying feeling. The paucity of debate around identity politics that both Leys and Michaels underscore certainly suggests evasion and the occlusion of shame.

Surprisingly, Leys' critique of reductive identity politics offers another important point of connection with Sedgwick's work. In her essay 'Paranoid Reading and Reparative Reading, or, You're So Paranoid I Bet You Think This Essay Is About You', Sedgwick presents a powerful critique of one of the mainstays of identity politics. That is, she throws into sharp relief the limitations of what would normally be called ideology critique; she renames this popular method, calling it paranoid reading practice. Sedgwick describes a 'paranoid' approach as one that adopts a posture of suspicion and operates as a kind of 'exposure' of traces of oppression or injustice.[42] She disputes the extent to which we are still enlightened by such approaches. Given that much oppression is all too visible, unveiling can hardly operate according to the surface/depth model that informed traditional critical theory. Nonetheless she argues, quite rightly I believe, that paranoid suspicion is central to critical practice in the humanities. Her diagnosis remains true over a decade later; the idea of exposure and the humiliation of the exposed still have immense critical and affective appeal.

In contemporary art, this approach is typical of the anti-aesthetic tradition and identity politics art, which favour critique and the exposure of wrong-

doing. Often, such art is protected from criticism and debate by invoking the idea of witnessing. For example, in her book *Seeing Witness: Visuality and the Ethics of Testimony* (2009), Jane Blocker uses the term 'witnessing' to refer specifically to artists' testimony. She introduces her alignment of witnessing and authorship by noting that much of the literature in trauma studies considers 'how' events can be represented; in contrast, she wants to examine 'who' can represent such events.[43] For her, the witness is 'a privileged subject position'.[44] To privilege the art of the victim of injustice in this fashion sets up an unnecessary asymmetry between the artist and his or her audience. Instead of being viewed as equal participants in the production and reception of art, the role of the audience is to 'listen' in a non-critical way. In effect, art is shifted from the public domain of debate and interpretation, which important or contentious art should receive, into a quasi-therapeutic register.

Sedgwick does not dismiss the idea that art or literature can have therapeutic effects as her alternative to paranoid reading – reparative reading – clearly indicates. The therapeutic dimension of the reparative approach, however, is fairly narrowly conceived; it is mainly an antidote to a paranoid reading, rather than having an uncritical or principally curative effect. This is evident in her diagnosis of these two approaches, which focuses on the key affects involved. She argues that paranoid suspicion is propelled by the desire on the part of theorists and critics to avoid surprise, shame and humiliation.[45] In place of a paranoid approach to culture, she proposes that critics adopt a reparative approach. A reparative motive, she suggests, seeks pleasure rather than the avoidance of painful feelings.[46] Avoiding negative feelings versus seeking pleasurable feelings is the principal dichotomy operative in the contrast. Ameliorative effects are also mentioned in passing as a benefit of reparative reading, but they are less clearly defined. Presumably, amelioration flows from a reading that seeks positive feeling and that is not preoccupied with relentless ideology critique or bent on exposure.

The responses of Sedgwick and Leys to the dominance of identity politics converge around the foreclosure of debate and critical thinking, albeit the way they approach this issue is very different. Leys shows how the autotelic theorization of affect maps onto a self-centred conception of identity, which in turn is mirrored by the closed nature of enunciation in the public domain. Sedgwick focuses on the closing down of critical and affective engagement by cultural critics who follow the well-worn path of ideology critique. Both thereby indicate the perils of articulating identity politics in overly prescribed and closed terms.

The most substantial difference between the two for my purposes is that Sedgwick proposes a solution in the form of reparative reading. This is an ongoing theme in her work, which, on the whole, is sympathetic to identity politics. For example, elsewhere she posits shame as a possible source of

transformation for queer identity albeit in the performative mode criticized by Leys. Sedgwick sees shame as both something damaging but also capable of being pressed into the service of transformation, as she puts it 'I suggest that to view performativity in terms of habitual shame and its transformation opens a lot of new doors for thinking about identity politics.'[47] Sedgwick does not spell out a general strategy for transforming shame. The close reading of Henry James, which occasions the analysis of shame, traces the homoerotic imagery of his work as simultaneously blushing and yet revealing. In particular, she focuses on the way in which sources of shame in the writer's past were reworked rather than repudiated when James edited the New York edition of his collected fiction. For example, she argues that in the newly written prefaces introducing his past work, he 'is using reparenting or "reissue" as a strategy for dramatizing and integrating shame, in the sense of rendering this potentially paralyzing affect narratively, emotionally, and performatively productive'. '[T]he flush of shame,' she continues, 'becomes an affecting and eroticized form of mutual display.'[48] Her analysis is guided here by the manner in which Tomkins defines shame. For Tomkins shame is temporary: 'shame-humiliation does not renounce the object permanently, whereas contempt-disgust does'.[49]

Leys zeroes in on exactly this part of Sedgwick's work to demonstrate the operation of the antimimetic model. She argues: 'For Sedgwick, the shamefully pleasurable-erotic relation between James and his earlier selves, at once identificatory *and* identity-transforming, deconstituting *and* individuating, takes place on the basis of an antimimetic (or disidentifactory) sense of personal difference and distinction.'[50] Here we are in the belly of the beast, the precise point at which Leys' criticism of Sedgwick really hits home. Performativity is used here to create precisely the difference from the self that both shifts cultural stereotypes (in Sedgwick's terms) and which resists internalization (in Leys' terms).

Such revisions, Sedgwick argues, are needed because identities are stubbornly and indelibly marked by their histories.[51] As she puts it: 'The forms taken by shame are not distinct "toxic" parts of a group or individual identity that can be excised; they are instead integral to and residual in the processes by which identity itself is formed.'[52] Her recourse to performativity is not, then, simplistic anti-essentialism, that operates as a form of denial of internalization or over-eager utopian voluntarism, which presumes all identities are infinitely malleable and open to change. While internalization is without doubt kept at bay in the instance of transforming paralysing shame, she is not opposed to more complex psychoanalytic models of subjectivity, as may be immediately evident to some readers through her contrast between paranoid and reparative readings. This opposition is, of course, indebted to Melanie Klein. To return to 'Paranoid Reading and Reparative Reading', Sedgwick's main argument in this paper is deeply indebted to Klein's work.

For my purposes, the most significant aspect of 'Paranoid Reading and Reparative Reading', is the way in which it combines Tomkins' affect theory and psychoanalysis. So not only does the essay provide an astute criticism of identity politics that aligns with Leys, it also brings into play precisely the body of knowledge Leys argues is missing from the trauma literature. The distinction Sedgwick draws upon between the paranoid position and the reparative position is fundamental to Klein's account of human development and psychology. These terms describe two phases or positions in very early psychic life. To give them their full names, the first is the paranoid-schizoid phase; the second is the reparative or depressive phase. As Juliet Mitchell notes, the two positions, the paranoid-schizoid and the depressive, 'develop in the first months of life, but they always remain as part of our personality, of our normal and our psychotic development'.[53] In other words, while they occur sequentially in infant development, neither is completely surmounted or resolved.

In the paranoid-schizoid phase, Klein describes the infant's oscillation between feelings of love for the mother and feelings of hate and greed, the latter feelings precipitate extraordinarily violent phantasies of destruction. She writes:

> When a baby feels frustrated at the breast, in his phantasies he attacks this breast; but if he is being gratified by the breast, he loves it and has phantasies of a pleasant kind in relation to it. In his aggressive phantasies, he wishes to bite up and to tear up his mother and her breasts, and to destroy her also in other ways.[54]

The imagined attack on the mother also evokes fear of retaliation, hence the paranoid dimension of this phase. While Klein notes that in this phase the infant's relations are predominantly with part-objects – the good (gratifying) breast is loved, whereas the bad (frustrating) breast is hated – the good and bad objects are 'not wholly distinct from one another in the infant's mind'.[55] The integration of these split part-objects only properly occurs in the depressive phase when the infant develops the capacity for internalizing whole objects and is able to tolerate the ambivalent feelings previously kept apart by the defence of splitting (the schizoid dimension of the earlier phase). Klein describes the integration as a kind of restoration: 'If the baby has, in his aggressive phantasies, injured his mother by biting and tearing her up, he may soon build up phantasies that is he is putting the bits together again and repairing her.'[56]

Reparation is precipitated by depressive anxiety resulting from guilt and remorse at the damage done in phantasy in the previous phase. As the infant seeks to repair the mother, he or she also internalizes both the damaged and

the restored mother, adding these objects of hate and love to his or her inner world. For Klein, objects are always simultaneously internal to the psyche as well as external, creating a complicated interweaving of inner and outer reality. Splitting and integration, thus, have consequences for both the constitution of the self and the relation to others.

Sedgwick is careful to stress that Klein's process of restoration does not undo the imagined damage done to the mother. She draws attention to the fact that the whole object is not a pristine object; the whole, she notes, is '*not necessarily like any preexisting whole*'.[57] She spells out the compromised quality of the whole object in a later article on Klein, citing Hinshelwood's dictionary definition of the potential pitfalls of integration: '*When such part-objects are brought together as a whole they threaten to form a contaminated, damaged, or dead whole object.*'[58] The reparative phase or position is not, then, redemptive or restorative in the straightforward way one might suppose. Sedgwick is at pains to emphasize precisely this point. She outlines the instability and vicissitudes of the reparative phase with great insight:

> Once assembled, these more realistic, durable, and satisfying internal objects are available to be identified with, to offer one and to be offered nourishment and comfort in turn. Yet the pressures of that founding, depressive realization can also continually impel the psyche back toward depression, toward manic escapism, or toward the violently projective defenses of the paranoid/schizoid position. We feel these depressive pressures in the forms of remorse, shame, the buzzing confusion that makes thought impossible, depression itself, mourning for the lost ideal, and – often most relevant – a paralyzing apprehension of the inexorable laws of unintended consequences.[59]

Two aspects of Sedgwick's analysis of Klein are of particular note. First, as is evident in the quote above, Sedgwick mostly elides the references to guilt, which is in fact a central concept for Klein. Indeed, guilt, when mentioned by Sedgwick, is predictably displaced by shame in precisely the manner identified by Leys. For example, Sedgwick argues that: 'Survivors' guilt and, more generally, the politics of guilt will be better understood when we can see them in some relation to the slippery dynamics of shame.'[60] As Sedgwick's focus is mainly on queer theory and the identitarian function of shame, the elision of guilt makes political sense; unconscious guilt about sexuality is understandable psychically, but harder to justify socially or politically. However, in the case of the kinds of topics routinely analysed by the paranoid approach – state supported violence, imperialism, neo-colonialism – is this lacuna supportable? In such instances, it might be preferable to slough off the perpetrator's perception of the victim through the distancing mechanism of shame, but

surely some measure of unconscious identification with the aggressor is an unavoidable legacy of our early aggressive phantasies? The complicated intertwining of internal and external objects that Klein's theory elucidates would also prohibit this recourse to simple externalization of the other's regard.

Most importantly, situations of extreme violence or lacerating oppression sufficient to cause psychic trauma plug into the libidinal economy and reactivate what Jean Laplanche views as the originary trauma of sexuality, or more correctly the preconditions for trauma: parental seduction, whereby the infant is first 'invaded by sexuality'.[61] Here, Laplanche returns to Freud's abandoned seduction theory, turning what Freud subsequently regarded as phantasy back into a real event, but significantly for Laplanche it is the blameless premature communication of sexuality from mother's breast to child. In other words, rather than the trauma of the perverse seduction of the child by a parent, the invasion of sexuality is what he calls the 'originary seduction of the normal', or 'the enigmatic message of the other', which precipitates the formation of the ego.[62] He explains that later traumas operate with the ego already in place, but 'the first trauma, which is not trauma, but seduction – the first seduction – is the way the ego builds itself'.[63] Subsequent trauma thus necessarily reactivates this fault-line of the psyche.

In an interview with trauma theorist, Cathy Caruth, Laplanche explains the perhaps unpalatable fact that all adult 'traumas make sexuality active again, that is, by developing sexual excitement'.[64] In particular he notes, returning to Freud, that trauma is not simply an external event that wounds the psyche. He explains:

> His [Freud's] theory explained that trauma, in order to be psychic trauma, never comes simply from outside. That is, even in the first moment it must be internalized, and then afterwards relived, revivified, in order to become an internal trauma. That's the meaning of his theory that trauma consists of two moments: the trauma, in order to be psychic trauma, doesn't occur in just one moment. First, there is the implantation of something coming from outside. And this experience, or the memory of it, must be reinvested in a second moment, and *then* it becomes traumatic. It is not the first act which is traumatic, it is the internal reviviscence of this memory that becomes traumatic. That's Freud's theory.[65]

When dealing with trauma, then, to avoid the question of internalization is an unsupportable theoretical move that would lead to a less complex account of subjectivity, and for that matter, sexuality.

Returning to Sedgwick, even though she has a somewhat phobic response to the internalization of guilt, acknowledging its presence and pertinence

surely better fits her conclusions about reparative reading and the way in which it operates through incorporating both the good and the bad. This brings me to the second point, Sedgwick's methodological conclusions. What she takes from Klein's complicated assemblage of internal and external objects is the idea of a reparative impulse that is 'additive and accretive'.[66] An unforeseen consequence of this additive approach may be that a reparative practice cannot be entirely separated from a paranoid one either. The uneasy co-existence of the two approaches would certainly be the theoretical direction Klein's work supports, given that neither position is psychically surmounted or resolved. Indeed, as indicated above, Sedgwick underscores the continuing risk of a return to the paranoid position, in addition to the deadening possibility of depression, even as she argues for the reparative motive as a distinct approach to queer politics. Her article, we can conclude, to some degree resists guilt and internalization, but in her desire for an approach that is 'additive and accretive' these feelings and this process must be admitted in order to forge a genuinely reparative way of reading or interpreting cultural material.

In practice, conceiving of reparative reading as inhabited by paranoid reading would mean remaining attuned to the idea of exposure while tempering this paranoid way of doing things with openness to the ameliorative and the aesthetic. Such an approach may be better suited to our times. The paradigm of unveiling and exposure is without doubt regaining critical force as we witness the death of high quality broadsheet newspapers, and the accompanying loss of in-depth news reporting provided by journalists with the time and support for proper research. In this context, artists more than ever become important advocates for attending to those aspects of our culture that, as Urich Baer puts it, 'no one ever wanted to know about'.[67]

Guilt and shame about the past

One of the key issues that emerges from the current debates in affect theory is the importance of the neglected moral emotion of guilt. With a consideration of the role of guilt comes a greater emphasis on internalization, a relation to sexuality, and a more complex psychoanalytic account of the relationship between subjectivity and external worldly events. Yet in political theory, unlike psychoanalytic theory, there is a hesitance to extend the question of guilt to occasions when we are not personally responsible for actions or omissions that cause harm to others. For example, in her assessment of collective guilt and responsibility, Lilian Alweiss falls into line with the shift Ruth Leys identifies by favouring shame over guilt as the appropriate response to distant historical events.

Considering the Holocaust in particular, she examines Hannah Arendt's influential distinction, formulated in the immediate aftermath of the war, between our legal and moral responsibilities as individuals (when guilt is at issue) and our political or collective responsibility as citizens; that is, when we are 'treated as representatives of a particular socio-political or national group'.[68] Arendt believed the language of guilt and blame should play no part in the latter scenario instead, when faced with atrocities of the magnitude of the Holocaust, she argued we should feel 'ashamed of being human'.[69] For her, collective responsibility for the Holocaust is linked to shame. Writing in 1945, she argues: 'this elemental shame, which many people of the most various nationalities share with one another today, is what finally is left of our sense of international solidarity'.[70]

Alweiss compares Arendt's approach with that of Avishai Margalit who contrasts the universal moral responsibility to remember atrocity such as the Holocaust, with ethical responsibility for events that have more limited or local relevance. He sees remorse as the appropriate response of all Germans to the Holocaust, irrespective of their level of involvement. Alweiss concludes by questioning Margalit's reliance on the language of guilt as well as Arendt's sharp distinction between public and private responsibilities that operates to exclude blame and guilt from the public sphere. Despite these caveats, ultimately she proceeds with Arendt's view that shame is the more appropriate collective response.[71]

Her reasoning here, which is typical of a sociological approach, pays little or no attention to the empirical psychological literature that indicates the negative consequences of the elicitation of shame; as mentioned previously, they include evasion, inaction and projection. More importantly, with the emphasis on either autonomous individuals or the collective – the one and the many – there is no consideration of the range of subject positions routinely used in trauma studies, namely: perpetrator, bystander, victim and, most importantly, beneficiary.[72] It is the latter subject position in particular that complicates the exclusion of guilt in any collective response to atrocity, injustice or discrimination. When one benefits from an exploitative class system or systemic racism, homophobia or sexism, it is not quite so easy to exclude feelings of complicity, guilt and remorse. While Alweiss mentions both 'deeds we have actually committed or failed to do' as part of individual responsibility, it is when we benefit simply because of our membership of a group that inaction and omission begin to have collective moral and ethical consequences.[73]

In the chapters that follow, this category of the beneficiary, as well as victim and perpetrator, will be crucial for examining the ways in which women artists approach injustice and atrocity in the histories of their respective nations. These psychologically freighted terms encourage us to engage more

deeply with the events presented and to consider more carefully our moral responsibilities as members of particular groups and the world community. Framing significant historical events in this fashion complicates the paranoid position, which seeks to simply externalize wrongdoing by exposing its workings in the deeds of others. Moreover, the aesthetic power of these works is without doubt a source of reparative pleasure.

2

Witnessing Fever

I want my work to become part of our visual history, to enter our collective memory and our collective conscience. I hope it will serve to remind us that history's deepest tragedies concern not the great protagonists who set events in motion but the countless ordinary people who are caught up in those events and torn apart by their remorseless fury. I have been a witness, and these pictures are my testimony. The events I have recorded should not be forgotten and must not be repeated.[1]

JAMES NACHTWEY

It is very common for photojournalists to refer to themselves as witnesses to historical events and their work as a form of testimony. James Nachtwey's account of his work is typical of this approach. In the quote above, he conveys the common sense understanding of the link between photography and witnessing: the photographer is present at a significant event and he or she records that event in real time usually for distribution via high circulation publications such as newspapers and magazines and their online equivalents. When encountered in the mass media under the auspices of a respected media outlet, the photographs are treated primarily as information about the world; the scepticism about the veracity of the digital image or the mediating role of the camera is not usually at play. In this everyday encounter, photographs simply illustrate or document current events. In other words, they contribute to the news. The very word 'news', as the strange plural form of 'new', underscores the demand that such imagery is novel, current and immediate.

This common sense understanding of witnessing has been profoundly complicated by the use of this same term to describe a variety of contemporary art practices that do not depend on the artist being present at the 'decisive moment', to invoke photographer Henri Cartier-Bresson's famous adage.[2] The range of practices that has been assembled under the rubric of witnessing is

quite astonishing: from the staged photographs of Carrie Mae Weems, to the fictional archives by The Atlas Group, and encompassing Colombian sculptor Doris Salcedo as well as conceptualist Felix Gonzalez-Torres and the performances of James Luna, to name just a small sample.[3] Some of these artists attest to their ongoing experience of oppression rather than a singular event (Luna, Weems, Gonzalez-Torres); others confront wars in their countries of origin in unconventional ways. For example, humour is a consistent tactic in the presentation of the Lebanese wars in the work of The Atlas Group, and the sculptures and installations of Salcedo memorialize the victims of the Colombian conflict by using strange and poetic amalgams of furniture and clothing.

The link between witnessing and typical documentary protocols is overwhelmingly rejected here, while, as these examples indicate, the traditional focus on lens-based media is similarly eschewed. The underlying idea seems to be that artists bear witness to the enduring experience of oppression or protracted civil war, and their work can have a testimonial character, even if they are not eyewitnesses to specific significant events. Dispensing with the necessity of first-hand experience of particular events forgoes one of the defining features of witnessing in both juridical and historical contexts. This curious action essentially unhooks the meaning of witnessing from what is usually regarded as one of its indispensable limits. How do we explain this radical expansion of the concept of witnessing? This chapter examines the peculiar inflation of the purview of this term. In particular, I focus on the intriguing shift in spectatorship signalled by its widespread, but seemingly inappropriate, adoption to describe distanced relations to world events.

Witnessing: from oral testimony to watching the news

While the immediacy of the eyewitness photograph is crucial for traditional documentary photography and photojournalism, in the scholarly literature on witnessing, oral testimony told after the fact is the more usual focus. The centrality of oral accounts no doubt flows from the importance of Holocaust testimony for the initial theorization of witnessing. In particular, discussions of the Yale-Fortunoff Archive, composed of over 4,400 videotaped interviews with Holocaust survivors and witnesses, has generated some of the most incisive analyses of testimony as well as setting the initial terms of the debate.

The importance of oral testimony has oriented the field in a particular way. Perhaps most significantly it has foregrounded the issue of memory, because oral testimony is a recollection rather than a record. Despite the substantial

difference between visual and verbal testimony, the issue of memory is frequently carried across into the studies of the image. For example, recent books in the visual arts combine the concepts of witnessing and memory, as these titles demonstrate: *The Image and the Witness: Trauma, Memory and Visual Culture* (2007), *Memory Effects: The Holocaust and the Art of Secondary Witnessing* (2002).[4] But is the photographic image (which is my concern here) really akin to a recollection? It can certainly be a trigger for remembrance and become part of collective memory, but is it subject to the vagaries of human memory that afflict oral testimony? Allowing for the unreliability of memory is integral to the efficacy of witnessing in the Holocaust literature; rather than being an error to eradicate, it goes to the heart of the nature of testimony, which is not so much concerned with verifiable factual truth (although this is not unimportant) but with the subjective experience of historically significant events.

Dori Laub, who is both a Holocaust survivor and a psychiatrist involved in the gathering of Holocaust testimony for the Archive, addresses precisely this issue of unreliable memory in his account of the specificity of witnessing. In what is now a well-known example, he cites a survivor's testimony that recalls an uprising in Auschwitz where the eyewitness claimed she saw four chimneys being destroyed by flames.[5] Laub notes that, when the testimony was presented to a group that included historians, there was consternation about a factual error; there was only one chimney. In response, he defends the exaggeration by pointing to what the event represented psychically: the occurrence of the seemingly impossible. As he puts it:

> One chimney blown up in Auschwitz was as incredible as four. The number mattered less than the fact of the occurrence. The event itself was almost inconceivable. The woman testified to an event that broke the all compelling frame of Auschwitz, where Jewish armed revolts just did not happen, and had no place. She testified to the breakage of a framework. That was historical truth.[6]

Laub uses the survivor's mistake to explain what testimony can reveal that historical accounts cannot, namely: the knowledge it brings into being about survival and for survivors and, in this instance, how the faulty recollection stands metonymically for recovery. The woman, he suggests, in recalling this brief but powerful glimmer of hope, is put in touch with her own capacity for survival and resistance: 'The woman's testimony . . . is breaking the frame of the concentration camp by and through her very testimony: she is breaking out of Auschwitz even by her very talking.'[7]

In other words, her exaggeration speaks to the magnitude of the event and its profound psychic significance. Like enlarged elements in a dream, the

inflated number of chimneys underscores the shattering of her expectations and beliefs about what was possible in Auschwitz. The testimony magnifies the break in the everyday reality of the concentration camp, yet the unreality of four chimneys more surely attests to the shock to perception that the incident constituted. The misremembered details signify that shock and the extraordinary psychic importance of something that broke with her immediate experience, or represented an outside to it; thereby connoting, when retold in the present, a world and a life not reduced to that framework.

Laub's deceptively simple language manages to hold apart the different temporal registers (past and present) of the survivor's testimony, and the shifting locations of agency (her actions, the actions of others), while also evoking their collapse: she is out of Auschwitz but also still in it, still breaking free; those who instigated the uprising broke the framework, she is breaking the framework. This careful rendering of the way equivalences are forged between internal and external events provides a startling glimpse into the unconscious processes involved in witnessing. The complexity of memory described here is hard to imagine outside the therapeutic testimonial framework.

This vignette of Holocaust witnessing brings to the fore another distinctive issue about the field as it has emerged in Holocaust studies: the importance of traumatic memory. More often than not, interpretations of witnessing in the visual arts are coupled with analyses of both memory and trauma. Indeed, when witnessing is invoked, it is implicit that the event has an afterlife, it calls for extended attention, precisely because it is not digested or understood, or cannot be by conventional means.

Laub's complex account of Holocaust memory appears in the seminal text *Testimony: Crises of Witnessing in Literature, Psychoanalysis, and History*, which he wrote with literary critic Shoshana Felman. The book addresses not just witnessing, but also the challenges and difficulties entailed. While it is one of the earliest publications on the topic (published in 1992), it has far more psychological and aesthetic complexity than most of the work in the visual arts that has followed, as his account of traumatic memory should testify. In this book, Laub provides a definition of the three levels of witnessing that retrospectively can be viewed as providing the toeholds for the current inflation of the term. Witnessing for Laub is expanded to consider not just the eyewitness, but also the reception of testimony. The three levels of witnessing are: internal witnessing (being one's own inner witness), external witnessing (being a witnesses to others) and finally the third level, which he describes as 'being a witness to the process of witnessing itself'.[8] Laub conceives these levels as operating within the specific dialogic framework of testimony gathering, with the external witness playing a crucial role in the production of testimony.

His account of the internal witness, and its destruction under severe traumatic conditions, accounts for why survivors have difficulty remaining separate from, and reflective about, the events taking place outside them. Feminist philosopher Kelly Oliver develops Laub's idea of the primacy of the inner witness in her refiguring of witnessing as the bedrock of subjectivity.[9] To bear witness requires this internal witness, yet much of the literature about witnessing in art or film seems to forgo this necessary separation, advocating instead the kind of viewing associated with the experience of trauma itself, that is, a kind of psychic flooding where identification borders on merger and admits no critical or reflective distance. The capacity for critical reflection is as necessary for the evaluation of art as for the maintenance of healthy psychic boundaries. I will return to this issue, which speaks to one of the potential problems with the adoption of this nomenclature in the visual arts.

Shoshana Felman in her sections of the book also complicates the role of the witness. As a literary critic, she draws attention to different, more formal qualities of artistic testimony; challenging content, she suggests, exerts pressure on language, such that poetry has to 'speak *beyond its means*'.[10] Here and throughout her chapters, she presents typical qualities of avant-garde art as fundamental to the experience of the literature of testimony, such as: inducing an experience of strangeness, or having qualities of opacity and incomprehensibility.[11] It is in this way that the 'crises' of witnessing of the book's title are articulated, the experiences to be communicated are consistently discussed as almost beyond representation, certainly beyond straightforward transmission.

One of her most cited examples, however, is not drawn from the literary texts she analyses but rather considers the reaction of one of her classes to viewing video testimony from the Yale-Fortunoff Archive. Here, the idea that the experience of trauma is untransmittable is undercut by the transmission of something akin to a traumatic experience to the class. The students, after viewing the testimony, described it as 'a shattering experience' that led them to feel lost, isolated, '*disconnected*', almost dissociated.[12] Felman explains the crisis in the classroom as caused by the way the students felt 'actively *addressed* not only by the videotape but by the intensity and intimacy of the testimonial encounter throughout the course'.[13] Asking the students to reflect on their experience in order to work through and integrate it, she instructs them to write about it, concluding that the results were a statement 'of the trauma they had gone through and of the significance of their assuming the position of the witness'.[14]

The idea that watching video testimony is a form of witnessing, or that it can traumatize its viewers, has sparked considerable debate. Critics such as Dominick LaCapra initially regarded this as hyperbolic, only later conceding

that viewing for some individuals could lead to secondary trauma.[15] In distinction to Laub, LaCapra introduces the term 'secondary witnessing' to distinguish between the eyewitness and the receiver of testimony such as the historian or psychoanalyst.[16] The ambit of this term is then frequently expanded to include the children of Holocaust survivors.

In the visual arts, Dora Apel identifies Art Spiegelman as the first to create a popular depiction of this kind of intergenerational transmission. His comic books, *Maus*, are described as 'a story about the relationship of the secondary witness to the memory of the Holocaust'.[17] Artists who make work from, or about, this subject position are then described as secondary witnesses; for Apel, this means artists born after the Holocaust, who nonetheless 'view *themselves as links* to an obliterated past' [my emphasis].[18] In a chapter discussing the appropriation of the testimonial form, she describes the artists' work as proceeding from identification with survivors, as well as a desire to refigure that experience. She states: 'While identifying with survivors, secondary witnesses also resist and reject the pathos and abjectness that are associated with victimhood, often constructing the survivor in ways that create a tension between the horror of the past and the resilience to it that has brought them into the present.'[19] In sum, the term secondary witness correlates with second-generation Holocaust memory, what is called 'postmemory' by Marianne Hirsch, 'afterimages' by Robert Young and 'memory effects' by Apel.[20] The art of secondary witnessing, then, has a very restricted meaning for Apel: artists must see themselves as linked to the past through second-generation memory.

In contrast to Apel, Ulrich Baer, in his book *Spectral Evidence: The Photography of Trauma*, applies the term secondary witness to the viewer of photography. Like Apel, he uses this expression to describe photography predicated on a belated relation to historical events. However, it is the reception of such images, rather than the subject position of the producer that interests him. Referring specifically to recent photographs by Mikael Levin and Dirk Reinartz of empty, nondescript landscapes that were the sites of former concentration camps, he argues that the tension between the historical significance of the sites, which engages our interest, and the absence of anything to see, makes us feel excluded from the images.[21] Ambivalence, absences, detachment and being thrown back on ourselves seem to be crucial for his idea of secondary witnessing. I say 'seem' advisedly, as this is not a well-developed concept in his book; instead, he has a series of suggestive asides about how secondary witnessing might be triggered. For example, concluding his analysis of these empty images, he states: 'By creating an experience of place for areas designed to destroy the very possibility of experience, Reinartz and Levin show that Holocaust commemoration is not site-specific and that acts of secondary witnessing depend less on geographic

or cultural positioning than on becoming aware of our position as observers of experiences no one ever wanted to know about.'[22]

These empty images, Baer seems to suggest, raise the issue of remembrance in the face of historical oblivion. In other words, the photographs deliver an experience of place, or more accurately of absence, which is at once consonant with a site of annihilation and yet also a wholly inadequate representation of it. Presumably the play between what is offered to perception and our knowledge of these historically freighted sites is what shifts our attention away from the site itself. There is simply nothing to see, and this lack of evidence becomes in turn evidence. Evidence, as Baer puts it, that no one ever wanted to know about these sites. Baer assumes that the images, although inadequate for the purposes of commemoration, nonetheless trigger the desire to know. Such images, Baer continues, 'position us as secondary witnesses who are as much spectators as seekers of knowledge'.[23]

Baer returns to the question of secondary witnessing in the following chapter 'Meyer Levin's *In Search*/Mikael Levin's *War Story*: Secondary Witnessing and the Holocaust'. In this analysis of two interrelated texts, Mikael Levin occupies the conventional position of secondary witness outlined by Dora Apel. When travelling with the American Army in April 1945, his father, war correspondent Meyer Levin, was an early eyewitness of the liberated concentration camps. Mikael Levin becomes a secondary witness by retracing the journey of his father. *War Story* consists of Meyer Levin's autobiography, *In Search*, original photographs taken by Eric Schawb, with whom his father travelled across Europe, and Mikael Levin's photographs from 1995.

Focusing on Mikael Levin's photographs, Baer argues it is precisely the evacuation of the photographer's point of view that forces the viewer into the position of witness: 'The viewer is turned into a witness precisely by the absence of a gaze with which he or she could identify.'[24] Amplifying this point, he argues: 'This is the crux of Mikael Levin's photographic investigation of the nature of witnessing: although one might choose to testify at a later date, one becomes a witness involuntarily.'[25] It is curious here that in a chapter ostensibly devoted to secondary witnessing, Baer uses the more immediate term witnessing to describe the viewer's position.

While this may seem a strange term to use for images so distanced from the event, the practice of referring to the viewer of mediated testimony as a witness is routinely adopted in media studies. Indeed it is in media studies that the inflation of the concept of witnessing reaches its apotheosis. Not only is the viewer conceived as a witness, so too is the camera. The technological armature of Holocaust witnessing, namely the reliance upon the camera in the production of video testimony, is seized upon as evidence of the centrality

of technology. Returning to the seminal account of witnessing in Laub and Felman's book, media theorist Amit Pinchevski contends that Felman's analysis of the crisis in the classroom overlooks the central role of what he calls the 'audiovisual technology of recording and replaying'.[26]

In media studies, typically the difference between oral and visual media is collapsed by emphasizing the issue of mediation. The mediation of oral testimony by language is regarded as equivalent to the mediation by the camera. The distinction between a recollection and a record is lost, as is the primacy of the eyewitness. The camera is regarded as the eyewitness for an audience that hypothetically can be expanded to include anyone and everyone. The audience, in turn, becomes implicated in the strange contagious effects of video testimony, just like Felman's class.

Stretching the term to its limits, John Ellis asserts that photography, cinema and television have made us all into witnesses of distant events.[27] Paul Frosh extends this argument to include digital media, claiming that in the contemporary world 'witnessing has become a general mode of receptivity to electronic media reports'.[28] In short, witnessing is so generalized that it has become a synonym for watching television or surfing the net; the only limit perhaps being that the content watched should be disturbing, traumatic, catastrophic or historically significant.

In some of the strongest arguments for the importance of mass media, the audio-visual technology of transmission is even argued to displace or surpass the importance of the original oral testimony. For example, against the idea that witnessing is first and foremost an interpersonal relationship, Pinchevski asserts that the camera provides what the Buberian I–Thou relationship cannot. He states: 'the camera . . . serves as a technological surrogate for an audience *in potentia* – the audience for which many survivors have been waiting for a lifetime – providing them with the kind of holding environment that is unattainable in the solitude of an off-camera interview'.[29] The therapeutic holding environment is shifted to the public sphere; this conflation presumes the safeguards of the psychoanalytic dyad can be mobilized in the agonistic and antagonistic realm of public discourse. The inadequacy of this presumption is clearly evident in the responses to Holocaust art placed in the public domain in Berlin. Dora Apel reports that when the artist Shimon Attie projected archival images of lost Jewish Berlin onto the walls of the city, the images stirred up a range of antagonistic responses. She reports that in the last three months of the project he was harassed or threatened every single night.[30] The transposition of the therapeutic register into the public domain is another key problem for the utilization of the concept of witnessing in the visual arts.

A further drastic displacement occurs in Pinchevski's account. For him, the video archive itself constitutes an 'affective community' for the survivor.[31] The emphasis on the archive and the camera, at the expense of the human

participants and human relations, follows the materialist anti-intentionalist methodology criticized by Ruth Leys, which was canvassed in the previous chapter.

Most controversially, Pinchevski argues that the audio-visual recording is the repository of traumatic or deep memory. In his words: 'the audiovisual archive is the ultimate depository of deep memory'.[32] Updating Walter Benjamin's idea of an optical unconscious, he argues for a 'technological unconscious of trauma and testimony'.[33] According to Pinchevski, the audiovisual marks of trauma are uniquely visible in the archive, the capacity to replay the video testimony grants access to pauses and moments of silence,[34] and what he calls 'hidden aspects of familiar reality'.[35] That hidden aspects of familiar reality might signal the 'disrupted narratives' of trauma, as Pinchevski asserts, overlooks the very ordinary capacity of the camera to make mundane reality strange.[36]

For art historians, the revelation of the hidden moments of the familiar is a well-known artistic strategy, more usually referred to as defamiliarization or making strange. The expression, first coined by literary theorist Victor Shklovsky in 1917, is applied to photographic techniques that rendered the familiar unfamiliar, particularly German photographers of the 1920s associated with New Objectivity.[37] There is now a very long tradition of artistic engagement with this idea. For example, the capacity to replay and make the familiar strange is exploited by videos artists like Candice Brietz. Plucking small vignettes from Hollywood cinema in works like *Mother and Father* (2005), she renders the narratively inconsequential details of gestures into radically asignifying elements simply through repetition. The gestures, or 'indexical and temporal markers of corporeality captured by the camera', to use Pinchevski's phrasing, when replayed several times in quick succession become progressively stranger and stranger until they appear like incomprehensible tics.[38] That repeated viewing of gestures, pauses and silences enables access to deep memory simply because they become unfamiliar, confuses the capacities of the camera with the nature of the traumatic testimony.

The key voice in media studies opposing this inflation is John Durham Peters. He reinstates the primacy of the eyewitness, underscoring the importance of proximity to the event and the mortality of the body exposed to risk: 'Witnessing places mortal bodies in time. To witness always involves risk, potentially to have your life changed. . . . You can be marked for life by being the witness of an event.'[39] His interpretation curtails the contagion of testimony, limiting the role of the witness to those directly involved. While this is an appealing corrective, it cuts across the inflation rather than taking it into account.

Reading the inflation symptomatically, it seems to me, what it demonstrates first and foremost is a desire for deeper engagement with global events

such that a more sharply defined kind of spectatorship is required, one that has a reparative, pedagogical or ethical function.[40] Additionally, the inflation marks a powerful turn to worldly affairs and a less sceptical attitude to documentary and the representation of reality than prevailed during the heyday of postmodernism. This shift can be discerned in media theory and in the dramatic rise of art practices that adopt ethnographic or documentary protocols, as well as in the reinventions of those genres whose departure from tradition is marked by terms such as postdocumentary or semidocumentary.[41] Finally, the inflation speaks to the strange currency that some significant past events still possess, such that exposure to the testimony of those marked for life leads to what Caroline Wake has described as a feeling of emotional co-presence. Wake introduces this term to distinguish between the spatiotemporal co-presence of the witness required by Durham Peters and the sense of empathetic proximity invoked in more distant audiences.[42] Her advocacy of tertiary witnessing as the most appropriate term for distant audiences maintains the sense of a distinct mode of viewing while also honouring the distance from an event.[43] When artists deal with highly charged historical material, the idea of making viewers into tertiary witnesses more closely approximates the kind of emotional co-presence that is evoked. This emotional co-presence is the terrain of identification that will be discussed in the next section.

Identification and non-identification

That simply seeing can mark your bodily fate is a suggestive way of getting beyond the idea of mere spectatorship.[44]

JOHN DURHAM PETERS

In contrasting 'mere spectatorship' with the transformative experience of witnessing, John Durham Peters inadvertently touches on the immense appeal of witnessing as a modality of viewing. A powerful relation to events seems much more desirable, when the alternative is simply looking. Yet, the kinds of traumatic experience that forever mark one's bodily fate are not transformations anyone would want to undergo willingly. One of the most profound and damaging long-term consequences of trauma is losing one's inner witness through unbidden processes of identification. In the psychoanalytic trauma literature, this phenomenon is referred to as identification with the aggressor, first theorized by both Sándor Ferenczi and Anna Freud in very different ways in the 1930s.[45] Identification with the aggressor renders the victim forever porous to the feelings and projections of others, subject to the 'confusion of the tongues', to use Ferenczi's evocative term, and thereby more prone to complementary identifications, rather than

the more familiar concordant identification associated with empathy.[46] I will return to this term 'complementary identification' that rarely, if ever, rates a mention in contemporary criticism, despite its unacknowledged prevalence in the reception of contemporary art.

It is perhaps not surprising that complementary identification is not a key term of analysis in art history. Identification has never had the kind of critical purchase in the visual arts that it has had in film theory. From apparatus theory to feminist film criticism, psychoanalytic ideas of identification and disidentification have been central to thinking about film spectatorship. Substantial engagements with identification have also featured prominently in feminist and queer theory, suggesting that the issue is considered most pertinent for the analysis of subaltern identities.[47]

As the attentive reader will have noted, identification was mentioned several times in the previous section on witnessing. Usage like this, *en passant*, as it were, rather than as a key term to tackle or nut out, is extremely common in art history. However, when politically or socially engaged contemporary art is discussed, identification is not a prominent theme. When it is mentioned, it is more often as a term to be qualified or rejected. Or to broaden the source of contention, in the analysis of political art practice the rejection of the *psychological* dimension of art is very widespread, if not systemic. No doubt the aversion stems from a longstanding opposition to liberal ideas of individualism when collective issues are at stake, for which psychology is sometimes a convenient, if misguided, shorthand.[48] Some typical examples of this tendency can be found in Claire Bishop's approach to relational art and Ariella Azoulay's recent work on photography.

Azoulay's book *The Civil Contract of Photography* is one of the most important recent texts on trauma and witnessing in the visual arts, although significantly she does not emphasize these terms. Her reticence about using the term 'trauma' no doubt proceeds from her desire to move the discussion of images of victims of catastrophe out of a psychological framework and into the political arena. Her text suggests that she believes these are mutually exclusive approaches. Discussing her exposure to photographs that document 'the daily horrors of the Israeli occupation', which one might expect to arouse shame, guilt, empathy, identification or emotional co-presence, she asserts that she wants to look at these 'photographed individuals beyond guilt and compassion – outside of the merely psychological framework of empathy, of "regarding the pain of others" '.[49] Susan Sontag's phrase 'regarding the pain of others', from her book of that title, becomes shorthand for a *merely* psychological framework.

While Sontag was concerned with modes of representing atrocity and the spectator's response to the surfeit of images of pain and suffering, Azoulay endeavours to displace speculation about the nature and qualities of the image

and its reception. In the place of such traditional aesthetic assessments of photography's role and value, she wants to substitute an entirely political and ethical function for photography. Hence, she deflects attention away from universal themes like victims' pain and suffering by using the less emotive nomenclature 'citizens of disaster' to refer to those affected by catastrophe or chronically vulnerable to injury and injustice.[50] Using this terminology enables the non-citizens of her native Israel, as well as other stateless or displaced peoples, to be properly included in the claims made by and through photography. Identification, for her, works against this kind of inclusion; it is negatively viewed as state-sanctioned cohesiveness. As she puts it:

> The nation-state creates a bond of identification between citizens and the state through a variety of ideological mechanisms. . . . This, then, allows the state to divide the governed – partitioning off non citizens from citizens – and to mobilize the privileged citizens against other groups of ruled subjects. An emphasis on the dimension of being governed allows a rethinking of the political sphere as a space of relations between the governed, whose political duty is first and foremost a duty toward one another, rather than toward the ruling power.[51]

To effect this neutralization of state partitioning, the political and ethical function of photography is framed primarily in juridical terms. Azoulay contends that audiences should 'watch' photographs rather than merely look at them, asserting that photographs thereby enact what she calls the civil contract of photography.[52] All parties involved in the photographic act are part of this contract; photographed victim, photographer and audience are all on an equal footing. Hence the language of trauma – victim, perpetrator and bystander – is mostly avoided as it introduces a differentiated field of positions that her analysis aims to neutralize.

Looking at what she calls 'the image of horror' does not require the spectator to take on the special role of witness to disaster; instead the image is what she calls an 'emergency claim'.[53] Rather than eliciting empathy, sympathy or identification with the victim, photography is the field where the victim's claim is lodged; it is, she says, a 'space of political relations'.[54] For Azoulay, photography is like a court of law: the space to air grievances, to expose injustice, to appeal for justice. Her aim is to downplay the reliance on feeling by invoking the ideas of citizenship, claims and what she describes as a contractual obligation to look at photographs. As she puts it, 'I employ the term "contract" in order to shed terms such as "empathy," "shame," "pity" or "compassion" as organizers of this gaze.'[55] In short, the language of law – with contractual obligations and responsibilities – is to regulate the traffic between victims and the public.

But who will enforce this civic duty, these obligations to attend to injustice? In the absence of a community of feeling, what will motivate the public to 'watch' distressing images of atrocity and violence? Rather than disputing compassion fatigue, Azoulay's approach simply disqualifies compassion as a valid response, or indeed any other psychological engagement with the citizens of disaster. Here, Azoulay echoes a long line of theorists from Bertolt Brecht to Allan Sekula whose arguments are structured by these same oppositions: the political must be separated from the personal, ideas from feeling, knowledge from identification.

Claire Bishop's rejection of identification proceeds somewhat differently, there is no alignment of the state and citizenry entailed, however her analysis similarly relies on the idea that art concerned with politics and democracy is not served by its means. In her article of 2004, 'Antagonism and Relational Aesthetics', she sharply contrasts relational art practices that involve identification and those that do not. Identification is aligned with a recognition of commonality, as she puts it 'a community of viewing subjects with *something in common*'.[56] The typical view of concordant identification is relied upon here; Bishop calls it 'transcendent human empathy'.[57] The practices she favours involve what she calls 'nonidentification', where instead of mutual recognition there is mutual estrangement.[58] Such practices she sees as offering not only better politics but also a more complex concept of subjectivity, as she puts it 'not the fictitious whole subject of harmonious community, but a divided subject of partial identification open to constant flux'.[59]

Her key examples of artists making this kind of praiseworthy relational art are Santiago Sierra and Thomas Hirschhorn. For example, Sierra's work for the Venice Biennale in 2001 is commended for setting up a situation of 'mutual nonidentification' between Biennale visitors and the street vendors selling knock-off Fendi bags in his allocated space at the Arsenale.[60] Reflecting on the subdued behaviour of the vendors in this unfamiliar location, Bishop concludes that vendors and visitors were 'mutually estranged by the confrontation'.[61] Sierra's slightly sadistic scenario, she continues, 'disrupted the art audience's sense of identity, which is founded precisely on unspoken racial and class exclusions, as well as veiling blatant commerce'.[62] In a similar vein, Thomas Hirschhorn's *Bataille Monument* (2002) in suburban Kassel for Documenta XI constructed a situation where visitors became 'hapless intruders' in the working-class migrant community where the work was constructed.[63] Situated between two blocks of flats were temporary shacks housing a locally run bar as well as a library dedicated to the work of French philosopher, Georges Bataille. Visitors were ferried to the site by a Turkish taxi service and, as Bishop puts it, they were 'stranded' there until a return cab could be secured.[64] Rather than the local community being subjected to what Hirschhorn calls the 'zoo effect', Bishop argues the work set up a

'complicated play of identificatory and dis-identificatory mechanisms'.[65] While the source of dis-identification is fairly obvious, quite what enabled identification here is not spelt out. It is interesting to note that the current preference for dis-identification, noted by Ruth Leys in the trauma literature, is also present in the more distant field of art historical discussions of political art. In the previous chapter, this antimimetic model of trauma was presented by her as resisting internalization.

In sum, both of these artworks brought together people who would not normally share social space and both exploited the unease or social discomfort this might provoke in some viewers. These situations, while a useful foil to the conviviality model of relational art, fall a long way short of providing a model of democracy founded on 'contestation', which is the guiding principle of Bishop's evaluation.[66] The contrived situations successfully underscore class and ethnic divisions, if that is their main aim, but it is hard to see how estrangement leads to the kind of vibrant public sphere advocated by Roslyn Deutsche. Bishop cites with approval Deutsche's argument that: 'Conflict, division, and instability . . . do not ruin the democratic public sphere; they are conditions of its existence.'[67] While mutual estrangement or non-identification might be one of the preconditions for conflict, surely something more than embarrassment is required for productive contestation?

Like Azoulay, Bishop's analysis relies on a narrow view of identification, which in turn is used to polarize the two types of art practice. Identification is based on sameness and empathy, whereas non-identification supposedly leads to antagonism, conflict and contestation. Examined more carefully, identification in fact is precisely what unifies these different practices and the supposedly mutually exclusive inter-subjective relations they incite. Despite the very widespread understanding of identification as a synonym for empathy, it is not simply a mechanism of recognition or idealization of the other, nor is it necessarily generative of sympathy or empathy.[68] It is, as Freud noted, 'ambivalent from the very first', that is, potentially violent and tender, aggressive and loving. In 'Group Psychology and the Analysis of the Ego' of 1921, he states:

> Identification, in fact, is ambivalent from the very first; it can turn into an expression of tenderness as easily as into a wish for someone's removal. It behaves like a derivative of the first, *oral* phase of the organization of the libido, in which the object we long for and prize is assimilated by eating and is in that way annihilated as such.[69]

According to Freud, identification is the very basis of the social bond. That such ambivalence underpins this bond helps to explain on the one hand the idealization of community as built on communion, as well as the alternative

group formation so well described by the crowd, the rabble or the mob. Non-identification, then, is not the opposite of identification if antagonism is the salient issue of comparison. However, non-identification could be the opposite of identification if it is conceived as a kind of sociopathic indifference.

An exception to the general rule of downplaying or dismissing identification in political art can be found in the work of Ernst van Alphen. In his discussion of the highly contentious use of Nazi imagery in contemporary art, he distinguishes between two kinds of identification. Drawing on the work of Kaja Silverman, he considers idiopathic and heteropathic identification. Essentially, concordant identification is split into two. The quest for sameness proceeds in two directions: idiopathic identification emphasizes projection, the other becomes like the self; heteropathic identification emphasizes introjection, the self becomes like the other.[70]

From this small but typical sample of the literature on identification in political art, it is clear that even when the concept is seen as having pertinence, there is no acknowledgement of the ambivalence at its root. Most importantly, concordance is overwhelmingly assumed to be the base note of identificatory processes, whether that sameness is assumed to be projected outwards, or taken into the self. Complementary identification upsets this assumption. Originally theorized to account for the variety of identificatory responses evoked in the psychoanalyst – in clinical parlance, the psychoanalyst's countertransference – complementary identification is defined by Heinrich Racker as a failure of concordant identification. He states: 'it seems that to the degree to which the analyst fails in the concordant identifications and rejects them, certain complementary identifications become intensified'.[71] Instead of identifying with the analysand, Racker observes that the analyst is scripted into identifying with an internal object of the analysand, such as a parental figure.[72] The contrast between these two types of identification is well explained by Jay Frankel. Speaking from the point of view of the analyst, he says: 'if I am with someone who is outraged about an injustice and I respond by also feeling outraged, I have made a concordant identification; if I am with the same outraged person but instead feel guilty, as if I have caused this person to be hurt, I have made a complementary identification'.[73]

The dynamic described by Frankel, where a complementary emotion is aroused instead of a shared one, accounts very vividly for the shaming effect of certain kinds of identity politics art. A work of art that demonstrates anger or outrage about racism, sexism or homophobia may well lead to a complementary identification of this kind by a viewer from a beneficiary or bystander group. The viewer is not identifying with the expressed emotion but rather with the internal object of the artist – the authority figure, oppressor or aggressor. In the responses of conservative critics to political art, as Amelia Jones demonstrates, one can see very clearly the public operation of

complementary identifications. She notes how responses to the 1993 Whitney Biennial, renowned for its high percentage of political art, assumed the works spoke to the 'guilt' of the aggressor, in the words of one critic: 'that enemy was the mythologically constructed "straight, white, male" – the preeminent protector of culture'.[74] In such instances, the fleeting affect of shame is frequently outpaced or displaced by anger, derision and contempt. The desire to push away the feeling of shame, discussed in the previous chapter, leads to a series of evasions.

The complicated intertwining of inner objects and outer feelings that takes place in complementary identification is also a crucial process in the experience of trauma. The passage from Frankel cited above appears in the context of his effort to understand what underpins Ferenczi's theory of identification with the aggressor. Frankel uses Racker's work to explain how trauma induces complementary identification with the aggressor:

> To know her attacker from the inside, the victim molds her own experience into the attacker's *experience of himself* – what Racker calls *concordant identification*. By doing this, she learns who he expects her to be and may be led to identify, in her feelings and behavior, with her attacker's *inner object*, his 'other.' This *complementary identification* then guides her compliance with him.[75]

Complementary identification, then, begins to address the annihilation that Freud argues is the other face of communion and empathy. In this instance, however, it is self annihilation instead of the annihilation of the other. Complementary identification also vividly demonstrates how the inner witness is lost. Miguel Gutiérrez Peláez describes the devastating result of trauma in stronger, more active, terms as 'self-abandonment'.[76] Commenting on Ferenczi's description of the shock of trauma, he writes: 'Subjectivity lies in ruins, and the person is destroyed, having totally surrendered to the "other" who perpetrated the aggression.'[77] Ferenczi's 'confusion of the tongues' is, then, just one consequence of the shock of trauma. In notes from 1932, the year he delivered the 'Confusion of the Tongues' paper, he describes not just a skinless openness to the feeling and thoughts of others, but a loss of one's own form.

> 'Shock' = annihilation of self-regard – of the ability to put up a resistance, and to act and think in defence of one's own self; perhaps even the *organs* which secure self-preservation give up their function or reduce it to a minimum. (The word *Erschütterung* is derived from *schütten*, i.e. to become 'unfest, unsolid,' to lose one's own form and to adopt easily and without resistance, an imposed form – 'like a sack of flour').[78]

This colonization of the soul is reserved for the victim of trauma, the one whose bodily fate is forever marked by the experience. However, as Felman's classroom example ably demonstrates, empathy can lead the spectator to resonate with that experience. In other words, there are ways in which these processes and feelings circulate in entirely able-bodied bystanders.

In the well-meaning directives to be empathetic or to consider the public sphere as like a therapeutic holding environment for testimony about injustice, there is an unwitting replication of this merged identification and resulting formlessness. Rather than responding critically and reflectively, as befits the public sphere, the emphasis in the witnessing literature frequently falls on issues such as identification and emotional co-presence. It is in this context that the need for distance, if not confrontation, comes to the fore. To confront injustice in the public domain requires contestation, as Bishop rightly argues, but the capacity to argue, to disagree and to contest opinions and cultural representations will not proceed successfully from embarrassment and shame.

Bringing together the two strands of scholarship canvassed in this chapter, which curiously do not often intersect, an interesting debate emerges about the stance spectators should adopt in relation to political art dealing with victims of injustice, state violence or disaster. The two sides of the debate about politically engaged art can be characterized as on the one hand a sort of bleeding-heart openness to victims by the advocates of witnessing, and a steely resolve to outlaw identification and empathy from the anti-psychological theorists on the other. In the chapters that follow, I outline how women artists have carefully navigated the difficult territory of pity and shame, facilitating a reparative approach that enables a qualified kind of witnessing that is mindful of the contagious effects of trauma and its confusion of tongues, but that does not reject the need for aesthetic engagement and identification.

3

Shame and the Convict Stain

Anne Ferran's *Lost to Worlds*

. . . a ruined past can never be made whole again. It can only be glimpsed, gestured towards, evoked, conjured, lost again.[1]

ANNE FERRAN

Speculating on the meaning of recurrent images of emptiness in contemporary photography, Australian artist Anne Ferran suggests that it registers a kind of belatedness. Her intriguing argument is mounted with recourse to the work of Sophie Ristelhueber, Alan Cohen and Roni Horn, as well as her own. Each photographer has taken pictures of historically significant sites that are devoid of people and visual incident. The photographs and their tone of withholding, Ferran proposes, point to the loss of photography's traditional tasks of bearing witness and capturing time. The photographers, as it were, arrive too late to document an event. As she puts it: 'The emptiness in these photographs arises because the photographers have, consciously or unconsciously, employed it as the visual counterpart of their own photographs' untimeliness.'[2]

This sense of untimeliness, and the transformation of the mode of witnessing it implies, are two of my concerns in this chapter. The difficult task of representing a ruined past, shot through with shame and contempt, is the other key issue considered. I examine Anne Ferran's photographic series, *Lost to Worlds* (2008), which is comprised of thirty large-scale digital prints on aluminium. The images show the meagre traces of a nineteenth-century House of Correction or female factory for women convicts in the small town of Ross in the rural midlands of Tasmania, the most southern state in Australia. Today the female factories are important heritage sites that commemorate Australia's convict past, although as I outline in the next section, this recognition has also been belated.

During the period when Australia served as a penal colony for Britain, roughly 15 per cent of the convicts transported were women (at least 24,960), most of whom spent time in the factories.[3] Using exile as the principal form of punishment meant that the colonies were more like open prisons: female convicts were assigned to free settlers, mainly as domestic workers. While this might seem preferable to incarceration, in a novel of 1859, the assignment system in Van Diemen's Land (present day Tasmania) is likened to slavery.[4] The factories served several purposes within this system: they accommodated women convicts waiting to be assigned or reassigned; they were sites of secondary punishment for further offences committed in the colonies, such as insolence, drunkenness and pregnancy outside of wedlock; and, as the name indicates, they were places of work,[5] although Kay Daniels cautions that employment was the 'least significant of their functions'.[6]

Ferran's *Lost to Worlds* is the last series in a body of work made over a ten-year period that addresses what little remains of two female factories in Tasmania: the one at Ross, and the Cascades Female Factory in South Hobart. The suite of works on the female factories includes three photographic series – *Female House of Correction* (after J. W. Beattie) (2000–2001), *The Ground at Ross* (2001) (also known as *Lost to Worlds*, 2001), *Lost to Worlds* (2008) – and a tripartite installation, *In the Ground, on the Air* (2006). The first of these, *Female House of Correction*, enlarges very small details of J. W. Beattie's photographs of the exterior of the Cascades Female Factory taken in 1892, over thirty years after its closure. The details have a foreboding quality, as if looming out of the darkness, an impression Ferran ascribes to the vignetting effect produced by using a photographic loupe or magnifying glass (Figure 3.1).[7] *In the Ground, on the Air* highlights the very high rates of infant mortality in South Hobart and Ross. Both *The Ground at Ross* and *Lost to Worlds* focus on the scarred landscape of Ross.

All traces of the other female factories in Tasmania (Launceston, George Town) have been completely effaced. There is an added poignancy, then, in attending to what little has survived of the other two. Ferran has turned this privation to her advantage. She deliberately draws attention to what are in essence severely depleted historical records, thereby necessarily departing from the traditional feminist aim of seeking to recover the lost voices of women who passed through the sites.[8] As she puts it: 'Once something gets left out of the historical record, that absence itself becomes a fact and not something you are free to recreate/reinstate later. Not that I'd want to – it's the gaps that interest me.'[9] Ferran is drawn to these kinds of histories that have been occluded or neglected, particularly those of marginalized and dispossessed Australian women.

In this context, *Lost to Worlds* could be described as having a slightly perplexing aim: to redress a historical gap but not to fill it. Ferran's photographs

FIGURE 3.1 Anne Ferran, *Untitled*, from *Female House of Correction* after John Watt Beattie, 2000, type C photograph, 38.5 × 55 cm.

of evocative emptiness serve this double function. On the one hand, that emptiness can be understood as representing the paucity of visual records of women convicts in Tasmania and, on the other, the evocative quality conjures up something like a mood, an atmosphere or a feeling of place. Through this emotional tone, *Lost to Worlds* attempts to visualize a kind of haunting of the present by the past. In other words, the past hovers out of reach, it is not something properly remembered or recorded that has been, or could be, photographically captured. This liminal state between remembering and forgetting best serves the kind of historical memory that Ferran explores.

What remains: the heritage of convict women

Ferran began photographing the ruins of the female factories at Ross and South Hobart in the late 1990s just as a new generation of feminist scholarship revitalized the study of convict women. Several books based on careful archival research were published around this time: Deborah Oxley's *Convict Maids: The Forced Migration of Women to Australia* (1996), Joy Damousi's *Depraved and Disorderly: Female Convicts, Sexuality and Gender* (1997) and Kay Daniels' *Convict Women* (1998).[10] These specialist publications, along with Babette Smith's *A Cargo of Women: Susannah Watson and the Princess Royal* (1988), built on the pioneering feminist research of the 1970s on Australian

women's history such as Anne Summers' *Damned Whores and God's Police, the Colonisation of Women in Australia* (1975), and Miriam Dixon's *The Real Matilda: Women and Identity in Australia* (1976).[11]

While there is now a wealth of historical studies on convict women, there is no art historical study of the topic.[12] Perhaps this is because there are few images to study. If the images reproduced in various publications to date, along with online pictorial databases, represent the full record, it seems that despite the importance of convicts for the history of white settlement in Australia, the female convict is not a topic that has generated much visual representation.[13] Writing specifically about architectural images, Joan Kerr argues that 'genteel watercolours or professional oil paintings' of places of incarceration would have been regarded as inappropriate topics at the time of their greatest visibility; these institutions, and the people confined within them, she says were to be kept 'out of sight'.[14] Hence in the nineteenth century there appear to be very few paintings, prints, drawings or photographs of women convicts or the factories, while there are images of the more public construction work of male convicts in chain gangs. Given Kerr's caution, photographic documentation of the factories is the most likely mode of depiction. Certainly, photographs of the buildings were at least a possibility in the final years of the two female factories that interest Ferran (Ross closed in 1855, Cascades in 1856). The first photographic studio was established in Hobart in 1843 and landscape photography was possible from 1855.[15] To further entrench the pictorial neglect, in more recent times little interest has been shown in this topic by modern and contemporary artists. In short, the image of the female convict is largely absent from the cultural imaginary.[16]

This neglect is compounded by the sometimes murky and troublesome border between history and art history. Where the disciplines should intersect, they are more often than not at odds. Indeed it is a common complaint, on the part of art historians at least, that historians ignore visual culture or simply regard images as illustrations, rather than sources of knowledge in their own right. For example, in the historical literature on female convicts, Deborah Oxley reproduces what she refers to as an 'incredibly rare' prison photograph of transported convict Margaret Greenwood, but does not explain the rarity, or the provenance of the image reproduced.[17] Joy Damousi mentions in passing that there are very few sketches of the women, but immediately turns to absconding notices to discuss their appearance, rather than providing details or analysis of extant sketches.[18] Similarly, a recent exhibition on convict life in the female factories offered no evaluation of the visual material in the exhibition, nor even a summary of it. The catalogue essays written by historians address written records only.[19]

Kay Daniels is the exception to the rule; her book on convict women is distinguished by the attention it bestows on material culture, if not images *per*

se. The final chapter of her book examines heritage and seeks to explain the scarce material remains of female convict life. Convict women, she notes, cannot be remembered through their clothing, tools or instruments of punishment since few remain; instead, as Ferran also concluded, the historic sites are the most tangible remains, depleted as they are.[20] Ross has one remaining building, the Overseer's cottage, set in a field; the Cascades Female Factory has one building, the matron's cottage, as well as some of the original walls of the four yards. Intriguingly, Daniels mentions photographic records of Cascades (it was photographed in the 1860s and 1870s) but in keeping with the neglect of visual culture of most historians, she provides little information about this photographic archive.[21] The two photographs she reproduces from the 1870s are not analysed or clearly labelled.

Nonetheless, her focus on heritage uniquely illuminates attitudes to the convict past by examining what survives of it, and thus what was regarded as worthy of remembrance and preservation. In the case of female convict heritage, forgetting and destruction are the leitmotifs. Daniels draws attention to the general desire to expunge 'the shame and pain of the convict inheritance' and that it 'began early and continued well into the twentieth century'.[22] This wish to efface the 'convict stain' affected female convict heritage more dramatically, so that convict heritage, Daniels contends, is 'for the most part the heritage of male convictism'.[23] Port Arthur, a male convict site, became a tourist attraction almost as soon as it closed in 1877 (transportation to Tasmania ends in 1853).[24] In 1916, it becomes the first historic site in Australia. By way of comparison, Ross was only declared a historic site in 1980, and although the preservation of the Cascades Female Factory site began in 1976 with the purchase of Yard 1, it was only granted National Heritage status in 2007 (World Heritage in 2010, along with Port Arthur).

The 'shame and pain of the convict inheritance' is a telling phrase. Babette Smith notes that right up until the 1970s the so-called convict birth stain was a source of shame.[25] While it is now frequently claimed that convict heritage is celebrated, more often than not, when it is referred to in the popular media, it is to account for some shortcoming of contemporary society. A recent article by economics editor Peter Martin, titled 'Could our convict past be why fewer women get ahead in Australia?', claims that the shortfall of senior business women and politicians can be traced back to the very unequal ratio of male to female convicts. When women are in short supply, he argues, women are unlikely to be in the work force and conservative views about women and gender roles are established.[26] Clearly, he believes these views persist and are pertinent centuries later.

While Martin draws a rather long bow between the past and the present, historian John Hirst's argument about the influence of convict heritage on Australia's racial politics is more convincing. The 'strongest influence of the

convicts,' he writes, is 'in the trauma of a nation which had to come to terms with its shameful origins.'[27] The repression of this trauma, he suggests, underpinned the White Australia Policy, a policy that was in force from 1901 to 1973 and which sought to restrict migration to white settlers only. He speculates: 'I think this stress on the nation's purity was the Australian response to the impure origins of the nation.'[28]

Perhaps most significantly, the cruel treatment of Australia's indigenous population is also attributed to the convict past. Aboriginal writer Ruby Langford Ginibi sees the oppression of Aboriginal peoples as emanating directly from the convicts' own oppression – what is not redressed is simply enacted on others. As she puts it:

> The people who colonised this country were not the cream of the British aristocracy, they were the dregs of an oppressed society. They brought that oppression here and oppressed our Aboriginal people with it. They were the builders of gaols and prisons, and in 200 years the mentality hasn't changed. . . . They were convicts, you see what I mean? Now they're building more gaols and our people are still dying deaths in custody.[29]

These recurring patterns of cruelty and callousness were also transmitted through institutional frameworks. As Kay Daniels points out, the way in which convict women were treated became the template for the treatment of working-class and Aboriginal girls in the twentieth century.[30] In the twenty-first century, Ferran sees parallels between the attitudes to convict women and the indifference towards refugees.[31]

Today shame about convict origins has without doubt been overtaken by other more recent sources of national shame, such as the oppression of the original indigenous inhabitants. Yet what these various accounts suggest is that the harsh treatment of the convict population framed subsequent attitudes and actions in highly significant ways.[32] While Hirst ends his article with a salutary reference to contemporary pride in convict origins and thus the purported end of repression, his list of events of the twentieth century that were shaped by underlying shame leaves one wondering how much we have actually come to terms with this history, or even if this is possible. If Australians are no longer ashamed of convict heritage, as Hirst and so many others claim, we are nonetheless still very much entangled with that shameful history, as the unfinished business of reconciliation with Aboriginal and Torres Strait Islander peoples surely demonstrates. The pattern of dehumanization and oppression, followed by repression and failure to acknowledge guilt and shame, is all too obviously repeated in contemporary race relations.

Lost to Worlds: shame, guilt and reparation

Given the pictorial neglect of the female convict and the efforts to expunge or repress all signs of the convict stain, what are sometimes termed 'aftermath images' have a particular pertinence for addressing this refractory history. In a seminal article on this genre of photography, published the year after Ferran's essay on emptiness, David Campany registers the importance of the same issue of photographic belatedness that intrigues Ferran. His analysis of what he calls 'late photography' encompasses both photojournalism and contemporary art photography. In photojournalism, he reports, photographs of aftermath are now more common than photographs of an event.[33] He argues that today photographs rarely breaks the news, having been displaced by the moving image, with the use of image grabs becoming increasingly important instead of photographic reportage.[34]

It is in the context of this diminished role for documentary photography that he situates the rise of untimely art photography. The artists he identifies as the most interesting practitioners are Ristelhueber, along with Willie Doherty, Richard Misrach and Paul Seawright.[35] Notably, these are all photographers who depict the aftermath of war, mostly relatively soon after the cessation of conflict. Here the contrast with Ferran's broader more poetic concern with emptiness is marked; late photography for Campany has a much narrower focus depicting the aftermath of well documented and newsworthy public events that everyone knows about: 9/11, Hurricane Katrina, the Troubles in Northern Ireland, the war in Afghanistan, the Gulf war. In other words, there is already an audience for these afterimages of disaster and conflict.

The late photography of this kind, Campany says, present us with 'traces of traces' of events.[36] For him, the doubling of the trace serves as a reflection on both the indexicality of the medium and the diminished power of the documentary function of photography; as he puts it, such images 'offer an allegorical, distanced reflection on the photograph as evidence and the claims of mainstream documentary photography'.[37] In a more sceptical vein, he observes that while late photography has become a prevalent and 'convincing' contemporary style, he refutes some of the common claims that have begun to circulate about the modes of presentation it has adopted, for instance, the idea that distance from an event or the cool treatment of subject matter necessarily deliver critical positions.[38] Yet these images are, he argues, frequently seen as vehicles of mass mourning and working through, (here he has in mind Joel Meyerowitz's post 9/11 Ground Zero project).[39] His main criticisms of the genre are left for the conclusion where he asks whether the distancing may be an occasion where 'indifference and political withdrawal . . . masquerades as concern'.[40] The claim that such images are concerned

with collective mourning or working through, he then dispatches by reducing mourning to a merely aestheticized response – 'liberal melancholy that shuns political explanation' – following in the well-worn track of Allan Sekula's suspicion of aesthetics, which he cites at length.[41] It is with these criticisms in mind that I want to turn to Ferran's series *Lost to Worlds*, which is concerned with the aftermath of events that are in the distant past.

Significantly, the events and histories that interest Ferran are not highly visible or well known, presumably because they are significant principally for women's history. Ferran reports that it was precisely the emptiness of not just one, but two, sites of importance for women's convict history that suggested to her that the topic was worth pursuing.[42] The paradoxical desire to give form to lacunae as lacunae is the challenge her work pursues. Indeed, for almost three decades her photographic practice has focused on forgotten Australian women's histories, which she brings to light with great care and a very refined aesthetic. For each series of photographs she uses a different strategy tailored to the representation of the women in question, what is known of their histories, and the presence or absence of visual traces. For example, she has used archival photographs that were hidden from public scrutiny and she has reconstructed objects, based on historical records. In addition, she has photographed objects in the collections of historical museums and depicted historical sites, some of which are relatively well preserved.

The same cannot be said for the site of the female factory at Ross; it has been razed to the ground. Although, despite the erasure of the convict buildings, by accident rather than intention, the site is archaeologically rich because it was not built over – for most of its subsequent history it was used for farming.[43] When Ferran first began to photograph the former location of the factory in 1999, it was little more than a field: only a modest sign indicated the historical significance of the site. In 2008, the situation changed quite dramatically with the introduction of substantial perimeter walls incorporating a large sign, thereby identifying the historical site in a similar fashion to the Cascades Female Factory. The wall demarcates the site from the otherwise indistinguishable rural pastures.

Situated on the outskirts of Ross, there is still very little by way of publicity to draw tourists away from the centre of town and the celebration of wool production, to this relatively barren and deserted site. In the early part of the twenty-first century, the open field would have been an unlikely landscape with which to conjure up the harsh conditions suffered by convict women and to attempt to bring forth a history that Ulrich Baer would describe as one that 'no one ever wanted to know about'.[44] Least of all, the people directly affected by the so-called stain of convict origins – the original convict women, their immediate descendants and perhaps even the free settlers of Ross – all would have had a vested interest in destroying the evidence of the past. Particularly,

as Babette Smith reports, the anti-transportation movement in the middle of the nineteenth century provoked a shaming campaign that led many convicts to conceal their origins.[45] As a consequence, much of the building material from the factory has most likely been seamlessly incorporated into the fabric of the township, which is a short drive away from the site.

Lost to Worlds, as the title indicates, underscores what has gone forever, yet the series also tries to use the very meagre remains of the factory to somehow counter this irredeemable loss or absence of historical material. This former site of incarceration and forced labour for nineteenth-century convict women is now reduced to suggestive scars on the landscape: soft indentations, mounds, bare patches and stones. Most of the images in this series are intensely focused close-ups of the ground and its occasional marks and undulations, generally without horizon or any other means of orientation. These ground images are to some degree empty: all-over shots of swathes of long grass, stretches of clipped lawn; occasionally there are patches of weed and scatterings of rocks (Figures 3.2, 3.3 and 3.4). Not unlike the empty images Baer describes of former Holocaust sites, Ferran's series does not attempt to directly picture what is historically significant about the site.

FIGURE 3.2 Anne Ferran, *Untitled*, from *Lost to Worlds*, 2008, digital print on aluminium, 120 × 120 cm.

FIGURE 3.3 Anne Ferran, *Untitled*, from *Lost to Worlds*, 2008, digital print on aluminium, 120 × 120 cm.

FIGURE 3.4 Anne Ferran, *Untitled*, from *Lost to Worlds*, 2008, digital print on aluminium, 120 × 120 cm.

Taken when the artist was looking down at the earth, they are nonetheless displayed vertically so that we do not view these images, as it were, in the artist's stead. The departure from viewing conventions enabled by this simple displacement creates a very slight spatial unease. The images also have an engulfing quality, which adds to this very mild sense of threat. While they are quite large, each image is 120 cm by 120 cm, the sense of engulfment is more an issue of proximity. The grasses seem larger than life size as if somehow brought too close without the proper perceptual mediation of a body length (Figure 3.5).

The mounds with their strange depressions and deep inky black shadows are suggestive of burial, even though that association has little pertinence for the immediate context of colonial Tasmania (Figures 3.6 and 3.7). Indeed, these images of rounded forms partake of that strange alchemy of the close-up where landscapes can suggest bodies and bodies can suggest landscapes. Figure 3.5 recalls this relation between land and body in a different way; the central blaze of lighter grass is redolent of Ana Mendieta's *Silueta* Series, which found or created outlines or silhouettes of the body that were imprinted directly in the landscape. Mendieta also tipped her desolate landscapes towards the viewer to create disorienting slightly vertiginous spatial environments.

FIGURE 3.5 Anne Ferran, *Untitled*, from *Lost to Worlds*, 2008, digital print on aluminium, 120 × 120 cm.

FIGURE 3.6 Anne Ferran, *Untitled*, from *Lost to Worlds*, 2008, digital print on aluminium, 120 × 120 cm.

FIGURE 3.7 Anne Ferran, *Untitled*, from *Lost to Worlds*, 2008, digital print on aluminium, 120 × 120 cm.

While logically it is the earth that is tipped towards the viewer, the orientation of the photographer nonetheless seems to haunt the images. Hence there is a sense of looking down, even though the viewer does not perform the downcast glance. It is an uncomfortable positioning both spatially and emotionally. Is it a posture of contempt or shame? 'Looking down' has this double valence, at once a sign of contempt – looking down on someone – and also a mark of shame: averting one's eyes, a downcast gaze, not wanting to be seen. Shame conjures strange magical thinking: I cannot see you and therefore you cannot see me.

These two affects, shame and contempt, are recurring motifs in narratives of the female convict. Taking shame first, not only does it describe the attitude of the recent past – shame about the convict stain – but it was also a tactic used to discipline and punish convict women themselves. Joy Damousi describes the ritual humiliation of shaving off their hair. Through this particularly gendered form of punishment, she reports, 'colonial authorities attempted to instil shame in women they believed were immune to such humiliation'.[46] Here the socialising function of shame is clearly in evidence, the women are assumed to be shameless and yet the very affect they are claimed not to possess is nonetheless used to combat this. Can shame be inculcated in this fashion?

Contempt for the women is clearly evident in contemporaneous accounts. To give just one example, Lieutenant Breton reported: 'far the greater proportion are utterly irreclaimable, being the most worthless and abandoned of human beings'.[47] Terms like 'abandoned' and 'outcasts' occur frequently in reports about convict women. The contempt was not one-sided as an infamous collective action in Hobart demonstrates. At Divine Service in 1833, attended by the Governor's wife, 300 convict women bared and smacked their bottoms in an act of disobedience that Kay Daniels observes was not only 'indecent', but is still universally viewed as 'synonymous with contempt'.[48] Shame and shamelessness, contempt met with contempt, these are the competing and colliding affects that circulate around the figure of the convict woman.

The orientation of Ferran's images stirs up these feelings, even though it is a landscape rather than a figure we encounter. But there is also a curious counterforce, a visual undertow of resistance, if you will. Countering shame if not contempt, there is an equally strong sense of something answering or coming back from the ground. The ground is not a stable field we can visually master or objectify. Rather, under certain lighting conditions the reflective aluminium surfaces of the photographs create the illusion of three-dimensional space; it is as though something emanates from the surface into our space, and consequently there is also a sense of something receding or retreating to create an illusion of depth. In other words, the limits of the image are hard to properly locate, this three-dimensionality is strongest when viewed askance or at a distance. Needless to say, the effect is impossible to photograph, the images

need to be seen in the flesh. More than this, the projection and recession of the images require a motile viewer. The stereoscopic effect is highly fugitive and escapes easy scrutiny: for a stationary viewer, close to the surface, it is hard to see or to pinpoint its source. This dependence on the phenomenology of viewing is crucial for the affective tone of the work as it suggests a highly responsive and unstable state. Mixed emotions perhaps: retreat/shrinking away/shame and advance/resistance to shame/maybe even pride.

The issue of pride is raised very powerfully by Thierry de Duve, who reads the persistent downward gaze of *Lost to Worlds* in an intriguing manner. In an interview with Ferran for her recent retrospective, he begins his analysis in a startling fashion by querying her identification with the female convicts. It is worth quoting the interchange at length. He says:

> I have heard (and read) you provide the narrative that gives the photos of the ground at Ross their historical depth and load of human tragedy. You do this as soberly and tactfully as possible. The photos themselves, though, are poignant in a way the narrative, with its inevitable humanism, cannot be. They don't seem to proceed at all from an evocation of the lives the women imprisoned at Ross suffered. I read them as proceeding from shame, your shame. Am I right?[49]

Ferran responds by acknowledging her feeling of shame, stating 'that's part of what I feel but not all of it. Sorrow and outrage, resistance to knowing more, a certain hopelessness, all of these things come up'.[50] She then articulates more precisely how she attempted to minimize feeling ashamed through identification with the victim, rather than the perpetrator:

> If I spare myself some shame over what happened to the convict women, it's because I imaginatively side with them and not with their gaolers. However, I know that it's the intervention of lots of time that allows me to do this, and how much of a luxury it is to be able to choose a side, rather than have one allocated to me.[51]

Ferran's response is a common defence to shame, only a partial evasion in her case as she indicates. To align oneself with the victim when personal responsibility and guilt are not obviously at stake is instinctively, and perhaps self-protectively, what most of us do. However, while this is no doubt her conscious response, it is interesting that her work does not entirely conform to it, as the mixed emotions evoked indicate, and indeed as de Duve argues in his reply to her.

First, he turns the tables by criticizing empathy (normally viewed as admirable, but that he views with suspicion in a political context). In turn, he

praises the more uncomfortable feeling of shame, which he argues 'is one of the rare feelings that can count (it doesn't always) as a political feeling'.[52] He then points out:

> You, Anne, are so aware of siding with the convict women imaginatively that you cannot forget that you are, sociologically speaking, on the other side of the fence: having the choice is a luxury, you say. Shame is a feeling you can genuinely have on behalf of others, but it implies that you also identify, and not *imaginatively* this time, with the gaolers.[53]

De Duve's reading is very astute about the class dynamics of shame, but I disagree that Ferran's position aligns straightforwardly with the gaoler, although the gaoler is indeed part of the equation. What the series enacts, I would suggest, is unconscious identification with the aggressor. The strange positioning of the viewer looking down encompasses both convict and the gaoler and speaks to the structure of the 'confusion of tongues' discussed in the previous chapter. To briefly recap, the victim (or convict in this case) identifies with the gaoler's internal world and loses the self, adopting an imposed form. The sense of something coming back at you, returning your gaze, invading your space, is also amenable to this double reading, describing at once gaoler surveillance and the Talonic return of convict resistance.

As we saw in the first chapter, identification with the aggressor brings into play guilt and the model of internalization that this implies. Guilt should lie on the side of the gaoler, the one whose actions are judged, but here too the situation is more complex. The convicts are not without blame, and the gaolers (and their descendants) are not beyond shame. While the psychological literature tends to sharply distinguish between these two emotions, here it is clear they are more entangled. The contagion of shame swirls around this topic and the images, infecting and confusing positions both past and present. And on the horizon, de Duve argues there is another emotion, pride, calming or complicating this maelstrom of negative affects.

De Duve makes a distinction between images focused on the ground, which he aligns with the perpetrator, and images that look to the sky. More specifically, pride enters the series through the four images that are more spatially legible with visible horizon lines or other markers of orientation. For example, one image shows a small strip of sky, another a fence and a line of trees along the upper edge (Figures 3.8 and 3.9). Such indications of direction provide geographical bearings and thereby approximate conventional landscape depiction. Moving from the ground to the air, de Duve argues holds the possibility of pride. The downcast images, he says, do not express shame:

They come out of shame, they emerge from shame, and of course they don't stay there; otherwise they could stake no claim on the political. The downward gaze on the land and the way it slowly moves up to barely reach the horizon is, to me, one of the most moving aesthetic features of the photos. It's the gaze of the lower classes when they have interiorised as shame the contemptuous gaze of their masters on them. But then it's that gaze adopted by you. I have the feeling that once it musters enough courage to rise to the horizon and dare look beyond at another, non-confined future, it changes into pride. That feeling is incredibly strong.[54]

Reparation is very strongly invoked in this reading of looking up. Yet, the rhythm of advance and retreat also infects these images that de Duve is interpreting principally through the prism of hope. Reparation, in other words, does not make whole again, it incorporates the damaged and the contaminated, to invoke Sedgwick's careful articulation of the ambivalence of the reparative position.

Looking closely at the images with a vertical orientation, it is clear that they are not unequivocally hopeful or suggestive of freedom and movement.

FIGURE 3.8 Anne Ferran, *Untitled*, from *Lost to Worlds*, 2008, digital print on aluminium, 120 × 120 cm.

FIGURE 3.9 Anne Ferran, *Untitled*, from *Lost to Worlds*, 2008, digital print on aluminium, 120 × 120 cm.

Instead they invoke the opening of the horizon, landscape and the human inhabitation of the land only to refute it. The sky has a peculiarly opaque almost malevolent presence in Figure 3.9; it suggests a blockage or a limit to the landscape. Certainly, the impenetrability of the sky blocks the eye's passage deep into the picture plane, the picture plane is thereby rendered as shallow, the convention of aligning the sky with infinite distance is negated. Similarly, the strange compression of foreground and background makes the eye restless and uncertain. The grass of the foreground seems to be bulging out or moving forward. In the rural image (Figure 3.8), where human activity is visible, the swelling of the earth in the foreground engulfs most of the visual field, human labour dwindles in this picture or is pushed to the margins. While such images might seem to provide establishing long shots, the anchorage is only temporary and the sense of the long view is quickly lost again as the more tightly focused images absorb the viewer's field of vision. This is not to refute entirely the power of hope that the upward gaze connotes, but the pleasure of the reparative aesthetic in this series is not simply the result of glimmers of pride. It is the result, I believe, principally of the capacity to catch

up the negative affects in all their complexity, alongside this opening up of the horizon.

Aftermath images and witnessing

It should be clear by now that I do not think Ferran's series is 'liberal melancholy that shuns political explanation' or that it offers 'safety in numbness', which is the rather telling title of David Campany's article on late photography. Although it is doubtful he would view Ferran's images as part of this genre. A large part of his argument rests on the idea of photography responding to technological changes in journalism such that the still image, and its 'muteness', 'mourning and paralysis', come into focus only in relation to the moving image.[55] Hence he restricts his analysis to contemporary photography of newsworthy events, other than a passing reference to Eugène Atget.[56] Significantly, Roger Fenton's photographs of the aftermath of the Crimean war and Mathew Brady's of the American Civil War are explicitly discounted as suitable precedents for current practice.[57] For him, there is a technological reason for photography's belatedness and the associated melancholy. If we broaden the remit of late photography, this technological determinism is less pertinent. Ferran's idea of emptiness is the key to this more expansive view. Here, the contrast between moving images and still images is irrelevant, it is the technique or tactic of using emptiness that matters most, irrespective of medium.

Indeed, the focus on place, or rather empty place, as a way of indirectly representing the traumatic events of the past is first broached by film. As a technique of allusion, it is most famously associated with Claude Lanzmann's film *Shoah* (1985). As Florence Jacobowitz reminds us, the title of Lanzmann's film was originally going to be *Le lieu et la parole* [The place and the speech], a title that emphasized one of the techniques of the film's construction, namely the montage of footage of empty places filmed in the present, with the testimony recalling the events of the past by survivors, bystanders and perpetrators.[58] Lanzmann's approach has been aligned with a principled refusal to represent atrocity directly, favouring instead the power of the spoken word as the most appropriate mode to bear witness to the events of the past. Testimony and witnessing here proceed without the support of the available documentary images. Given that decision to exclude images of the past, the empty landscapes become like blank screens for the viewer's imagination, while also reassuring us of the pastness of the events being retold. The landscape, which bears no trace of what has happened, can thereby function as a holding environment for the traumatic testimony.

In Ferran's case, emptiness is not the result of a deliberate choice in this manner, she has not eschewed available visual documentation, but

nonetheless her decision to show us 'almost nothing' is a continuation of this aesthetics and ethics of refusal. Ferran herself describes such images of emptiness using a vocabulary that suggests reticence: she calls the address of the images 'tight-lipped, even monosyllabic'.[59] While the metaphors she uses suggest incapacity, inarticulacy or wilful muting, Ferran counterbalances this characterization with a kind of visual flourish. She continues:

> Yet, for all that, they [images of emptiness] possess a formal assurance that says they are sure of something. Initiates into their own inadequacy is how I like to think of them, fully aware of their limitations. As such they might yet turn out to be the variant form of photography best suited to the times we are in.[60]

Ferran's diagnosis here of the current state of photography and one possible response to it, suggests that visual testimony is much more complex than the literature on witnessing has registered. The confidence in visual art's capacity to bring forth counter memories or to convey previously unheard voices or unheard things is at odds with the acknowledgement of the severe limits of contemporary photography. Ferran's approach emphasizes the fact that photography taking place in the aftermath of distant world events is not able to retrieve traces of those events.

That much is fairly uncontentious. The incapacity to capture the past is well documented by the art organization called The Legacy Project, which aims to chronicle precisely these kinds of aftermath images. They describe the depiction of empty places as a distinct genre of contemporary photography, built around images of absence and the search for the 'shadows of the past'.[61] Using their catalogue of images, Ferran's list of artists of emptiness could be expanded even further to include photographs by Willie Dougherty (also mentioned by Campany), Drex Brooks, Henning Langenheimand, Kikuji Kawada, amongst others.

The Legacy Project notes that photographers have returned to scenes of terrible violence in order to document what they call 'the emptiness of places'.[62] It is interesting that they posit documentation as seeking emptiness rather than the event; and shadows, it seems, are the most one might expect. What can primary or secondary witnessing mean when there is not an assured presentation of documentation, when instead we are asked to apprehend something much less tangible?

And what can we make of the much stronger and more contentious claim that Ferran makes that the emptiness of the image speaks of a crisis of photography, leading to at best a reflective relationship with incapacity? A sceptical approach to the indexical function of photography is, of course, now a common response to the advent of digital photography, but that is not

quite what is being proposed here. Rather than scepticism, there is uncertainty and most importantly a reduction of what is claimed for the image. This pictorial modesty, to put the case more positively, can be seen more clearly by considering the way in which Ferran's images address this problem of belatedness.

While *Lost to Worlds* cannot show the harsh conditions of the female factory, the images nonetheless convey a very strong sense of atmosphere. That strange word, which means both a kind of apprehended mood of a place and more concrete weather conditions, is one way of trying to capture the affective tone of the photographs, part of which I have already enumerated. Thinking about the series as a whole, the atmosphere is bleak – the light suggests deep mid-winter and bitter cold. The hard surfaces of the aluminium add to this feeling of an ungiving coldness. Yet in spite of these mildly repelling features, the images are also visually enticing. Features of the images create unease, like the deep shadows eating into the land and the strange 'bloom[s] of light', as Ferran calls them, which appear on some of the photographs.[63] These are the accidental effect of a light leak that has traced its own paths across the ground (Figure 3.2, Figure 3.9).

This accident is just one of a number of visual tropes that suggest emanations, movement, or even a kind of haunting or nesting of the past in the present. The reflective surfaces of the aluminium images create a sensation of visual instability, as I indicated in the previous section, and to varying degrees the images possess a destabilizing shimmer. The images change as you walk towards them and as you walk away, shadows become light and voids become shapes and vice versa. These formal fluctuations suggest evidence that is at once tantalizingly present and yet just out of reach. This sense of something glimpsed out of the corner of the eye, however, is countermanded by the relentless evidence of nothingness. The photographs' close scrutiny of the variable topography of the ground, its shadows and depressions, shows no discernible trace of the building, the women, or their lives. Yet the visual scrutiny suggests searching for something, and the shimmering surfaces deliver movement in the undergrowth, as if signifying what remains of long past actions. The sequence of images is also enlivened by a remarkable sense of rhythm and subtle movement, the ground seems to swell up and taper away like rich symphonic sound creating arcs of activity that surge and then disappear into nothingness.

In these very indirect and allusive ways, the images of this deserted historical site give the viewer a feeling of the place. Perhaps not the feeling or atmosphere of the actual site, which has nothing at all unsettling about it, but a feeling for the harsh history we cannot know or apprehend visually. In other words, there is an affective dimension to this series, which deeply involves and engages the viewer in the futile search for the irrecoverable past. This less

tangible aspect of this photographic series is part of the visual assurance of *Lost to Worlds* – the capacities of photography – to finally switch from the concentration on photography's limits and limitations to what it can achieve.

The emotional tone or affective dimension of the photographs gives considerable expressive power to this series. That tone is complex and multi-layered. It includes the sense of vitality from the flickers of light, the bleakness of an abandoned site, the unsettling qualities of the images and their austere beauty. This feel or tone conveys to the viewer very forcibly the sense of the past as disturbing and a disturbance for the present. We cannot bear witness to this past in the usual sense of finally knowing things that were concealed or comprehending things that no one ever wanted to know about, but on the other hand we are engaged by the quest for that history which must, at least visually, elude us.

In this way, Ferran has not ceded to the scepticism about photography that usually leads to either laments (or on occasions celebrations) about the mixing of truth and fiction or even their current indistinguishability. Rather, she remains committed to photography as a truthful representation of what can be historically excavated, even when that can be little more than a mood, a disturbance, a feeling of loss or destabilization. Thinking about this in photographic terms, however, we could say that capturing a mood is no less of an achievement than photography's traditional task of capturing time.

This reduced and modest adherence to photography's truth-telling capacities means that witnessing remains the correct term to describe how we should look at these images. Their visual complexity and intrigue means that they are both witnessed and 'watched', to use Ariella Azoulay's term intended to signify the attention and duration owed to photographs of the disenfranchised and the victims of injustice.[64] By carefully scrutinizing these images of an obliterated history, and being ever so slightly put on edge by them, we bear witness to some remote glimmer of the past, no matter how opaque, strange and incomprehensible it remains. As Shoshana Felman reminds us, this may be the only way to speak or visualize what lies beyond our representational means.[65]

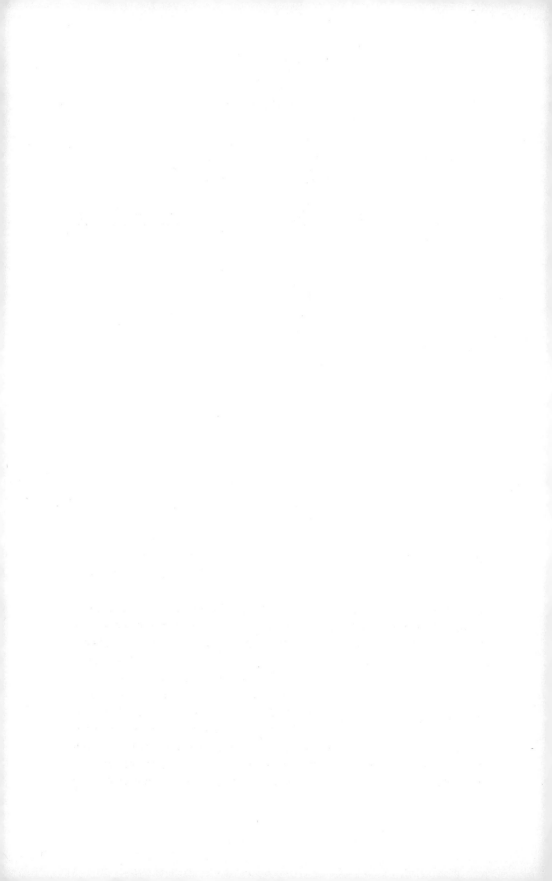

4

Fiona Pardington

Colonialism and Repair in the Southern Seas

It's easy to make beautiful photographs; it's hard to make photographs of really beautiful ideas.[1]

Just how is it that the photograph and its remarkable power come to impact on the mauri or life principle of each taonga [cultural treasure]?[2]

FIONA PARDINGTON

The power of photography to aestheticize whatever it pictures is routinely viewed with suspicion. One of the most frequently cited examples is Walter Benjamin's famous claim that photography can turn even 'abject poverty, by recording it in a fashionably perfected manner, into an object of enjoyment'.[3] This censure of aestheticization is part of a much more generalized mistrust of the power of photography. As Susie Linfield reports, there is an unusually high level of guardedness and negativity about photography on the part of its chief interlocutors: critics of photography, postmodern theorists of photography and even photographers with a political bent. She characterizes the typical responses to photography as 'suspicion, mistrust, anger, and fear'.[4] While anger and fear may seem unlikely responses, there is ample evidence of mistrust and suspicion, particularly of the seduction of beauty.

Alongside the well-documented disparagement of beauty, there is also a pronounced aversion to feeling, as we have already seen in the work of Ariella Azoulay discussed in Chapter 2. The disdain for such traditional aesthetic concerns is certainly not limited to photo-criticism; it is part of the much wider anti-aesthetic sensibility that dominates the interpretation of modern and contemporary art.[5] However, as Linfield observes, in criticism about other art

forms, such as film and literature, the interplay between ideas and feelings is regarded as normal practice. In contrast, those who write about photography, she argues, regard emotional responses, as 'an enemy to be vigilantly guarded against'.[6] Linfield concludes: 'It's hard to resist the thought that a very large number of photography critics – including the most influential ones – don't really like photographs, or the act of looking at them, at all.'[7]

She demonstrates the prevalence of this antipathy with reference to the work of Susan Sontag, Roland Barthes, John Berger, Rosalind Krauss, Douglas Crimp, Carol Squires, Victor Burgin, Allan Sekula and Martha Rosler. Vilém Flusser could also be added to this list, amongst many others. One particularly telling criticism is from Victor Burgin who asserts that we are 'complicit' with photography, unable to choose what we make of a photograph and thereby forced to take up one of two positions: 'narcissistic identification' or 'voyeurism'.[8] Here, the familiar structuralist argument about the prison-house of language is imported into photographic discourse: apparently photography, too, interpolates us into constricted systems of thinking and feeling.

New Zealand artist Fiona Pardington has a particularly acute response to this view of photography. She says: 'there are many truths rather than one truth when it comes to the world, so why would a photograph be any different?'[9] Here she is not advocating relativism – the 'anything goes' of spectator-centred criticism that Burgin is keen to combat – rather, as her reference to 'truths' indicates, she is acknowledging a world composed of different perspectives and positions, all of which would be equally strongly held. Dispute and disagreement are clearly possible, and expected, when perspectives are presented as having a claim to truth in this fashion.

Pardington's work, which is my concern in this chapter, very powerfully questions the idea that photography is a system of ideological restraint. For her, it is a source of liberation, a chance to present her truth of a living past. Her position as a Māori artist of Ngāi Tahu, Ngāti Mamoe and Ngāti Waewae descent is not used to shame the western viewer for the racist practices of the past. Instead, she reinvigorates the possibilities of identity politics by making deeply moving and arrestingly beautiful photographs that show a path beyond the insular self-expression invoked by the affective turn. In this way, she also queries the anti-aesthetic position that opposes beauty to pain and the realities of political or social concerns. The opposition of beauty and political ideas is unequivocally refused by Pardington's work.[10]

This chapter examines Pardington's photographic series, *The Pressure of Sunlight Falling* (2010), which was exhibited at Govett-Brewster Art Gallery in New Plymouth, Aotearoa/New Zealand in 2011. The exhibition was comprised

of twenty-one large-scale photographs of nineteenth-century life casts of the heads of different peoples of Oceania. Most of the images show the casts head on to accentuate the portrait-like quality; five profiles were also shown of Māori heads. The book of the same title, which accompanied the exhibition, included sixty-seven photographs of the casts, with the addition of some rear views as well as profiles. To date, the full range of photographs has not been exhibited, however the reservoir of images enables the creation of different ensembles of characters. Indeed, each time the series has been shown the selection has been slightly different; the number of images has also varied. For example, earlier iterations of the series were much smaller. *Āhua: A Beautiful Hesitation* (2009) was composed of ten photographs. It was exhibited as a single room photo-installation at the Museum of Contemporary Art, Sydney as part of the 17th Biennale of Sydney in 2010. At a further exhibition, at Two Rooms Gallery in Auckland, New Zealand in 2010, *Āhua* was shown in conjunction with *The Language of Skulls*, a series of photographs of life casts painted over to function as phrenology charts. Two of these golden heads, both labelled *Gall's Buste Three*, were included in the catalogue of *The Pressure of Sunlight Falling*. The reference here is to Franz Joseph Gall, the founder of phrenology.

As the references to Gall indicate, the Oceanic life casts were originally taken as a phrenological exercise intended to buttress emerging theories of racial difference. While the central idea of phrenology that parts of the skull are indicative of character traits and moral capacities is not necessarily a racist idea, in nineteenth-century writings on the Pacific, Bronwen Douglas points out 'how readily phrenological terminology could slide into conventional racist essentialism'.[11] Indeed, the belief that there was a biologically determined hierarchy of peoples that could be ascertained by measuring skulls was one of the unsavoury ideas associated with the phrenological enterprise as it was deployed in the Pacific.

Pardington's photographs breathe an entirely new life into these embarrassing relics of a more flagrantly racist past. The series brings back into wider circulation these largely forgotten casts taken on one of the last so-called 'voyages of discovery' of the early nineteenth century. While these heads have been shown in recent decades in the more circumscribed contexts of exhibitions of historical ethnography and scientific voyages, it was a considerable risk on Pardington's part to place them in the contemporary art museum where the display of people as racial specimens, without the typical distancing framework of ideology critique, might be viewed as profoundly politically incorrect.[12] This chapter examines how Pardington radically reinvents these shameful artefacts through a reparative Māori perspective on the unstill history of the ethnographic past.

Colonialism, postcolonialism and voyages to the Southern Seas

Pardington first became aware of the existence of the life casts in March 2007 when Tahu Potiki, an expert on South Island Māori history, mentioned to her that casts of their Ngāi Tahu ancestors were in Paris. At that time, she was unaware of the casts much closer to home, but kept out of view, in storage at the Auckland War Memorial Museum. They had been in New Zealand since 1878. Their arrival from the National Museum in Paris was considered newsworthy at the time; the *Auckland Weekly News* refers to them as 'a great acquisition' of 'ethnological types' exhibiting the 'finest typical peculiarities of the various races of men – the European, the Mongolian, the African, the Negro, the Malay, the Maori, American Indian, and others'.[13] It also unabashedly reported that they were obtained '"in exchange" for Maori skulls'.[14] Racial classification and the traffic in human remains are an integral part of the casts' history.

The seven white plaster casts that survive in the Auckland War Memorial Museum are regarded as 'copies' of the highly painted French 'originals', if the latter term makes much sense when speaking of busts made from a mould.[15] Certainly, when compared with the busts in the collection of the Musée de l'Homme (Musée National d'Histoire Naturelle) in Paris, the Auckland heads suggest a further remove from the mould. The busts in Auckland have much rougher surfaces, and the details are less refined and precise.[16] In the exhibition *The Pressure of Sunlight Falling*, only the casts from French Museums were used, although three of the Auckland casts are included in the book, one of which, Takatahara/Tangatahara, is from Pardington's iwi, or tribe, Ngāi Tahu.

Pardington discovered the French life casts via a somewhat circuitous route. Her search for the āhua, or likenesses, of her ancestors has something of the character of a detective story, with many twists and turns and several propitious chance encounters, like the comment from Tahu Potiki that sparked her initial interest. One clue came from Yves le Fur, the director of collections and heritage at the Musée du quai Branly in Paris, which features indigenous art from Africa, Asia, Oceania and the Americas. Pardington had previously exhibited at Quai Branly, and le Fur, knowing of her interest in casting, told her about an exhibition of casts, or *moulages* as they are called in French, at the Musée d'Orsay in 2002, *À Fleur de Peau: Le moulage sur nature au xix^e siècle*. He sent her the catalogue, which included the exquisitely tattooed head of a Māori warrior Matua Tawai/Matoua Tawai, but none of her Ngāi Tahu tupuna or ancestors.[17] Another chance encounter, this time with an auction catalogue, delivered a further clue: a lithograph of two life casts of Māori heads, Matua Tawai again but this time pictured alongside Piuraka/John Love Tikao, one of

Pardington's tupuna. The catalogue, *À Fleur de Peau*, along with the lithograph, eventually led her to France to photograph the heads in two museums: Musée de l'Homme and Musée Flaubert et d'Historie de la Médecine, in Rouen (Figures 4.1 and 4.2). Along the way, the personal voyage of discovery opened

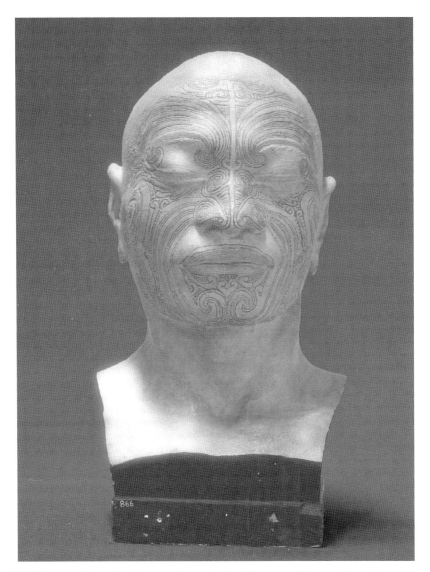

FIGURE 4.1 Fiona Pardington, *Portrait of a life cast of Matua Tawai, Aotearoa/ New Zealand*, from *The Pressure of Sunlight Falling* series, 2010, pigment inks on Hahnemühle photo rag, 146 × 110 cm. Courtesy: Musée de l'Homme (Musée National d'Histoire Naturelle), Paris and Starkwhite, New Zealand.

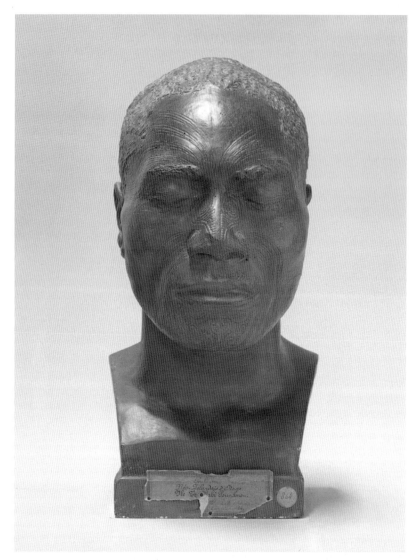

FIGURE 4.2 Fiona Pardington, *Portrait of a life cast of Piuraki/John Love Tikao (painted), Aotearoa/New Zealand*, from *The Pressure of Sunlight Falling* series, 2010, pigment inks on Hahnemühle photo rag, 146 × 110 cm. Courtesy: Musée de l'Homme (Musée National d'Histoire Naturelle), Paris and Starkwhite, New Zealand.

out to consider the origins and broader purpose of the casts and their maker Pierre-Marie Alexandre Dumoutier.

The original life casts were taken by the phrenologist Dumoutier when he accompanied the voyage to the Southern Seas led by Jules Sébastien César

Dumont d'Urville in 1837–1840. This voyage, like most of the European expeditions to the southern hemisphere, was part of the colonialist project. Although, it was at the very tail end of that enterprise: as Susan Hunt observes, by the 1830s most of the Pacific had already been 'carved up and claimed' by other colonial powers.[18] The voyage, she argues, was nonetheless motivated by 'territorial ambitions'.[19] Antarctica was the 'last frontier' in the region.[20] Dumont d'Urville's main mission was to reach the South Pole; he claimed Adélie Land in Antarctica for France in 1840.[21] In addition, as Martin Terry reports, Dumont d'Urville was charged with several other official tasks: to search for the remains of the missing French explorer La Pérouse, and in Oceania to look for suitable places for French penal colonies as well as safe harbours for French warships. Terry indicates that '[m]any fields of science were also expected to benefit', most notably the fledgling discipline of anthropology.[22]

Physical anthropology particularly interested Dumont d'Urville and it was for this reason that Dumoutier was appointed as 'anatomical assistant and phrenologist' for the expedition.[23] Dumoutier was one of the most prominent phrenologists of his time, and was most likely the only phrenologist appointed to a scientific expedition of this nature.[24] Dumont d'Urville was clearly also interested in phrenology in its own right as indicated by his consultation with the founder of the London Phrenological Society, James Deville, prior to the voyage, to have his own head interpreted. Terry reports he received a reading 'as flattering and as vague as any contemporary astrological chart', which no doubt affirmed his commitment to the pseudo science.[25]

Whether the fifty or more casts accumulated on the voyage actually contributed anything at all to the sum total of human knowledge is less than clear.[26] Dumont d'Urville's chief anthropological contribution to the classification of human diversity had already been made well before the 1837 trip. On the basis of his previous expedition from 1826 to 1829, he divided the peoples of the Pacific into three distinct races and regions: Melanesia, Polynesia and Micronesia. Terms, that Nicholas Thomas attests, became standard usage.[27] These findings were delivered in a paper to the Société Géographie in 1829. Thomas summarizes the main achievement of the paper:

> It divided the region up, racially and geographically, in a fashion that owed a good deal to both de Brosses and Forster but was more rigorous, speaking not vaguely of 'great varieties' but concretely of 'races'. Most importantly, and for the first time, Dumont d'Urville identified the boundaries between the regions occupied by the 'races' on an actual map.[28]

The casts, then, have a slightly redundant quality; they are intended to illustrate a theory already elaborated, to simply affix that theory *ex post facto* onto the body. For Oceania, the chief contrast the theory proposed is that the

'copper-coloured' or 'yellow' race (living in Polynesia, Micronesia and Malaysia) was superior to the 'darker race' of Melanesia (Australia, Papua New Guinea, Fiji, New Caledonia, the Solomans and Vanuatu). Dumont d'Urville described the 'black race' as '[m]ore degraded towards the state of barbarism', with 'inferior' intelligence; their women were, according to him, 'hideous'.[29] Australians and Tasmanians, by his account, were 'incapable of ever being civilized' and thus 'will end up disappearing entirely'.[30]

These shocking pronouncements about the peoples of Melanesia and Australia leave little doubt about the racist underpinnings of the theory. Yet many commentators also note the jostling between the grand racial theory and the empirical evidence collected by the voyages. For example, the phrenological evaluation of two skulls from the Papuan Islands claimed the Papous had 'dispositions to theft', a 'penchant for murder' and 'a tendency to superstition', but Bronwen Douglas draws attention to the more progressive side of phrenology asserted in the authors' conclusion: the Papous were also 'capable of education'and were 'wrongly considered by clever naturalists to be close to the Apes'.[31] Even in this purportedly ameliorating addendum, the full horror of the racial hierarchy is revealed. The ape is at the bottom of the hierarchy of the races; at the top is, of course, the white race. Roger Blackley sees the confluence of phrenology with late eighteenth-century racial theory occurring at precisely this point: the 'ideal' skull of the *Apollo Belvedere* is at the pinnacle of humanity, from there it is a value-laden chromatic slide downwards to the ape at the other.[32] The objectification of human beings, their reduction to mere illustrations of a self-aggrandizing narrative of white supremacy is clearly in evidence here. Viewed in this context, it might seem as though the Oceanic life casts are forever caught in this web of derogations, objectifications and invidious comparisons of indigenous peoples. Certainly, when situated in ethnographic or natural history museums such artefacts usually speak of the colonial culture of collecting and classification that objectified and demeaned indigenous cultures and indigenous practices.

These deeply disturbing representations of a bygone western world-view cannot fail to shame the contemporary reader. Despite being entangled in this shameful history, the casts nonetheless piqued Pardington's interest. Initially, of course, the appeal was deeply personal; the fascination of seeing likenesses of one's ancestors, taken before the photographic era, cannot be underestimated. But there is more to the casts than their genealogical interest, no matter how compelling that may be for individuals. The casts, like all very powerful representations, have an afterlife. Or to put it another way, the purpose for which they were originally made does not foreclose upon future alternative meanings or uses. Indeed, the potential for repurposing was already evident in the nineteenth century: the casts were purchased by the

Musée d'Histoire Naturelle in 1873, a decade after phrenology had ceased to be regarded as important.[33] This speaks of the disengagement from phrenology, if not the grand racial theory with which it was complicit.

But there is another important sense in which the casts are able to outrun their intended use. Since life casts are 'stenciled off the real' they are frequently seen as both analogous to, and the forerunners of, photography. Photography, and by extension other indexical techniques of image production, have a particular purchase on hermeneutical openness. Both include the contingent and the unintended as part of the scoop of reality they capture, but do not create. Indeed the casts were prized precisely for their objectivity, unlike more fully intentional drawings and paintings, which in the Pacific have been interpreted as bending their depicted subject matter towards western pictorial ideals. In other words, the casts by their very mode of production exceed both their author's, and the commissioner's, intentions.

Reading the casts in this way correlates with Nicholas Thomas's recent auto-critique of his previous emphasis on the entanglement of indigenous and western identities post contact. Thomas elaborates this auto-critique in the context of outlining anthropology's four main approaches to cross-cultural comparison: universalism, evolutionism, relativism and finally historical anthropology.[34] The latter approach, which is his own, seeks to avoid the presumptions of the previous three by examining what he calls the 'historically shaped social and cultural phenomenon', or in his case, the 'entanglement of cultures and local effects of colonialism'.[35] To dislodge entanglement or rather to complicate it, Thomas draws on Simon During's acute critique of one of the mainstays of postcolonial theory – the disempowering tenet that 'after contact each group can only articulate its identity in relation to the other' – which in turn supports the very prevalent idea that hybridity is the most appropriate concept for post-contact identity.[36]

Thomas argues against the articulation of indigenous identity always in relation to western interpretations of it, as if the non-western and the western are forever locked in an airless and unproductive *folie à deux*. Instead, he suggests that while it is universally true that 'identities are articulated relationally', it is 'not true that indigenous peoples, or any others, need constantly express their identities in relation to colonizers rather than to each other, or in relation to other indigenous peoples or nonindigenous peoples other than the colonizers (e.g., nondominant migrants)'.[37]

Pardington's strategy is to interpret the heads through a Māori world-view, so that the Melanesian, European and Polynesian peoples who were subjected to the life cast process are now subjected to a different framework of interpretation and depiction. I will return to the assertion of an indigenous point of view in the final section of the chapter, first I want to examine the way in which the series complicates the idea of photographic witnessing.

Presence, occluded vision and witnessing

When I first saw Pardington's *Āhua* series in 2010 at the Biennale of Sydney, I assumed the casts were death masks, having never before encountered a life cast. On that first viewing, my attention was drawn to the closed eyes and the consistently relaxed, emotionally neutral facial expressions, which created a strong sense of unity out of cultural diversity. To my naive eyes, the group seemed to have shared what looked like the same experience of a very peaceful death. I could not imagine another circumstance, other than sleep, that could account for the stillness of the subject and the calm expressions. Moreover, the faces conveyed a strange sense of each person having in some way departed, of them not being fully present, while also having a very strong collective presence. The impression of absence is partly the result of the closed eyes, but it is not only that; the shared mood, for want of a better term, also suggests something like the evacuation of the ego. Having since seen a death mask in the Auckland War Memorial Museum, my mistake is all too obvious. The complete loss of body tonus, which is immediately obvious in a death cast, very clearly announces that the life force or soul that once held the body together has indeed departed. The face and neck of the cast I saw had a slackened appearance; the erectness and muscular control of life were no longer present.

The peaceful expression of the life casts is something of a puzzle. The process of producing the cast could not have been pleasant for the model. Le Fur astutely compares it to like being buried alive.[38] In the final stages, the liquid plaster would have completely enclosed the head shutting out all light and no doubt muffling hearing. The understandable response to this confinement might be panic, a feeling of extreme vulnerability, sensations of suffocation or even claustrophobia. Little wonder, then, that on Santa Isabel Island, one person fled in the middle of the process, breaking open the cast by hitting his head against the side of the ship.[39] There are also numerous reports of people refusing to submit to the process, despite inducements that the French, at least, thought were sufficient recompense for submitting to the time-consuming and uncomfortable process. Yet Dumont d'Urville reports that one man at Mangareva 'underwent the whole operation without making a single movement and without giving a sign of displeasure or boredom'.[40]

The 'whole operation' was quite complicated. Anne Salmond describes the process as involving a number of stages designed to allay the models' fears. First, the inducements (various western goods, such as axes or knives) were put within sight and the subjects were told they could have them after the process was finished. While they were distracted by the goods, some of the hair on their heads would be cut off, and following the hair cutting, Dumoutier reported, most people agreed to submit to the process.[41] The cast was made

in two parts. First, the back of the head was coated in plaster, as Salmond explains, 'to show that there was no pain involved'.[42] From the way she describes the process, it seems that consent was obtained at each stage. She indicates that after the assurance provided by the painless procedure on the back of the head, 'they generally agreed to have their faces encased in quicker drying plaster'.[43] Le Fur adds that the whole head would be coated in grease, another unpleasant part of the process.[44] A much later description of Dumoutier's process, by E. T. Hamy, recalls how he worked:

> The person's head, prepared in the usual way, rested in a sort of box with a part cut out for the neck and half filled with a very liquid plaster. The artist kept the patient entertained while the plaster set and it was not until the part behind the ears was completely finished that he hastily prepared a very salty plaster (for a faster set) to lay over the face. He quickly cut this layer into two symmetrical quarters with a wire.[45]

How Dumoutier 'entertained' the various Oceanic people he encountered, without a shared language, is an interesting question to consider. The very existence of the casts nonetheless speaks of the establishment of a level of trust sufficient to accumulate over fifty casts from various points along the voyage.

Hamy's description of Dumoutier's process with not one but two references to speed – 'hastily,' 'quickly' – might be a clue to the peaceful facial expressions. The front casting, which would have been the most intrusive, may have been relatively quick; none of the accounts indicate exactly how long this part of the process would have taken. And because the casting required the subjects to keep still, as Dumont d'Urville indicates, we might surmise that the cast captures the face briefly at rest. Here the contrast with the pose of the photographic portrait is instructive. The face of the sitter is not 'composed' for reproduction in the manner of a photograph, casting is a blind process where the subject does not look at the apparatus of reproduction and nor does the caster have access to the likeness being captured.[46] Instead, the cast steals the face in a less public or self-possessed state.

At rest, though, the face still shows the lineaments of the emotions that predominantly animate it: the sour downward turned mouth, the irritated strain around the eyes. While the skull is no guide to temperament, we still trust the face to give some indication of character. An idea so well expressed by George Orwell's famous adage that 'at age 50, every man has the face he deserves'. While it is doubtful that any of the models were as old as fifty, there are still some very minimal signs of facial wear and tear. For example, the face of the leader of the exhibition, Dumont d'Urville (Figure 4.3) has ever so slightly knitted brows and a downward cast to the mouth.

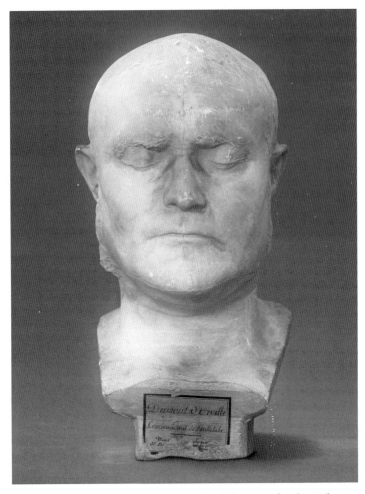

FIGURE 4.3 Fiona Pardington, *Portrait of a life cast of Jules Sébastien César Dumont d'Urville*, from *The Pressure of Sunlight Falling* series, 2010, pigment inks on Hahnemühle photo rag, 146 × 110 cm. Courtesy: Musée Flaubert et d'Histoire de la Médecine, Rouen and Starkwhite, New Zealand.

He is the most likely person to have reached fifty at the time of casting. Would it be too fanciful to imagine that his face shows a very serious man, mildly disappointed at a distinguished career that nevertheless was forever cast in the shadow of the more celebrated English explorer, James Cook? Or, carefully scrutinizing other faces in the book, is it strain that can be seen around the eyes of Ma Pou Ma Houmi from the Gambier Islands (Figure 4.4)? The lines around his eyes, more clearly visible in profile (Figure 4.5), are not laughing lines but more suggestive of squinting or concentration.

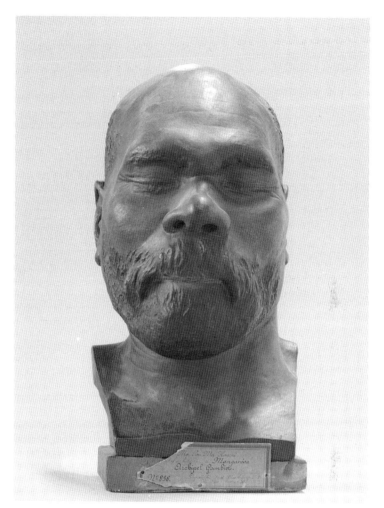

FIGURE 4.4 Fiona Pardington, *Portrait of a life cast of Ma Pou Ma Houmi, Gambier Islands (painted)*, from *The Pressure of Sunlight Falling* series, 2010, pigment inks on Hahnemühle photo rag, 146 × 110 cm. Courtesy: Musée de l'Homme (Musée National d'Histoire Naturelle), Paris and Starkwhite, New Zealand.

Is it mere projection on my part that when I look at the portrait of Guenney of Port Sorrell, Tasmania, who was not photographed by Pardington, that I think I can discern sorrow in his face? This cast was exhibited in Sydney in 2002 as part of the exhibition *Lure of the Southern Seas* held at the Museum of Sydney. In his essay in the exhibition catalogue, Martin Terry imagines the Tasmanian Aboriginal survivors of the Black War (1824–1831), who were encountered on the voyage, as 'dignified', and that too I see in Guenney's face, along with resignation.[47] According to Terry, these Australian casts may

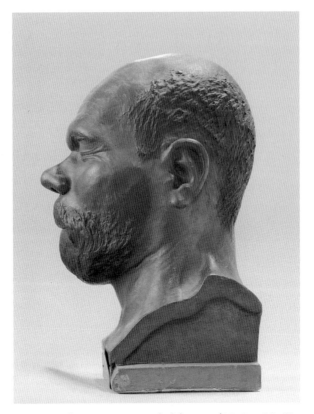

FIGURE 4.5 Fiona Pardington, *Portrait of a life cast of Ma Pou Ma Houmi, Gambier Islands (left profile, painted)*, from *The Pressure of Sunlight Falling* series, 2010, pigment inks on Hahnemühle photo rag, 146 × 110 cm. Courtesy: Musée de l'Homme (Musée National d'Histoire Naturelle), Paris and Starkwhite, New Zealand.

have been taken under duress, or at least without the same level of negotiation that otherwise occurred – a handwritten note on a later inventory indicates the Tasmanians were in Hobart Gaol.[48]

With the exception of Dumont d'Urville, none of the above mentioned casts or photographs were in the exhibition of *The Pressure of Sunlight Falling*. The selection of casts for the show, whether consciously or unconsciously, emphasized calmness and tranquility. The exhibition was presented in one room at Govett-Brewster with the portraits arranged roughly chronologically, that is as they were encountered on the expedition. As the viewer moved clockwise around the exhibition space they retraced the stops along the voyage: starting, as it were, in Toulon with the natives of France – the heads of the navigator Dumont d'Urville and the phrenologist Dumoutier – and ending in Madagascar (Figure 4.6). The inclusion of the two Frenchmen

FIGURE 4.6 Fiona Pardington, *The Pressure of Sunlight Falling* (installation view), 2011. Govett-Brewster Art Gallery, New Plymouth, New Zealand. Photo: Trevor Read.

alongside the Polynesians and Melanesians accords with Dumoutier's view of the unity of the human race; he did not hold with the polygenist theory of descent that radically separated the races, assuming what Dumont d'Urville called 'different or successive creations or formations'.[49]

At the Biennale of Sydney, Pardington included casts of Dumont d'Urville, his wife Adèle d'Urville (after whom Adélie Land was named), as well as their child Jules d'Urville (Figure 4.7). The inclusion of the explorers and, in the case of the Sydney exhibition, their immediate family, disrupts a straightforwardly anthropological reading of the work. A typical postcolonial assumption is thus not in play, namely that 'westerners look and non-westerners appear' – to adapt John Berger's neat aphorism for the ocular fate of women. In any case, Nicholas Thomas queries the application in Pacific studies of these kinds of bipartite oppositions that have flowed from the popularity of Edward Said's Orientalism.[50]

At the Govett-Brewster exhibition, beginning the voyage with two distinct characters set up the way all subsequent portraits were viewed. Even though we may suspect not all of the identifying names of the sitters are strictly accurate (Orion for an inhabitant of Papua New Guinea seems unlikely), nevertheless each portrait is individualized by a name that was recorded along with information about his or her place of origin. Viewed singly the sense of realism is very powerful, as many commentators have noted. Once the misapprehension of death masks is dispelled, one might be further fooled into thinking these are photographs of seventeen men and one woman in a

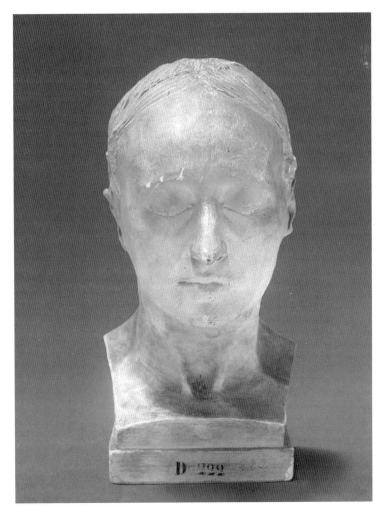

FIGURE 4.7 Fiona Pardington, *Portrait of a life cast of Adèle d'Urville*, from *The Pressure of Sunlight Falling* series, 2010, pigment inks on Hahnemühle photo rag, 146 × 110 cm. Courtesy: Musée de l'Homme (Musée National d'Histoire Naturelle), Paris and Starkwhite, New Zealand.

meditative state or in sleep. The realistic rendering of hair and skin texture accentuates this deception, drawing the eye to the face, instead of the truncated shoulders and the base with identifying label or number affixed (Figure 4.8).

The focus on the face was accentuated at Govett-Brewster by hanging the photographs quite low on the wall so that when viewed close-up the top of the sitter's head aligned with the top of the beholder's head. The double mediation of a photograph of a proto-photographic technique is of course all

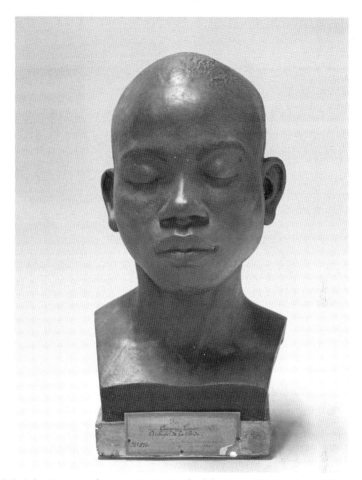

FIGURE 4.8 Fiona Pardington, *Portrait of a life cast of Koe (painted)*, *Timor*, from *The Pressure of Sunlight Falling* series, 2010, pigment inks on Hahnemühle photo rag, 146 × 110 cm. Courtesy: Musée de l'Homme (Musée National d'Histoire Naturelle), Paris and Starkwhite, New Zealand.

too evident at a distance but does not lead one to feel doubly displaced from the real.

When encountered as a group of faces mainly turned towards you (as mentioned earlier there are five profiles), it is as though you are in their presence, rather than the other way around. It would be overstating the effect to say that the viewer feels looked at, but the portraits without doubt hold the room and control its atmosphere, exuding calm and a sense of contained power. The profiles turned towards each other along the back wall suggest a closed circuit of relations that augments the feeling of an installation that does not require the viewer's gaze to complete it (Figure 4.9).

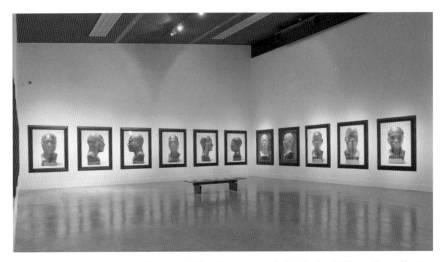

FIGURE 4.9 Fiona Pardington, *The Pressure of Sunlight Falling* (installation view) 2011. Govett-Brewster Art Gallery, New Plymouth, New Zealand. Photo: Bryan James.

The most obvious source of disruption to typical viewing conventions is, of course, the closed eyes. They suggest 'absorption' or self-absorption, rather than a 'theatrical' address to the viewer, to invoke Michael Fried's contrasting terms that stand for the negation of beholders on the one hand, and their necessary inclusion on the other.[51] Or to better calibrate this negation and the power of the portraits, it is as though we have been granted an audience with the reclusive ancestral figures, rather than simply being the audience. Agency, in other words, does not feel as though it resides solely with the beholder.

Pardington locates the powerful effect of the portraits at a bodily level. She explains:

> It's impossible to know how meaning is generated. . . . The only way we can understand is through either analogy or empathy. We respond to portraits through our bodies; likenesses of the human face affect us powerfully, they affect us at a pre/subconscious level as an archaic response; life casts are mechanisms of appraisal and the recognition of sentient life.[52]

There are portraits, of course, that do not have this power and certainly the casts when seen in routine photographs for documentation purposes do not possess this uncanny presence that Pardington has achieved. She has animated them in a very particular way. This effect is partly the result of the intense and deep focus of the photographs, which accentuates the volume of

the head, while flattening the space around them. The heads seem to almost float forward from this neutral background, with only the tiniest of shadows to anchor them in a hazy space without clear co-ordinates. There is a very dreamy quality to the indeterminate space that chimes with the closed eyes.

The scale also contributes to the quiet vitality – Pardington describes the heads as 'somewhat larger than life but not so big as to appear as gods'.[53] The mention of gods is interesting, as it points to another type of witnessing that would not be out of place here – religious witnessing. By this I do not mean testifying to the unseen presence of gods, Pardington is clear that it is sentient beings to which we should attest. Rather, it is to call up rituals that ask us to remember, to bear witness, to something we never experienced directly. Religious witnessing is one of the few exceptions John Durham Peters grants to his insistence on the need for proximity to an event in order to produce what he calls variously 'body-witnessing' and 'fleshly wisdom'.[54] Religious rituals like the Passover Seder or Christian communion, he states, give us 'witnesses without experience and memories without events'.[55] Participants are active not passive witnesses, 'sayers rather than seers'.[56] The key for him is a metaphoric re-enactment of the past that is both like witnessing and yet not entirely commensurate with witnessing.[57]

In Pardington's work, there is a feeling of hallowed space that makes this recourse to religious witnessing apposite. It begins with the self-abnegation that religious spaces sometimes inspire. In the exhibition space, there is no sense of the beholder possessing a sovereign gaze surveying the room; as I mentioned earlier, the stronger feeling is of being in the presence of the photographs. In other words, power is ceded or lent to the portraits – the 'Thou' that typically prevails over the 'I' in such experiences. We could follow Pardington and affirm that the viewer 'recognizes' the sitters' 'sentient life'; although recognition is perhaps too ocular to describe how the contact between beholder and sitter operates. It would be more correct to say that the likenesses, produced in darkness with no exchange of gazes, evokes in the viewer a strange echo of sightless and wordless contact. The likenesses, we could say, are documents or testimony to contact between western and Oceanic peoples, but like the occluded gazes at the centre of their making, it was a doubly blind encounter. A fitting metaphor perhaps, for the lack of mutual recognition that is at the heart of the colonialist enterprise. Viewed in this way, it is as though the introverted gaze of each sitter refuses the objectification to which it was once subjected. The refusal leaves in its wake a strange feeling of not seeing or being seen that encompasses the beholder as much as the sitter, making contact like a "missed encounter with the real" to invoke Jacques Lacan's characterization of trauma.[58] For this contact could not have been other than traumatic for the Oceanic peoples, marking just one recorded moment in the long process of colonization and dispossession.

Lacan's account of trauma is unusual in the literature for this stress on a lack of connection, rather than a massive intrusion or rupture to the psyche. The often quoted phrase that trauma is "a missed encounter with the real" underscores negation: what doesn't happen, contact that isn't made, an encounter that is averted. He takes his cues from Freud's idea that trauma has a temporal lag; it is not the event or encounter in the first instance that is traumatic. To repeat Jean Laplanche's summary from Chapter 1, 'It is not the first act which is traumatic, it is the internal reviviscence of this memory that becomes traumatic.'[59] Shifting the emphasis from time (Freud's *Nachträglichkeit* or afterwardness) to space (not meeting or coinciding with the real) suggests a lacuna in experience that is as much spatial as temporal. The familiar phrases for traumatic self-alienation conjure with this spatial disjunction: being beside oneself, out of body. Being out of synch in both time and space creates a much stronger sense of dislocation, casting the traumatized subject into limbo.

The real in Lacan is, of course, a notoriously difficult concept; in the passage from which the quote is drawn 'reality' is used interchangeably with the real. In his early work, the real is akin to the Kantian thing-in-itself, the 'plenum' of the concrete world outside our representations and understandings, however Lacan progressively complicates this register and in particular attributes to it negative psychic qualities such as anxiety: the ultimate real, he says, is 'the object of anxiety *par excellence*'.[60] To define trauma as a missed encounter with this register suggests the creation of a void in experience that cannot be represented, only repeated. If we take seriously Nicholas Thomas's critique of postcolonial entanglement, then characterizing the trauma of contact in this way adds to the account of psychic intrusion and subsequent ventriloquism described by Ferenczi's confusion of tongues (discussed in Chapter 2).

The uncanny repetition of a kind of blanking of the viewer by Pardington's photographs commemorates this missed contact while also metaphorically re-enacting it, producing the curious kind of witnessing I mentioned earlier: John Durham Peters' idea of 'witnesses without experience and memories without events'. While one might think that such commemoration is usually consciously undertaken via a symbolic ritual, according to Diana Taylor the underlying theory of ritual stresses a primarily corporeal mode of transmission: 'people learn, experience, and come to terms with past or future behaviors by physically doing them, trying them on, acting them through and acting them out'.[61] This way of thinking, she emphasizes, stretches from Aristotle's theory of mimesis to recent theories about the role of mirror neurons in the generation of empathy.

The viewer is by no means traumatized by re-enacting near contact with the abyss; instead the experience yields a highly complicated version of witnessing. To return to Ulrich Baer's formulation of witnessing discussed in Chapter 2, material is brought forth that 'no one ever wanted to know

about' – spurious anthropological knowledge in the service of colonization – but this is at least partially voided by the powerful presentation of the sitters' humanity in the present.[62] And as Pardington notes, this lesson is delivered in a corporeal register, so that it is not so much knowing and seeing anthropological truths or untruths, but rather feeling the effects of effacement, alongside a very strong sense of awe.

The empathic proximity that usually underpins accounts of distant or secondary witnessing is also qualified by the emphasis on re-enactment and a blind meeting. Instead of marshalling identification with the sitters, or using ideology critique to activate disidentification with racist thinking and stereotypes, Pardington adopts the strategy Sianne Ngai describes as asserting the right to '*preserve* "blank spots"' of racial identity.[63] Asserting this right means refusing the typical task of the subaltern subject: to fill in the blanks with a new self-definition or to provide an alternative account of racial identity. In other words, the missed encounter is *détourned* to preserve the opacity of identity. Instead of following the postcolonial demand to answer back to the empire, Pardington's series reveals the power of silence.

Life aesthetics, mortuary aesthetics: reparation and the redemption of damaged life

Experience destroys; art restores.[64]

. . . art would be our 'real life' not in the sense of an essentializing version of experience, but rather as a first or original (but originally missed) contact with phenomena.[65]

LEO BERSANI

In his book *The Culture of Redemption*, Leo Bersani offers a strong critique of the idea that art is redemptive, that it 'repairs inherently damaged or valueless experience'.[66] He argues this view of art devalues both historical experience and art: the 'catastrophes of history' can be ignored in this formulation because they can be redeemed by art, and art is reduced to a 'superior patching function'.[67] He calls this approach to art the 'mortuary aesthetic', which he believes psychoanalytic theory renders as normative by devaluing life.[68] Against this view of high culture, in his chapter on Proust, he concludes by arguing for modes of representation that 'reinstate a curiously disinterested mode of desire for objects', what he calls 'a mode of excitement' that enhances the specificity of objects.[69] In this section, I examine the way in which Pardington's photographs are reparative in precisely this way. Contrary to Bersani's view that the reparative or redemptive approach to art demeans

historical reality, Pardington's *Āhua* series enables new contact with historical material, or in his terms 'first' contact.

Predictably, Bersani's critique of psychoanalytic ideas of reparation focuses on the work of Melanie Klein. However, her theory of reparation is not his target as one might expect, rather it is her elaboration and development of Freud's incomplete theory of sublimation. This focus on the diversion of libido to so-called "higher aims" skews his analysis of reparation towards ideas of 'transcendence' and 'idealization' typical of bourgeois notions of art.[70] Such ideas are not commensurate with Klein's idea of the reparative phase. As we saw in Chapter 1, the result of the reparative phase is the incorporation of both good and bad objects, damaged and repaired. Hence Eve Kosofsky Sedgwick characterizes a reparative approach as 'additive and accretive', it is not elevating and idealizing.[71] Despite the delimited and incomplete account of Klein's position, Bersani's criticisms are a salutary reminder of the more usual understanding of redemptive approaches to culture and, in particular, the devaluation of life that frequently results from the "elevation" of art.

A more complicated picture of this opposition emerges in Pardington's work where the distinction between art and life is not so easy to draw. If retrieving the past is necessarily tainted by mortuary aesthetics, in her work this is tempered by the assertion of life aesthetics derived from an entirely different view of the ontology of cultural objects. In *The Pressure of Sunlight Falling*, she reclaims the casts as *taonga*: cultural treasures that embody the life principle or *mauri*. Such treasures, like carvings or *hei tiki* figures (greenstone neck ornaments), are traditionally understood not as a substitute or representation of life, but as having life themselves.[72] Describing her practice more generally, Pardington states that she respects the 'belief of Te Ao Maori in the potential for consciousness to reside, take residence or remain in objects'.[73] In other words, she adopts what she calls an 'animistic' Māori perspective on these anthropological artefacts that might otherwise be regarded as dead, embarrassing or shameful.[74]

Portraits have a particularly important function in this animistic world-view. As Anne Salmond explains: 'Ancestral portraits allow forebears to come into presence, cancelling the distance between life and death, subject and object. They act as portals between te pō (the dark world of ancestors) and te ao (the everyday world of light).'[75] The interpenetration of life and death is a consistent theme in Pardington's theorization of her practice. Its application to the *Āhua* series is well captured by Kriselle Baker, who very eloquently writes: 'It is as if a double life is lived: that of the mortal being and the ongoing life that exists as part of the cast and now as the photograph, a continuing presence in parallel worlds of living and dead.'[76]

The strong presence of the portraits in *The Pressure of Sunlight Falling* owes much to this underpinning philosophy: Pardington has photographed

inanimate objects as if they are alive. She describes her process as looking for 'the right time when the image seems to leap into life, the beauty coalesces with the technical plane of the ghost in the machine and the demi-urge of pixels'.[77] This anthropomorphism of photographed object and photographic processes remakes contact while preserving blindness and incomprehension as the necessary gap between viewer and work. The uncanny vitality of the resulting portraits partly undoes their shameful history, augmenting the other diversionary tactics described in the previous section: the inclusion of the French explorers, the individualization of each sitter, the tranquility of their collective demeanor, the use of large scale and the consequent diminution of the beholder.

Two further tactics enable guilt and shame to be navigated in reparative ways. First, the shame of the oppressed or colonized is not in play in Pardington's work. Or if shame is always residually associated with subjugation, then it is has been very successfully transduced into an installation of great beauty and complexity about this difficult history, suggesting the ascendancy of pleasure and surprise advocated by Sedgwick. In other words, shameful events of the past are revisited rather than repudiated in line with the core strategy for transforming shame that Sedgwick identifies in the work of Henry James.

Second, Pardington has not adopted the position of victim, thereby complicating the typical way we think about colonialism and its aftermath. It is instructive to think about how the casts could have been presented, if Pardington had wanted to foreground that position and to make use of the typical art strategies of repudiation associated with identity politics, such as ideologue critique. If this had been her aim, she could have emphasized the original purpose of the casts. Following the example of African American artist Carrie Mae Weems, racist descriptions from the voyage could have been superimposed onto the images to limit the way in which the casts are perceived (Figure 4.10). Adopting this approach would underscore the guilt and shame of the western viewer, both perpetrator and beneficiary of this world view.

Alternatively, she might have followed the approach that Sianne Ngai dubs the 'uplift' aesthetic.[78] Filling in the 'blanks' of racial identity with positive representations that contest negative stereotypes – another familiar strategy from the recent history of feminist, queer and postcolonial art. To give just one example, the Australian indigenous artist Brook Andrew has 'uplifted' a typical ethnographic photograph of an Aboriginal man by amplifying body decorations and adding across his chest the text 'sexy and dangerous'. Andrew thereby directs the viewer towards a positive reading of the photograph as surely as ideology critique underscores the negative (Figure 4.11).

Pardington's reparative method can be understood as combining these two approaches while also reinventing them. Insofar as she asserts an alternative

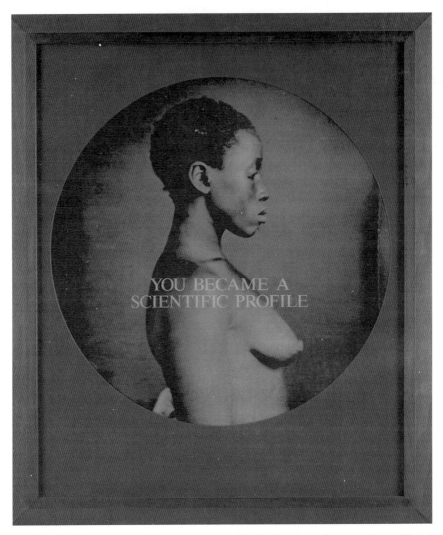

FIGURE 4.10 Carrie Mae Weems, *A Scientific Profile*, from the series *From Here I Saw What Happened and I Cried*, 1995–96, C-print with sandblasted text on glass, 26½ × 22¾ inches. © Carrie Mae Weems. Courtesy of the artist and Jack Shainman Gallery, New York.

animistic world-view, the *Āhua* series makes amends in a straightforward manner like the uplift aesthetic. However racial identity as such is not the principal concern, rather it is the beautiful idea of a life principle joining the past to the present. This new understanding of history and patrimony sits alongside the colonial legacy rather than displacing it, ensuring that the damage of the past is not forgotten. The room brochure for *The Pressure of*

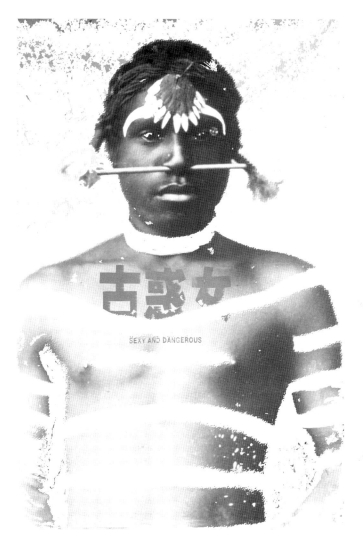

FIGURE 4.11 Brook Andrew, *Sexy & Dangerous*, 1996, digital image printed on Duraclear mounted on acrylic, 183 × 182 cm. Courtesy of the artist, Tolarno Galleries, Melbourne and Galerie Nathalie Obadia, Paris and Brussels.

Sunlight Falling well captures this delicately balanced ambivalence: 'the artist investigate[s] museum collections as imperfect yet infinitely precious archives of cultural memory'.[79] Imperfect and yet precious describes life rather than its transcendence or sublimation.

The familiar tactic of repudiation is also present yet refigured. The damage done by disgraceful racial theory is not erased simply because Pardington has pictured these colonial artefacts in such a surprising and unexpected way. But

even that colonial history is presented in a novel and surprising way: the beholder's strange and subtle experience of sightlessness, effacement and diminution commemorates and bears witness to the trauma of colonization. Pardington's carefully choreographed exhibition ensures that the beholder feels the vertigo of the missed encounter in equal measure to the presence of the peaceable life principle. A type of double vision is the result: consciousness of how the casts once operated as specimens illustrating a racist theory, and at the same time portraits that confound that reductive thinking. The series thereby perfectly embodies Melanie Klein's reparative or depressive phase by holding together in exquisite tension past and present, damage and repair.

5

Rosângela Rennó

'Little Stories of the Downtrodden and the Vanquished'

Brazil is a very young country and is still learning how to deal with its own memory. I was always told we are a country made for the future, and the rush to reach this hypothetic apogee leads our establishment to erase steps and experiences, especially when they are bad or inglorious memories.[1]

Memory is variable and manipulable; I even think it has to be manipulated so that it becomes tolerable.[2]

ROSÂNGELA RENNÓ

When Allan Sekula wrote 'The Body and the Archive' in 1986, he observed that the 'repressive' use of photographic portraiture, that is for the purposes of state surveillance and policing, was barely acknowledged as part of histories of social documentary photography.[3] Disavowing police photography maintained what he called the 'liberal humanist myth of the wholly benign origins of socially concerned photography'.[4] Since that time, there has been an explosion of writing on anthropological and other institutional uses of photography.[5] Alongside this scholarly literature, there is a parallel trend in art practice of artists examining precisely the kinds of archives Sekula identified as missing from photographic history – what he called 'a *shadow archive*'.[6] Brazilian artist Rosângela Rennó is an important proponent of this genre of contemporary photography. Indeed, she has used surveillance images in two of her photographic series, *Cicatriz* [*Scar*] (1996) and *Vulgo* [*Alias*] (1998). In these series, she transforms the voyeuristic scrutiny of the

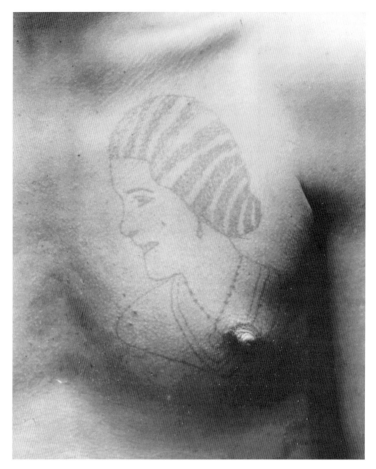

FIGURE 5.1 Rosângela Rennó, *Untitled (chest with nipple/woman)*, from *Cicatriz* [*Scar* series], 1996, laminated black and white photograph on resin coated paper, mounted on PVC Sintra, 54 × 60". Private collection, São Paulo.

prisoner's body – a strange photographic catalogue of tattoos and cowlicks – into powerful and erotic images of the male body (Figures 5.1 and 5.2).

Does this burgeoning genre of contemporary photography escape the criticisms Sekula aimed at socially concerned documentary photography? Sekula was a trenchant critic of this genre, which he elsewhere dismissed as 'the find-a-bum school of concerned photography'.[7] His chief objection is that the evocation of feeling displaces action and understanding, as he put it: 'the subjective aspect of liberal esthetics is compassion rather than collective struggle. Pity, mediated by an appreciation of "great art," supplants political understanding'.[8] As we saw in Chapter 2, Ariella Azoulay and Claire Bishop

FIGURE 5.2 Rosângela Rennó, *Whip*, 2001, from the *Vulgo* series [*Alias*], 1999–2003. From original from Penitentiary Museum of São Paulo. Digital Lightjet print, laminated and mounted on Masonite, 170 × 110 cm.

maintain the same resolute stance against compassion, empathy and pity in art reception. For Azoulay, the appeal of art is to juridical rather than sentimental modes of evaluation and in the case of Bishop, empathy should be extinguished by the distancing effects of non-identification.

Is compassion really so dangerous that it clouds understanding? Rather than contrasting compassion and understanding, pity and justice, empathy and non-identification, the more salient point of comparison is surely between these feelings and their more dangerous counterpart – indifference to the plight of others. Indeed, Lauren Berlant argues turning away and compassion are two sides of the bargain modern subjects have made with structural

inequality.[9] Coldness and compassion, she reveals, are intimately related, their mutual interference calibrating and informing our responses. In other words, pity, compassion and empathy, far from being overwhelming forces to be defended against, are actually constantly modified by the opposite force of withholding. The ever-present impulse to withhold thus emerges as the more serious challenge to generating interest in the suffering of others.

This chapter examines the strategies used by Rennó to generate interest in what she calls 'the little stories of the downtrodden and the vanquished'.[10] Clearly, by her own description, the sufferings of such people are not the grand events that might be expected to evoke pity and fear – the Aristotelian terms employed to explain the emotions elicited and then purged by classical tragedy. Images of the devastating effects of Hurricane Katrina, the Indian Ocean Tsunami of 2004, and 9/11 would have this kind of status – there is worldwide knowledge of these catastrophic events. Rennó's stories are smaller scale 'inglorious' episodes of history ignored or unknown to the west; sometimes they are shameful events of the past that successive Brazilian political regimes would like to gloss over, at others, the kind of routinized violence that occurs in Brazil as well as other countries in South America.[11] Evidence of these kinds of episodes, Rennó says, can be found or uncovered in the 'lowest category' of the image: vernacular photography, identification shots, portraits, routine newspaper reporting.[12]

As this list might indicate, Rennó does not take photographs herself, instead she recycles existing photographs of this kind. Her practice involves both 'found' and 'sourced' photographs, to use Mark Godfrey's distinction between images that artists collect by chance and more purposeful or motivated assemblies.[13] This chapter focuses on two works that use 'sourced' images: the photo-installation Imemorial [Immemorial] (1994) and the series Corpo da alma [Body of the Soul] (1990–2003).

This kind of high art appropriation of vernacular photography is criticized by Martha Langford for having no regard for the specificity of the original image.[14] Rennó's work is a sophisticated counter to this criticism: she reminds us of the need to challenge oppressive images and to examine genres of photography that we have ceased to properly see. Her work very deliberately changes the meaning of the original shots in order to encourage us to 'watch' her images, to use Ariella Azoulay's term for the duration she believes should be accorded to all images of injustice.[15]

As we saw in Chapter 2, Azoulay poses watching, rather than merely looking, as the way to forge a civil contract of photography that encompasses photographer, victim and audience. Without such prolonged attention, the important processes of witnessing and attention to injustice cannot take place. While Azoulay dismisses Susan Sontag's view that the glut of photographs of war and disaster has produced compassion fatigue, she does

not consider what aesthetic means might counter the desire to look away and encourage watching.[16] Through Rennó's highly varied handling of archival and mass media images, she develops sophisticated strategies to encourage prolonged viewing, most notably the use of museum-scale photographs but also the attention given to the surfaces of the images and their sensual and perceptual qualities. For example, the photographs in the *Cicatriz* series are printed on watercolour paper giving them a soft receptive appearance like skin.[17] In contrast, the surfaces of *Vulgo* are rich in detail and enlivened by a delicate rose colouration directing the eye towards the cowlick patterns of scalp and hair. These photographs are warmed in tone both literally and figuratively through this infusion of the colours of flesh and blood.

Additionally, watching is encouraged by Rennó's tactic of decontextualization, which turns attention to the image itself, rather than the photographic referent. For example, she gives few if any details of the images sourced so that the focus shifts to the 'here-and-now' rather than the 'there-and-then' that usually signals the memorial function of photography. What is known of the past is constructed in the present through scrutiny of the image and what it yields through close attention and interpretation. Maria Angélica Melendi has called this strategy the 'blocking of the ubiquity of the referent' – the picture, she argues, is not seen when it is a mirror or a window referring to something else.[18] It is through such careful aestheticization and recontextualization that lowly images are elevated to objects of interest, and through that interest Rennó illuminates the two faces of structural inequality – compassion and coldness.

Immemorial: Brasília, capital of hope, cruel utopia

Fifty years of progress in five.

JUSCELINO KUBITSCHEK, *President of Brazil 1956–1961*

The first work I want to consider is Rennó's photographic installation, *Imemorial* [*Immemorial*]. Made for a group exhibition called *Revendo Brasília* [*Reconsidering Brasília*], it was initially shown in Brasília in 1994 and then toured to other parts of the country and finally to Berlin in Germany. According to Mariana Pagotto, most of the other artists in the exhibition approached the theme in a celebratory mode in keeping with the tenor of André Malraux's sobriquet for the city, 'the Capital of Hope', bestowed on his trip to Brazil as French Minister of Culture in 1959.[19]

The celebratory image of Brasília usually focuses on its utopian aspirations. The first of the 'rationally planned' cities in the world, it was built from scratch in the dry centre of the county in a little over three years.[20] Its futuristic modernist architecture and urban planning by architect Oscar Niemeyer, town planner Lúcio Costa and landscape designer Roberto Burle Marx, was intended to signal progress and the country's desire to be the 'land of the future'.[21] *Immemorial* presents a much less sanguine view of this part of recent Brazilian history, focusing on what is not remembered in the rush to be part of the future.

The installation was comprised of fifty photographic portraits of head and shoulders: forty are painted black and placed on the ground, evenly spaced to form two or three rows (depending on the installation). The grid so formed is broken up by blank spaces or gaps that give the impression of an incomplete series, as if only parts of a larger jigsaw are presented (Figures 5.3 and 5.4). Nuno Crespo has described Rennó's practice as '[c]onstructing ruins to bear witness to the present' and in the lacuna inscribed in this work, the idea of a ruin is made palpable.[22] This idea of a partial or incomplete record aligns Rennó's approach to witnessing with that of Anne Ferran; both are sceptical about our capacity to fully recover a ruined or neglected past. Yet both are nonetheless committed to bringing into visibility (albeit in shadowy form) what can be reclaimed.

The idea of an incomplete record is even more strongly evoked by the ten photographs positioned on the wall, towards which the forty darkened images

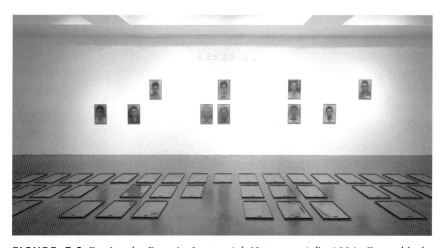

FIGURE 5.3 Rosângela Rennó, *Imemorial* [*Immemorial*], 1994. Forty black-painted orthochromatic film prints, 10 colour prints, aluminium, iron frames, bolts, title *Imemorial* written on white-painted iron letters, 60 × 40 × 2 cm (each iron frame). Private Collection, Brasília e Recife. Installation view: Museu de Arte Moderna Aloísio Magalhães, *MAMAM*, Recife, 2006. Photo: Flávio Lamenha.

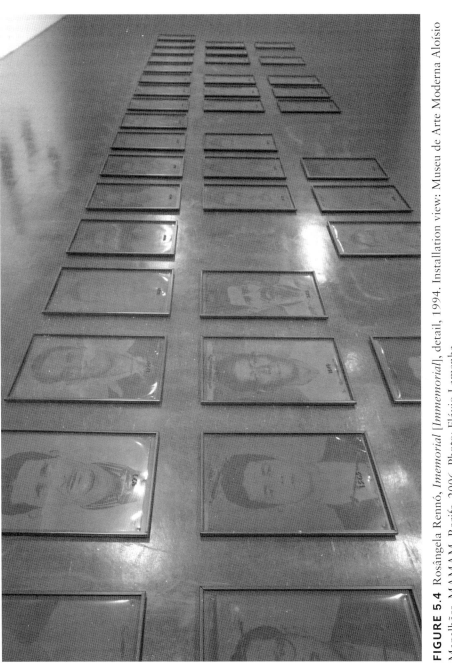

FIGURE 5.4 Rosângela Rennó, *Immemorial* [*Imemorial*], detail, 1994. Installation view: Museu de Arte Moderna Aloísio Magalhães, MAMAM, Recife, 2006. Photo: Flávio Lamenha.

are oriented. The wall-mounted photographs are reproduced in colour in warmer sepia tones; also in rows but the gaps far outnumber the photographic cells. These photographs are clearly of minors: young teenagers at the upper limit with some substantially younger children. The images are immediately recognizable as identification shots with rusted lines left by staples visible at either end of most images (Figure 5.5). These lines point backwards to an original photograph at a different scale, as well as the passage of time, deterioration and decay.

Rennó has substantially enlarged these images to a more commanding portrait scale. Some photographs include precise dates from the late 1950s until 1960, which places the photographs in the period when Brasília was being constructed (Figures 5.6 and 5.7). Brasília was built between 1957 and 1960. Numbers have been added to the base of each image to further underscore a system of classification.

FIGURE 5.5 Rosângela Rennó, *Imemorial* [*Immemorial*], detail, 1994.

FIGURE 5.6 Rosângela Rennó, *Imemorial* [*Immemorial*], detail, 1994.

All of the images are placed in iron trays, which gives them an object-like status. The lips of the trays protrude while the photographs are recessed, lying on the flat bed of the tray, thereby directing the eye backwards and inwards and reinforcing the isolation of each cell. Along with the gaps and even spacing, the object-like presentation of the photographs discourages the perception of an undifferentiated mass of bodies, such as often occurs in the work of Christian Boltanski.

Boltanski's work is an obvious point of comparison. His works that assemble head and shoulder portraits cheek by jowl into tessellated grids create a wall-like effect that keeps the eye on the continuous surface so created, rather than encouraging zooming in to consider particular individuals. In his work, the sitters are clearly practised participants in the photographic process; they adopt the norms of honorific and repressive photographic portraiture with either the obligatory smile of the snapshot, or the neutral expression of the identification shot.[23] Frequently, there is a disconcerting dissonance between the smiling expressions and the Holocaust memorial function his works are

FIGURE 5.7 Rosângela Rennó, *Imemorial* [*Immemorial*], detail, 1994.

intended to serve. In such installations, particularly when the grid is not used, the affective tone of the work is misdirected by the prominence of smiles. The smiles make it hard for the theatrical paraphernalia he uses to suggest a shrine – such as spotlights and metal boxes – to signify gravity and loss.[24]

In *Immemorial*, there is less evidence of ease and familiarity with photographic protocols. Some sitters look apprehensive almost afraid, some scowl, others look reproachful, sad or even melancholic, and many stare into the camera with an intensity that has few precedents (Figures 5.5, 5.6, 5.7, 5.8 and 5.9). August Sander's astonishing series, *People of the Twentieth Century* (begun in 1911), comes to mind as one collection of portraits that consistently shows the sitters' piercing gaze back at the camera. Through the relay of this address to the viewer, Sander's people of the twentieth century feel very present, sometimes unnervingly so. This presence, albeit not usually so commanding, is expected of honorific portraits that assume a future audience

FIGURE 5.8 Rosângela Rennó, *Imemorial* [*Immemorial*], detail, 1994.

even at the moment of production: they are intended to be viewed in public contexts such as books, newspapers or exhibitions, or in more private domains: a mantelpiece, a wallet, a computer splash page, a phone. Such future audiences naturalize the address to the camera. In contrast, the presence of an intense gaze seems strange and unsettling in a routine identification photograph destined to be stapled to a bureaucratic document and archived, perhaps never to be seen again.[25]

The current ubiquity of photo-ids in the west no doubt makes us forgetful of how intrusive, foreign or unfamiliar submitting to the photographic process once felt, and how unevenly spread around the globe such photographic documentation may have been. The portraits in *Immemorial*, with their very diverse range of facial expressions, remind us of these facts very forcefully. The absence of uniform photo-composure also delivers an added poignancy to the accumulation of portraits, further picking out individuals in a way that Boltanski's installations do not.

FIGURE 5.9 Rosângela Rennó, *Imemorial* [*Immemorial*], detail, 1994.

In case this failure to conform to photographic norms is seen as particular to Brazil or the Southern Cone, it is worth noting that American artist Zoe Leonard reports a similar unfamiliarity with photographic protocols in New York in the 1960s. For the Studio Museum in Harlem Postcard Project, she reproduced her school photograph from kindergarten in 1967 (Figure 5.10). It is an endearingly chaotic photograph with the six-year old students looking in different directions, barely one child is smiling, and several children have their mouths open in a puzzled dumbstruck way that I have often observed in my own adult students when not fully understanding what is expected of them. Leonard's commentary on the photograph is telling: 'As young children in the 1960s, we do not yet understand what it means to have our picture taken. We are bemused, unfocused.'[26] The expressions of apprehension evident in the *Immemorial* portraits, while much more disquieting, similarly speak of not understanding what it means to have a picture taken.

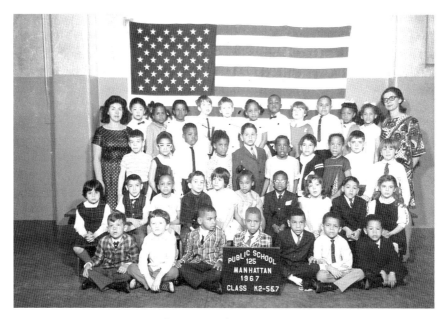

FIGURE 5.10 Zoe Leonard, *My Kindergarten Class Photo*, 2013, postcard, produced by The Studio Museum in Harlem, Fall/Winter 2013–14, courtesy the artist.

The source of the images for *Immemorial* is identified in the official description of the work: 'Reproductions of original photos attached to Novacap's working index files belonging to the Federal District's Public Archive.'[27] Novacap (Companhia Urbanizadora da Nova Capital, literally 'New Capital') was the government construction company responsible for the building of Brasília and the Federal District is the administrative unit within which Brasília is situated. With only this very minimal amount of information, it is nonetheless possible to deduce what happened to these workers by examining the installation itself. In this way, Rennó's strategy of decontextualization shifts the responsibility for joining the dots back onto the viewer. This method eschews the didacticism of ideology critique, what Rennó calls the '*panfletario*' [pamphleteer] approach to political art that loudly announces what the work is about.[28] Instead one must watch this work to figure out its meaning.

Turning first to the overall form, the combination of vertical and horizontal elements suggests both shrine and graveyard. The recumbent darkened portraits are partially effaced or cancelled out, consigned to the ground in seriated identical graves like casualties in a war cemetery, they are the fallen heroes, or rather the 'vanquished' to use Rennó's term. We surmise that they

are the dead and that children were part of the workforce. The secondary literature on *Immemorial* confirms these suspicions. Child labour was used and Rennó reports that amongst the 8,000 employee files she looked at in the archives, she found forty-five files of workers who died in the construction of Brasília.[29] In the archives, these workers were described by the unlikely phrase 'dismissed due to death'.[30] The suggestion that Novacap could sack an employee for dying is both tragic and ludicrous. The peculiar assumption of agency is suggestive of both Orwellian Newspeak and the vicious black humour of Monty Python. Even at the moment of death the bureaucratic procedure must go on: death is merely a breach of the contract of employment, rather than something for which the company should be responsible and accountable.

In an interview, Rennó reports that there are stories about cadavers concealed in concrete pillars and that the true number of deaths during construction is not known.[31] She also accessed an oral history project in the public archives that gave details of a massacre perpetrated by the special police (*Guarda Especial de Brasília*). It occurred at one of the camps after a fight over food. The massacre might account for the darkened portraits of women, who one would not expect to have been part of the actual construction process.[32]

A number of factors appear to have contributed to the deaths. Mariana Pagotto notes the unsafe speed of construction that proceeded both day and night to meet the proposed deadline of 21 April 1960, which commemorates one of the earliest efforts to oppose Portuguese rule in Brazil by the revolutionary Joaquim José da Silva Xavier, known as Tiradentes.[33] Inauspiciously, the date is when Tiradentes was hanged for his part in what is called the *Inconfidência Mineira*; the conspiracy fomented in the mineral-rich state of Minas Gerais.

Alex Shoumatoff, in his largely romantic account of Brasília, mentions men working day and night, but claims there was 'only one serious accident' – a crane overturned and went into a gorge.[34] However, radical architect Sérgio Ferro, who was present at the time of construction, paints a very different picture. Ferro, writing much later, states that the workers he lived with: 'told me of a suffering that we understood poorly then: numerous suicides, workers throwing themselves under trucks, dysentery almost every day, surrounded, without being able to leave'.[35] In addition to the carceral-like living conditions of the workforce, Richard Williams lists some of the unsafe practices Ferro enumerates in his book *Arquitectura e Trabalho Livre* [Architecture and Free Labour]: 'The cathedral involved workers swinging about the concrete ribs like "circus artistes," while masons polishing marble were developing silicosis among the clouds of dust.'[36] In addition, for one of the iconic space-age buildings, the Chamber of Deputies, Ferro testifies that it was 'painful to erect

this aesthetically dubious structure'.[37] Williams explains: 'a highly complex network of steel rods was used as the basis of the upturned bowl; as the structure was tied, the steel would catch and crush workers' bodies, injuring indiscriminately'.[38] These various accounts of the building of Brasília indicate astonishing disregard for the health and safety of the workers.

There is no public memorial or acknowledgement of these deaths. A statue by Bruno Giorgi was erected in honour of the 80,000 workers who constructed the city; originally called *Os Guerreiros* [*The Warriors*], it is popularly known as *Os Candangos*. Shoumatoff notes the complex origins of this untranslatable term. 'Candango', he says, refers to the 'pioneers' of Brasília: an itinerant labour force, who mainly came from the poor northeast of Brazil. According to Shoumatoff, the term also has racial connotations: someone 'two parts African, one part Indian, and one Portuguese'.[39] The bronze statue effaces any reference to the particularities of this labour force, choosing instead to present labour in an antiquated language of war that emphasizes male bonding: the two towering heroicized warriors are strangely conjoined at the shoulder, holding spears (Figure 5.11). *Immemorial* stands resolutely against this mythologizing tendency, lives were not sacrificed as one might say about war, instead they were needlessly and callously taken.

Paulo Herkenhoff refers to *Immemorial* as 'a work of mourning' and at first sight the affective tone of the work is sombre, perhaps even elegiac with its pared back, understated elegance.[40] But as the details of the photographs are

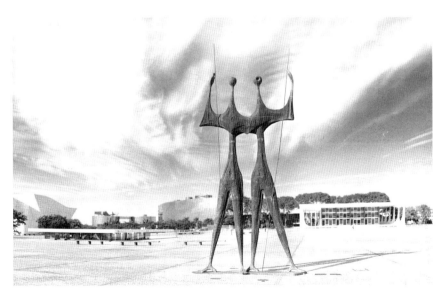

FIGURE 5.11 Bruno Giorgi, *Os Guerreiros* [*The Warriors*]/*Os Candangos*, 1957, bronze, Praça dos Três Poderes, Brasília. Photo: Bruno Cunha.

examined, the feelings of pity, regret and sadness expected of a mournful work are qualified or even deflected by the intense gaze of some of the workers, mentioned earlier. In other words, the response to the impingement of photography now feels like it is directed at us. We are addressed by the faces (drawn in by them) but also subtly rebuffed and rebuked. At once, they seem to ask: 'why have you forsaken us?' and yet also 'what do you want?' and 'why are you looking at us?' If, following Claire Bishop, partial identification is praiseworthy, then this installation is a far better example of that complex positioning than the embarrassment elicited by Santiago Sierra's work. Suspicion and reproach qualify empathy here, while the attendant complication of taking in each and every facial expression seems to amplify it.

For me, the wary or apprehensive expressions (Figures 5.5, 5.6, 5.7, 5.8, 5.9, and 5.12) have a particularly haunting quality, they stay with me when I think about this work, rather than look directly at it; perhaps because their wariness and suspicion were well founded, and translate readily into reproach now that the fate of these individuals is known.

FIGURE 5.12 Rosângela Rennó, *Imemorial* [*Immemorial*], detail, 1994.

Such faces may summon feelings of guilt about structural inequality from direct beneficiaries of the system of exploitation Rennó has pictured: the inhabitants of Brasília past and present, the government officials, the architects who may have profited from the building project. For the western viewer, guilt and shame are also at work: the face of the third-world victim of callous indifference underscores that we live in a world where some lives are not registered as grievable – to use Judith Butler's phrasing for the first-world arrogation of the sanctity of life.[41]

When such feelings of shame about inequality are directed outwards they may become anger, perhaps even outrage, at evidence of the exploitation of children and forty work-related deaths, which the incomplete grid implies are only part of the picture. Anger is not part of the affective tone of *Immemorial* itself – this would suggest adherence to the 'pamphleteer' approach to political art that usually dictates to the viewer how to feel. Such politically committed art, as we saw in Chapter 2, frequently provokes a complementary identification: antagonistic viewers align themselves not with the expressed emotion but with the authority figure that is the object of anger. Rhetorically, *Immemorial* is framed very differently, calling up instead one of the key literary modes for eliciting empathy: 'volunteered passion', an expression coined by Philip Fisher to describes the literary occasions when a reader supplies the missing feeling for a character, rather than sharing the feelings of a character.[42] In other words, while anger might be an anticipated response, it is not part of the work's address – the relative coolness of *Immemorial* means that viewers arrive at this feeling, if indeed they do, through an evaluation of the images and what they suggest about the treatment and conditions suffered by the labour force.

Kathleen Woodward has identified outrage as the appropriate corollary to compassion in such instances because it directs attention to injustice, and overcomes 'the injurious sense of the superiority of the spectator' that she argues frequently underpins pity and empathy.[43] In order to use compassion as a political tool to highlight social evils (her specific example is slavery), she argues compassion 'must include the element of recognizing injustice, which is a political and social condition, not only an existential one'.[44] Without a complex mix of compassion and anger, the representation of suffering risks a retreat to 'a private world' of easily consumable sentiment, as Woodward puts it, or the kind of merely aesthetic experience that fails to reach any kind of 'political understanding' as Allan Sekula complains when pity is the emotional keynote.[45]

When such state-sanctioned indifference to human life and the welfare of children is exposed long after it occurred, there is also the risk of being overwhelmed by the cumulative and concatenating effects of shame. In a Brazilian context, as in many other parts of the world, not only is the original event a cause of shame, there is also the disgraceful covering up, and the further shameful failure on the part of authorities in the present to apologise

for the reprehensible practices of the past. In Sara Ahmed's discussion of shame about the treatment of Indigenous Australians, she criticizes the concentration on the last of these three moments by the writers of a government report and ordinary Australian citizens responding to it; arguing that it serves a desire to quickly convert national shame into national pride.[46] While she may be correct that the desire for recovery from shame can also serve 're-covering', she ignores the way in which the piling up of layers of unaddressed shame creates a particularly intractable problem.[47] Compounded shameful events make reparation much more difficult and volatile as each layer of cruelty and neglect demands proper attention. The well-meaning writers that Ahmed criticizes, both civil servants and ordinary citizens, may not clearly distinguish between these layers, but I do not believe it is evasion that underpins their responses, either conscious or unconscious. To read their responses in this way is a classic example of paranoid reading, both in the colloquial sense and following Sedgwick's particular understanding of this mode of interpretation examined in Chapter 1. It assumes the worst motives on a colloquial level, and on a scholarly level it reinscribes views of the state and its citizenry that are routinely rolled out in much ideology critique. A reparative reading would instead view the writers' call for an apology as the kind of effective small-scale political action Gayatri Spivak describes as focusing 'where one can focus', rather than becoming paralysed or overwhelmed by the magnitude of the task of reconciliation.[48] Certainly, Rennó describes her practice in these terms; she states 'you can reach people by doing very specific, subtle and small aesthetic actions, which are still extremely political'.[49]

In this vein, *Immemorial* constitutes just one step towards the recognition of injustice, while also emphasizing the inadequacy of that gesture. The latter point is underscored by the title, which appears very prominently in the centre of the wall in large iron letters painted white. 'Immemorial' is not exactly the opposite of memory, the OED defines immemorial in the following way: 'that is beyond memory or "out of mind"'. The definition suggests something that exceeds human capacities to remember, and perhaps more wilfully something put out of mind. It is an unusual term to frame what is on one level a commemorative work; certainly Rennó refers to the work as 'a kind of memorial', and elsewhere calls it 'a memorial of the imponderable'.[50] It is imponderable both because the numbers of deaths are not known, much less the specific causes, thereby severely compromising what can be remembered, and it is unthinkable that slaughter is a by-product of a utopian building project. In such instances, memory must be 'manipulated so that it becomes tolerable', as Rennó puts it.[51] Without knowing the details of the fatalities or under-aged workers, *Immemorial* must hold in tension the fact of amnesia as well as the demand to remember at least the faces of these fifty people – the tolerable visage of state brutality.

Charles Merewether describes the installation as 'a redemptive gesture, a resurrection of fallen bodies, those sacrificed in the building of the future'.[52] Resurrection is, of course, at work in the installation insofar as it dredges up archival records that are not routinely discussed when Brasília's fabled identity as 'the capital of hope' is considered. However, Rennó is sceptical about the restorative capacity of photography, and indeed the constant recourse to the trope of memory both to explain photography and to account for this kind of art practice. She explains:

> I don't like the way that photography is tied so much to memory. The expression indirectly refers to the process and the ability of photographs to capture an eternal moment, saving the image from a spiritual death. All the sociological discourse on photography is based upon this. I think it is a mistake because you are never able to rescue anything from it, from its past. Like our own memory, they are not truthful.[53]

Rennó's attitude to photography explains her strategies of decontextualization, which shift the emphasis to the viewer's interpretation – hermeneutics rather than faith in documentary veracity guide her practice. The redemption, promised by Merewether, is at odds with this more postmodern sensibility and its close attention to contingency. But seeing things in these more uncertain terms does not preclude political action or moral purpose. Rennó describes her moral responsibility as 'a kind of duty to help these images to be seen'.[54] Viewing her images, however, does not deliver the kind of resolution of the past that could be described as redemption. Her reparative method simply makes the memory of brutality tolerable. The impulse to turn away is cheated.

Corpo da Alma: pictures of people holding pictures

Unlike the very specific historical and geographical focus of *Immemorial*, *Corpo da Alma* [*Body of the Soul*] addresses a global phenomenon: the widespread practice in newspapers and periodicals of publishing photographs of people holding photographs; a practice that can be understood using Lauren Berlant's concept of 'systemic crisis' or 'crisis ordinariness'.[55] Berlant coins these terms, with the stress falling on ordinariness, to counter the idea of a state of exception associated with the discourse of trauma, and to thereby better serve the contemporary experience of pervasive precariousness.

Her analysis focuses principally on Europe and North America where the effects of the global economy are slowly 'fraying' away, rather than dramatically

disrupting, optimistic expectations of the good life.[56] The slow almost imperceptible process of fraying enables a residual, but in the current situation, cruel optimism to persist in parts of the population, such as previously secure or aspirational classes who fail to recalibrate optimism downwards to match reality. In contrast, she argues people who are 'born into unwelcoming worlds and unreliable environments' may experience the current state of precarity very differently.[57] Indeed, for the poor and the *sans-papiers* in the west, or Southern Americans during the dictatorship period, precarity is hardly news. One possible interpretation of *Body of the Soul* is that it charts the spread of precarity, taking a phenomenon closely associated with the Southern Cone and generalizing it to show its global reach – more on this shortly.

In contrast to *Immemorial*, *Body of the Soul* is an open-ended series of 'sourced' photographs made over a much longer period of time; the first series was compiled over a thirteen-year period: 1990–2003. Rennó's practice alternates between projects that examine very particular events and archives with clear limits, and ongoing projects that have no clear terminal point. The latter works often highlight the unmanageability of the archival impulse, sometimes with a comic or absurd twist, such as the installation and artist's book, *Bibliotheca* (2003). The imaginary library, conjured in this work, is a kind of anti-archive: a place of forgetfulness where individuals deposit their photographic albums and slides in order to divest themselves of their past. In the preface of the book, the archivist responsible for 'minor histories of humanity' confesses to a crime against the archive: he or she decided to create an archive within the archive.[58] In this secret repository, the librarian has collected together: 'the more stimulating stories, precisely those that starred a reduced, albeit universal, humanity within the enormous mass of minor stories lost in time'.[59] The librarian then compounds this sin by secretly photographing the 'most emblematic, enigmatic and sincere images; namely those that metonymically summed up the archived document as a whole'.[60] When the archive is inadvertently destroyed, '[p]erhaps due to an administrative error', all that is left is the librarian's sample of humanity's minor stories.[61]

Rennó could be this librarian, the guardian of the 'minor histories of humanity', who takes upon herself the difficult task of organizing the flood of photographic images into something meaningful. Allan Sekula calls this difficult undertaking 'taming' photography. The challenge of the vast accumulation of archival images, he says, is to transform the 'circumstantial and idiosyncratic into the typical and emblematic'.[62] Rennó enlarges this more usual understanding of the archive to include the 'enigmatic' and the 'sincere'. The images in *Body of the Soul* are in equal parts emblematic, typical, enigmatic and sincere.

The enigmatic is the keynote when *Body of the Soul* is first encountered. The subject matter that links these images into a series is extremely hard to

FIGURE 5.13 Installation shot *Corpo da Alma* series, *Body of the Soul* series, 2003–2009. Auto adhesive vinyl and engraving on stainless steel. Exhibition view (partial). Centro Cultural São Paulo, São Paulo, 2004. Photo: Edouard Fraipont.

see; the glare of the reflective stainless steel surface is the dominant feature (Figure 5.13).

Closer examination reveals that the images are fragmented, and presented via the Ben-Day dots of newspapers and cheap printing. As the Ben-Day dots indicate, the images are all drawn from photojournalism. These broken up images are engraved onto the stainless steel surface. The images in this series have also been presented by adhering vinyl dots directly onto the wall, and a more recent version of the series, *The State of the World* (2003–2006), uses highly coloured Ben-Day dots and inkjet printing. In 2012, for the Paris Triennale, another version of the series was exhibited: *Corpo da Alma* (2003–2009), some of these images were printed as negatives, further complicating visibility. In what follows, I will concentrate on *Corpo da Alma I* and *Corpo da Alma II* (both 1990–2003), printed on steel, twenty-eight of which are reproduced in Rennó's artist's book *O arquivo universal e outros arquivos*, [*The Universal Archive and Other Archives*].[63]

While these images are relatively legible in reproduction, in the flesh it is only with some difficulty that the subject matter can be discerned: movement is required of the viewer in order to get the right angle to bring the images into focus, or more correctly to resolve the component dots into an image. In this way, fragmentation aids Rennó's desire to obstruct the viewer's gaze. She describes this impediment to visibility as 'disturbing and

potentialising the photographic surface to cheat the gaze of the spectator'.[64] This deliberate obstruction of the gaze is a very curious strategy particularly when the images themselves all show people very pointedly brandishing photographs for others to see. An interesting tension is created between the subject matter of the images – showing photographs – and the mode of presentation that works against showing, or rather does not allow easy consumption of the images. Witnessing is profoundly complicated by this technique; the viewer is at once blocked yet drawn in by the recurring gestures of supplication.

This dissonance between form and content is an effective means to subdue the sensationalization of events characteristic of contemporary mass media imagery. Kathleen Woodward astutely pinpoints the effects of mass media sensationalization on emotional experience: 'In a culture dominated by the media, much of our emotional experience, once understood in terms of a psychology of depth and interiority, has been reduced to intensities and sensations.'[65] In other words, such imagery functions to minimize thought through instant recognition and by plugging into more primitive emotions, perhaps the kind of non-intentional affects that Ruth Leys defines as the 'rapid, phylogenetically old, automatic responses of the organism that have evolved for survival purposes', discussed in Chapter 1.[66] To avoid this type of mindless gut reaction and its corollary habituated blindness, the process of perception is radically slowed down.

Once the repeated pattern is discerned through slow decipherment, attention is turned from the genre of modern photojournalism examined – people holding pictures of people – to the particularity of each image in Rennó's assembled archive. As one might expect of this genre, the photographs are from all around the world. The title of each image includes the original location where the image was taken (Naples, Amman, Moscow, São Paulo, Rio de Janeiro, Istanbul) as well as the name of the photographer and/or the press agency distributing the photograph. Significantly, none of the dates of the original photographs are given.

One of the original photographs is relatively easy to track down; it is labelled *Naples (Photo Robert Capa/Magnum Photos)*. The photograph was shot in Naples in 1943 by the famous American photographer, Robert Capa, and shows women mourners at a funeral for twenty young men who died fighting the Germans prior to the arrival of the allies (Figure 5.14). It is most likely the earliest image in the series: the one temporal clue Rennó gives in her book is the chronological order of the photographs in each part of the series. Capa's photograph is the first image in *Body of the Soul I*. Even with the chronological order, the other photographs are not sufficiently iconic to make identification of the originals so straightforward; most do not include the name of the photographer. Having one relatively early temporal anchorage point, however,

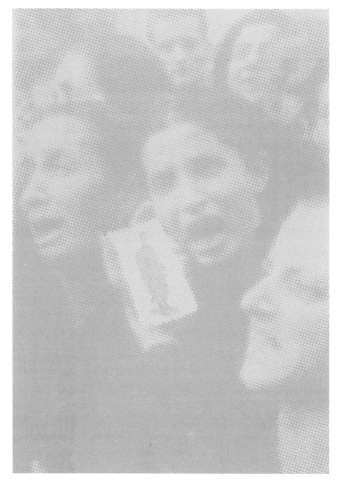

FIGURE 5.14 Rosângela Rennó, *Nápoles* (Photo: Robert Capa/Magnum Photos), from *Corpo da Alma* series, 2003, engraving on stainless steel, 158 × 110 × 3 cm. Private Collection, São Paulo.

functions to set the series outside the immediate time frame of the work's actual production.

Like Rennó's ongoing *Universal Archive* project, her 'permanent work-in-progress', which collects tragic, ironic and humorous newspaper texts about photography, the range of images in *Body of the Soul* is very broad.[67] Some suggest tragedy, such as the Capa photograph where the expressions on the women's faces speak of untimely death and extreme distress, but in others the role of the held photograph is much less clear. For example, the image of Stalin held aloft in Moscow, simply attributed to Reuters, could be a protest, a

procession, maybe even a celebration. Without the date of the image it is impossible to tell whether Stalin is being reviled or revered (Figure 5.15). Possibly the photograph captures grief following his death in 1953; the expression of the woman holding the image of Stalin is amenable to this interpretation. Or perhaps it is a more recent lament. I was surprised that as recently as 1999, Olga Chernysheva filmed a protest against democracy in Russia for her short video *Marmot*, where Stalin's portrait featured as an object of veneration.

The same ambiguity surrounds the image of former Egyptian President Hosni Mubarak whose faintly smiling portrait is held aloft in some kind of

FIGURE 5.15 Rosângela Rennó, *Moscou* (Photo: Agence Reuters), from *Corpo da Alma* series, 2003, engraving on stainless steel, 158 × 110 × 3 cm. Private Collection, São Paulo.

street demonstration in Cairo (the photograph is attributed to Agence France-Presse) (Figure 5.16). As this series concludes well before the Arab Spring, it is hard to pinpoint the occasion that might impel the citizens of Cairo to the streets with what looks like an official portrait. Arms with open palms are raised in the crowd, offering gestures of shared crowd passion that are nonetheless completely inscrutable without a date or an event to interpret their sentiment. Another instantly recognizable figure is Mother Teresa, her photograph wreathed with flowers is one of the few images not held; the hands nearby of another nun from her Order light a candle, but do not touch

FIGURE 5.16 Rosângela Rennó, *Cairo* (Photo: Agence France Presse), from *Corpo da Alma* series, 2003, engraving on stainless steel, 158 × 110 × 3 cm Private Collection, São Paulo.

the photograph (perhaps this is soon after her death in 1997, or a subsequent anniversary of it). Another image processed in public space of a male figure in elaborate military dress was taken in Amman (this time attributed to Reuters). He too is central to some mysterious group passion.

In contrast, most of the images showing domestic settings are less ambiguous in tone; the supplicants look sadly at the camera, or turn away in their grief (Figure 5.17). Their loved ones we assume are missing or dead. Because of the images of grief and public protest, many viewers' first response is to think of the 'disappeared' from the military dictatorship period in Brazil

FIGURE 5.17 Rosângela Rennó, *Rio de Janeiro* (Photo: Jorge William/Agência O Globo), 2003, engraving on stainless steel, 158 × 110 × 3 cm. Itaú Cultural Collection, São Paulo.

(1964–1985).[68] Curator Paulo Herkenhoff is totally unequivocal; he very confidently identifies the series as about the disappeared.[69] The starting date of the series, 1990, certainly creates a strong link to the disappeared for viewers in Brazil; it is when a mass grave of 1,200 bodies was discovered north of São Paulo.[70] Amongst what are believed to be the bodies of indigents, it was reported that there were 'as many as 50' murdered opponents of the military dictatorship.[71] This discovery renewed attention to the unaddressed history of the military dictatorship period.[72] The number of state-sponsored deaths in Brazil is still uncertain; the most comprehensive report, *Brasil: Nunca Mais* [Brazil: Never Again] (1985) produced privately rather than with state support, documented 17,000 cases of torture and 353 deaths.[73] The latter figure would need to be scaled up to over 400 to include the exhumed bodies from São Paulo.

Without doubt, this part of the recent history of South America is an important aspect of this series. Showing the images of the disappeared in public has been a crucial part of political protests, such as the demonstrations of the Mothers of Plaza de Mayo in Buenos Aires, Argentina. The Mothers' collective display of both family photographs and identification shots, worn on their bodies and displayed on placards, has forged a language of public protest. Ana Longoni describes their visual strategies as having 'gained the status of signs that, both inside and outside Argentina, refer unequivocally to the disappeared'.[74] The earliest image in *Corpo da Alma II* is most likely of the Mothers protesting in public: the clue Rennó gives is that her source was the Argentinian national newspaper *Pagina/12*.

In *Body of the Soul*, at least fourteen of the twenty-eight images could be interpreted as about the disappeared, or similar tragic losses. In these instances, the photograph correlates most strongly with the title of the series – body of the soul – the photographed body that is perhaps all that remains of the departed soul. The images seem to slide between tenses, demonstrating both existence and death: this is/was my loved one, smiling, happy and alive. The smiling faces of the disappeared in family portraits do not misdirect, as I indicated earlier sometimes happens with the work of Boltanski. Ana Longoni argues that when family portraits of better times are displayed by the Mothers, such images 'reaffirmed the existence of a biography that predated these subjects' kidnapping'.[75] Nelly Richard views such images as preferable to repressive portraits for signifying the disappeared. She argues the tension between 'the past carelessness of the face' unaware of future danger, and the present where we know they have died, 'generates the desperate *punctum* that makes these photographs from the album of the disappeared so moving'.[76] The framing device of another body makes this tension possible and very palpable. Without that framing, or some other aesthetic strategy of deflection, the carelessness of the face is likely to remain just that.

While the visual language of the disappeared is clearly part of *Body of the Soul*, it is certainly not safe to assume that all of the images of sorrow are part of the disappeared genre. First there is the Robert Capa image, with which I began, taken in Italy and, returning to a clear image of grief, *Rio de Janeiro* (Figure 5.17), the original image is by a contemporary photojournalist working for the Brazilian media giant O Globo. Given this may be a very recent image, it is highly unlikely that the boxer, whose photograph is held by a well-groomed woman, is a fatality from the dictatorship period. To complicate matters further, the smiling faces in *Body of the Soul* are not limited to the photographs being held. There are images where the holders of the photographs smile at the camera, making it difficult to imagine the circumstances in which such an image would be published in a newspaper (Figure 5.18).

FIGURE 5.18 Rosângela Rennó, *Rio de Janeiro* (Photo: Hipólito Pereira, Agência O Globo), 2003, engraving on stainless steel, 158 × 110 × 3 cm.

Such images unsettle the assumption that these are all images of tragedy, grief or public protest. The meaning of this genre of photographs becomes progressively more difficult to grasp as the variations on a theme mount up. Some sincere, typical and emblematic meanings of the genre emerge, such as: creating a tension between the past of the held portrait and the present of the person holding it; the held photograph as all that remains in tragic or uncertain circumstances; and the photograph as a substitute body that can receive or coalesce collective anger, dissent, grief, adulation and feelings of triumph.

But overall, there is an interesting perversity at work in this collection of photographs of people holding photographs of people. At the level of content and meaning, Rennó frustrates any easy reading of the work as solely about South America or solely about victims of violence, thereby undermining the typical art world expectations of South American art. To add to this frustration of expectations, there is the compounding issue of poor visibility, which leads to understandable mistakes about what the work is about. Critics, even experienced ones, reach for the stock responses of pity, sorrow or outrage that would be apt for art dealing exclusively with the disappeared. Yet, despite the complication of the issue, the disappeared are clearly part of this complex mix of images. What is the effect of the double gesture of contextualizing such images in a global framework, while also deliberately decontextualizing them?

Certainly, decontextualizing images of the disappeared makes the viewer look, rather than turn away from the sight of grief, loss and pain. Interest, curiosity, and pleasure in the unexpected are all generated by the unusual way in which the images are assembled and contextualized. The traumatic and shameful recent histories of South America are thereby presented in a completely unsentimental way that speaks more to the head rather than the heart. Which is not to say that compassion would be entirely out of place, but because it has no clear and consistent object of concern, it becomes diffuse, more like an atmosphere of current precarity and anxiety, rather than attached to any individual. Loss is also a generalized phenomenon in this work, suffered in many circumstances, the details of which we can only guess. These private and collective 'minor stories' of sorrow are set alongside what appear to be major historical events when people take to the streets to vent their passions, thereby linking the small and big picture in a suggestive, yet enigmatic way. What links all of the pictures together is perhaps only the attachment to pictures; such attachment speaks of the strange power photographs exert in the world, delivering temporary catharsis, if not permanent relief from 'crisis ordinariness'.

Rennó's method of decontextualization operates very differently in each of the two works analysed here. In *Immemorial* it makes the viewer piece

together the story; in *Body of the Soul* it invites 'the spectator to "look for" instead of to "look at" photographs', as Rennó puts it.[77] These partial and fragmentary representations of the past are her carefully constructed 'ruins to bear witness to the present'.[78] Like the empty images of Holocaust sites by Dirk Reinartz and Mikael Levin (examined in Chapter 2), her work is inadequate for the purposes of commemoration – which is clearly how she frames *Immemorial* and implicit in her deployment and deliberate subversion of the visual language of the disappeared in *Body of the Soul*.[79] But there is an important difference; commemoration suggests an issue already fully or partially understood that could be recalled. Rennó must work with a different context, one of profound forgetting where the rush into the future seems to preclude looking back.

Ulrich Baer assumes that the images of Reinhart and Levin despite their inadequacy nonetheless trigger the desire to know. Such images, Baer argues, 'position us as secondary witnesses who are as much spectators as seekers of knowledge'.[80] Seeking knowledge is even more strongly evoked by Rennó's photography. Living in Brazil, she must work against the tide of amnesia that seeks to sweep away 'bad and inglorious memories'. Her task in this context is to underscore the interlinking of pictorial and political oblivion, making viewers confront coldness and erasure, as much as the events erased. In this context of state-sanctioned forgetting, coldness and looking away have been entrenched. Rennó's 'subtle and small aesthetic actions' coax these difficult and disturbing issues back into visibility.[81]

6

Our Dark Side

Milagros de la Torre's *The Lost Steps*

The work is emblematic of our times, where there is an increasing militarisation, an overwhelming mechanics of violence and a climate of insecurity. These are terms I can relate to because of my upbringing in Peru; unfortunately they have global relevance today.[1]

MILAGROS DE LA TORRE

If we are living in a 'general global state of war' as many theorists claim, or in 'a climate of insecurity' as Peruvian artist Milagros de la Torre more modestly puts it, then the investigation of violence past and present assumes a renewed relevance.[2] No doubt in response to this situation, war has become a prevalent theme for recent exhibitions of photography, for example: *Memory of Fire: Images of War and The War of Images* (2008) curated by Julian Stallabrass for the Brighton Photo Biennial; *Stigmates* (2009) curated by Nathalie Herschdorfer for the Red Cross and Red Crescent Museum in Geneva (and subsequently published as a book *Afterwards: Contemporary Photographers Confronting the Past*, 2011); the large American touring show, *War/Photography: Images of Armed Conflict and its Aftermath* (2012) curated by Anne Wilkes Tucker, and *Conflict, Time, Photography* (2014) curated by Simon Baker for Tate Modern. The stress on time, memory and in particular the aftermath of war is striking. The 'decisive moments' of combat and victory captured by well known photographs like Louis R. Lowery's *First Flag Raising on Mt. Suribachi* (1945) or Robert Capa's *Death of a Loyalist Militiaman, Córdoba Spain* (1936), sit alongside temporally indeterminate images such as Simon Norfolk's tranquil landscapes of previous battlefields,

Raphaël Dallaporta's series of deadpan close-ups of anti-personnel bombs, as well as more traditional humanistic portraits of returned servicemen and women.

In the preface to *Afterwards* a contrast between images taken in the heat of the moment and more reflective images of aftermath is posed. The latter images, it is argued, take a longer view, examining the human effects of war: refugees, survivors, scarred landscapes and recovered ones.[3] Curator Nathalie Herschdorfer asks the salient question about the memorial function of such images: 'is it possible to communicate events that took place before a picture was taken?'[4] While her answer predictably enough is in the affirmative, many of the images she includes in *Afterwards* do not communicate what happened before. For example, there is little sense of the prior significance of the sites depicted in Christian Schwager's photographs of autumnal Bosnian forests, Christoph Schütz's Sugimoto-esque images of the Gaza Strip, Peter Hebeisen's panoramas of former European battle sites, or Léa Eouzan's shots of the carpark at Auschwitz. These fairly traditional landscape photographs demonstrably fail to evoke the kinds of associations and feelings that Herschendorf attributes to them: there is no sense of 'suffering, disorder, grief and injury' in these mundane images of former sites of conflict.[5]

When there is no visual evidence of violence, warfare or catastrophe, aftermath images rely solely on titles to signal historical significance.[6] Unlike Herschdorfer, Ulrich Baer recognizes the problem of pictorial emptiness that is central to this burgeoning genre of images. As we saw in Chapter 2, for him the lack of evidence becomes evidence itself. But is this lack of evidence really sufficient to make us 'aware of our position as observers of experiences no one ever wanted to know about' as he claims?[7] Surely, the spectator cannot in any sense be an 'observer of experiences'. The term 'experience' connotes a direct relationship to events. When historical events are not even depicted, only implied through a title, is 'experience' an appropriate or adequate term?

To give the viewer a visual experience that conjures past violence and enables the duration of witnessing, there needs to be careful consideration given to what Michael Fried calls the problem of beholding, which entails close attention to how the image hails, addresses or blocks the viewer and the allied psychological issues of identification and non-identification or, to use Ruth Leys' terms from Chapter 1, mimetic and antimimetic responses. Beholding is the central focus of Fried's recent book on photography, which transfers his ongoing concern with absorption and theatricality in painting into the realm of photography. What distinguishes current art photography made for the wall from past photography that could be shown in a book is not so much the scale of photographs from the 1970s onwards as Fried argues, but rather the constant grappling with what he calls photography's 'modes of address'.[8] To

suggest violence without showing it requires engagement with modes of address and the psychology of viewing. Milagros de la Torre's relatively small-scale photographs achieve this effect as surely as museum-scale works.

Her images are not depictions of the acts of aggression or violence, heroic or otherwise, that Jean Franco associates with male pack behaviour, what she calls the ethos of the 'band of brothers'.[9] Franco uses this expression 'band of brothers', made popular by the World War II mini-series of that name, to describe the peculiar male collusion that facilitated systemic violence in South America during the period of the military dictatorships.[10] What this transfer of nomenclature makes explicit is the way in which male bonding, relied upon during times of war, can just as easily support torture, lawlessness and state terrorism. Milagros de la Torre expands this way of thinking about violence showing how civilian crime, as much as war, demonstrates 'the dark side of human nature'.[11] In this phrase we are enjoined to share in the psychology that enacts violence rather than seeing it as something perpetrated only by others.

This chapter is about understanding our dark side in these terms. Specifically, I examine de la Torre's oblique representations of violence in the series of fifteen photographs: *Los pasos perdidos* [*The Lost Steps*] (1996). This series shows objects drawn from the archives of the Peruvian criminal justice system, encompassing incriminating evidence from the civil war in Peru, crimes of passion, cocaine production, as well as objects used for forced entry, victims' clothing and perpetrators' weapons.

The testimony of objects: war and crime in a time of fear

Literally, the object is a witness to an act . . . what is more, it carries us toward the drama that divided the life of an individual into a before and an after.[12]

MILAGROS DE LA TORRE

Milagros de la Torre's work has consistently addressed violence in an indirect, allusive and non-sensational manner by focusing on objects, rather than victims, perpetrators or scenes of destruction. Some objects at first sight seem far removed from violence such as her series *Antibalas* [*Bulletproof*] (2008), which shows an array of men's and women's garments: a T-shirt, blazers, jackets, through to the classic linen shirt of the Caribbean, the *guayabera* (Figure 6.1). Only the clothing labels, clearly visible on some of the necklines, indicate the strength of the bulletproof protection offered: gold and platinum. Scaled to the size of the body and set in a generous off-white field, the garments are hung singly on the wall as if offered to the viewer to acquire or try on. In

FIGURE 6.1 Milagros de la Torre, 'Guayabera', from *Antibalas* [*Bulletproof* series], 2008, archival pigment print on cotton paper, mounted on aluminium, 100 × 100 cm. Mexico.

contrast, *Blindados* [*Armored*] (2000) shows a range of armoured vehicles drastically diminished in scale, whose potency is further muffled by the tight cropping of the photographic image and the wide mat that surrounds and insulates it (Figure 6.2).

These contemporary objects that anticipate and seek to mitigate the effects of assault or attack contrast with *The Lost Steps* Series where the objects are part of an archive of past violence. The archive, called *Archivo de los cuerpos del delito* (from the Latin *corpus delicti* – body or evidence of crime), is located at the Palacio de Justicia de Lima, the Courthouse in Lima, Peru. The evocative title of the series, *Los pasos perdidos*, is drawn from the name given to the long corridor of the Courthouse that connects the front of

FIGURE 6.2 Milagros de la Torre, *Untitled*, from *Blindados* [*Armored* series], 2000, gelatin silver print, 40 × 50 cm. Mexico.

the building to the back where those on trial are held. It calls up both the condition of the prisoner (a lost soul), an irreparable moment, as well as going astray, perhaps following the wayward path to perdition.

The photographs in *The Lost Steps* are also scaled to the body, in this case it is the size of the print itself: each image is 40 × 40 cm, roughly the width of a body. They are large enough to fill the field of vision and yet small enough to draw the viewer close. The objects of varying sizes – bullets, knives, a flag, a letter, a satin skirt, a man's shirt, a crowbar and a gun, amongst other things – are reproduced at roughly the same size, giving a sense of equivalence despite the very variable qualities of the objects themselves (Figures 6.3, 6.4 and 6.5). This equivalency is an important feature of the series creating a visual unity that grounds de la Torre's reparative approach (more on this shortly).

The objects are shown in minute detail, their textures and substances exquisitely rendered by rich and dense black and white photographs made with a large format camera. Careful examination reveals small signs of damage and care: cigarette burns dotting the skirt, and a hand-knitted tag for attaching the flag. For things as concrete and particular as archived items of judicial evidence, they appear oddly spectral yet very three-dimensional, almost hyper-real. The spectral appearance is partly the result of their uncertain

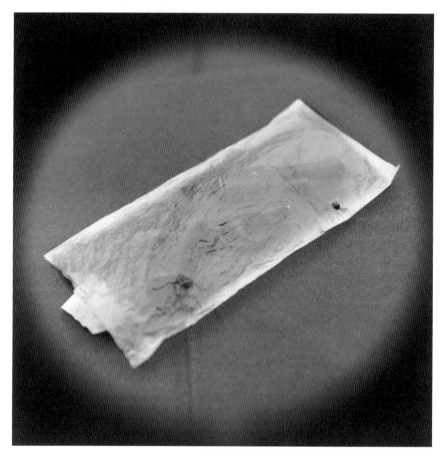

FIGURE 6.3 Milagros de la Torre, 'Handgun, incriminating evidence of murder', from *Los pasos perdidos* [*The Lost Steps* series], 1996, toned silver gelatin print, 40 × 40 cm. Lima, Peru.

location – they float radically decontextualized in a circle of light – and partly the way in which these pieces of evidence seem to glow as if emanating light rather than being illuminated by it, emerging from the inky darkness they have apparently pushed back.

Most of the objects, particularly the white ones, loom into the viewer's space, despite being viewed from above. The strange feeling of torsion or contradictory movements – forwards, downwards – results from the decoupling of the artist's viewing position above the objects and ours facing them. The frequent diagonals further disorient, for example, the skirt worn by Marita Alpaca, viewed from an oblique angle, seems to be sliding into oblivion at the lower end (Figure 6.6). All of the other objects are shown in their entirety, pictured within the confines of the central grey circle.

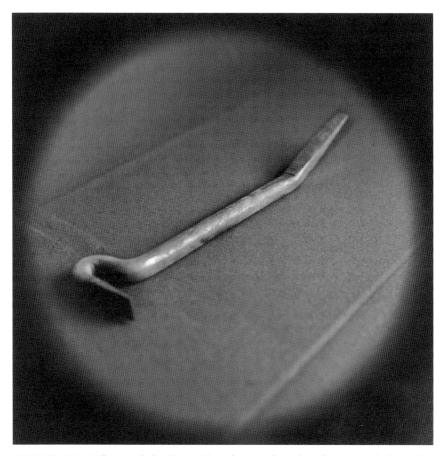

FIGURE 6.4 Milagros de la Torre, 'Crowbar, tool used to force entry', from *Los pasos perdidos* [*The Lost Steps* series], 1996, toned silver gelatin print, 40 × 40 cm. Lima, Peru.

The circles of illumination suggest a number of types of beholding: viewing through a telescope that has brought the far very near, the scrutiny of the spotlight, or a view through some secret aperture: a portal or keyhole. Although none of the above, except for the spotlight, can account for viewing both darkness and light together. Our viewpoint curiously includes both a view through to the object and a framing of that view. The effect produces a very intimate viewing experience, almost clandestine, the eye is funnelled into the centre of the image while binocular vision stands back and registers that inward pull. A kind of immersive vision is nested within a more modernist revelation of the image's own constructedness. The circular form at the centre of each image was produced using a nineteenth-century technique where the lens does not completely cover the negative. The technique places the images

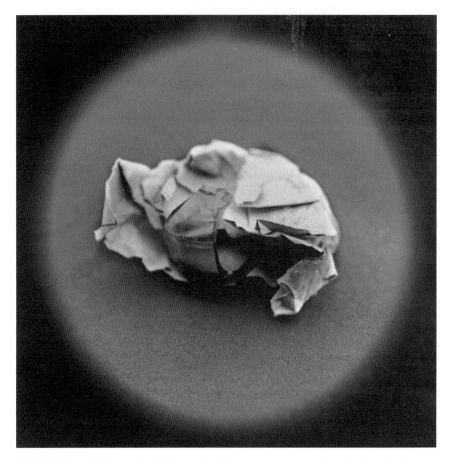

FIGURE 6.5 Milagros de la Torre, 'Rudimentary weapon from broken bottle and paper', from *Los pasos perdidos* [*The Lost Steps* series], 1996, toned silver gelatin print, 40 × 40 cm. Lima, Peru.

in the past where the limits of the photographic world were often visible in the image itself, while also underscoring the otherworldly quality of this ghostly archive.

The depiction of objects calls up the still life genre but the singular focus on one isolated object is more suggestive of portraiture and indeed de la Torre sees each object as a conduit to a particular person, evidence not so much of a crime (although that is implied), but a fateful moment dividing a life, as she puts it, 'into a before and an after'. Only three photographs, however, are linked to specific individuals. The skirt is identified in the title as 'The skirt worn by Marita Alpaca when she was thrown by her lover from the 8th floor of the Sheraton Hotel in Lima. She was found to be pregnant at the autopsy.' Alpaca's murder in 1990 by José Leandro Reaño Cabrejos, her wealthy banker boyfriend,

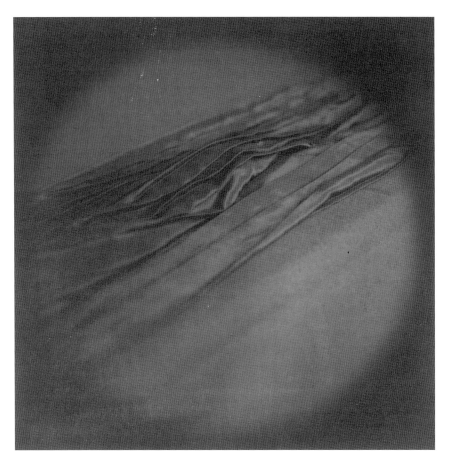

FIGURE 6.6 Milagros de la Torre, 'Skirt worn by Marita Alpaca when she was thrown by her lover from the 8th floor of the Sheraton Hotel in Lima. She was found to be pregnant at the autopsy', from *Los pasos perdidos* [*The Lost Steps* series], 1996, toned silver gelatin print, 40 × 40 cm. Lima, Peru.

was a tabloid scandal with claims and counter-claims about her being pregnant at the time of her death, and even queries about whether her uterus had been stolen postmortem. Infamously, one tabloid headline ran 'Where is the uterus of Marita?'[13] After Reaño Cabrejos attempted to elude justice, he was finally sentenced in 1995. Marita Alpaca's story returned to the spotlight after his release, when he supposedly spread rumours of his own death to avoid paying her mother damages awarded by a civil action.[14]

The second photograph of two intertwined belts is titled: 'Belts used by psychologist Mario Poggi to strangle a rapist during police interrogation' (Figure 6.7). The sober description contrasts markedly with the sensational nature of the crime. Poggi was jailed in 1986 for killing a suspected serial killer

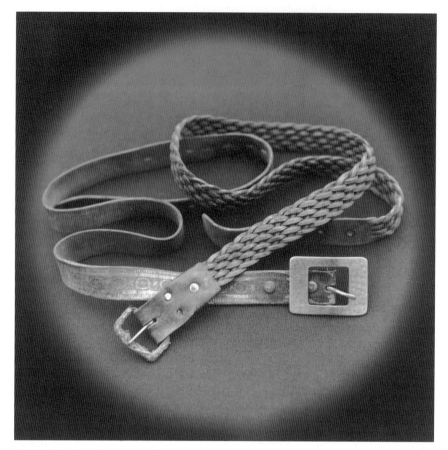

FIGURE 6.7 Milagros de la Torre, 'Belts used by psychologist Mario Poggi to strangle a rapist during police interrogation', from *Los pasos perdidos* [*The Lost Steps* series], 1996, toned silver gelatin print, 40 × 40 cm. Lima, Peru.

dubbed the Ripper, who raped and dismembered his victims.[15] Poggi also returned to the news, first in 2001 when he starred in a low budget film of his own life (originally to be titled *Poggi: Angel or Demon*) and again in 2006 when he ran for president of Peru.[16]

The final image is captioned: 'Police identification mask of criminal known as "Loco Perochena"' (Figure 6.8). Loco or 'Crazy' Perochena is a folkloric figure in the mould of Robin Hood who stole from the rich, and by his own account at least, gave to the poor. Arrested in 1982, he too returned to the news when upon his release after twenty-seven years in prison, he resumed a life of crime after supposedly becoming an evangelical preacher.[17]

These frankly fantastical stories, no doubt embellished to further thrill and excite, contrast sharply with the gravity and sobriety of the photographs of the

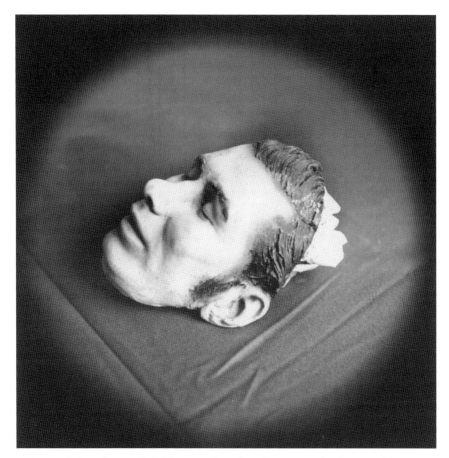

FIGURE 6.8 Milagros de la Torre, 'Police identification mask of criminal known as "Loco Perochena"', from *Los pasos perdidos* [*The Lost Steps* series], 1996, toned silver gelatin print, 40 × 40 cm. Lima, Peru.

three objects associated with these crimes. For example, the skirt showing cigarette burns around the pubic area makes one wonder if more extended abuse is indicated. Set alongside twelve other photographs of objects without such clear links to particular individuals, our salacious interest in notorious crime is deprived of further inflammatory air.

One other object, however, points to a very particular crime: 'Shirt of journalist murdered in the Uchuraccay Massacre, Ayacucho' (Figure 6.9). It is part of a group of three objects that references the civil war in Peru, instigated in May 1980 by the Maoist insurgents known as *Sendero Luminoso* [Shining Path]. In that year the Senderistas launched what is usually described as a terrorist campaign, but which they called *Inicio de la Lucha Armada* – the beginning of armed struggle.[18] The other two objects linked to the

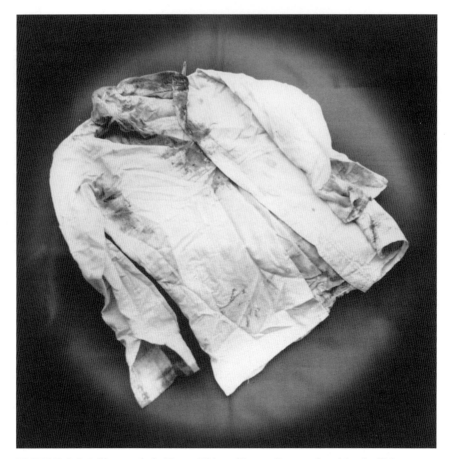

FIGURE 6.9 Milagros de la Torre, 'Shirt of journalist murdered in the Uchuraccay Massacre, Ayacucho', from *Los pasos perdidos* [*The Lost Steps* series], 1996, toned silver gelatin print, 40 × 40 cm. Lima, Peru.

Senderistas are labelled: 'Fake police ID used by terrorist' (Figure 6.10), 'Flag confiscated from Shining Path terrorist' (Figure 6.11). These three images place the series in an intriguing relation to both war photography and atrocity photography. Rather than posing war, terrorism, and atrocity as special cases of violence, they are presented alongside other instances of crime both notorious and anonymous. The archive in Lima where the objects are stored similarly makes little distinction between these objects, which are not rigorously catalogued or organized. De la Torre reports that what is known of the objects rests largely with the memory of the archivist who has worked at the courthouse for thirty years.[19] She was alerted to the existence of the archive by a small display of some of the objects in an exhibition at the Courthouse.

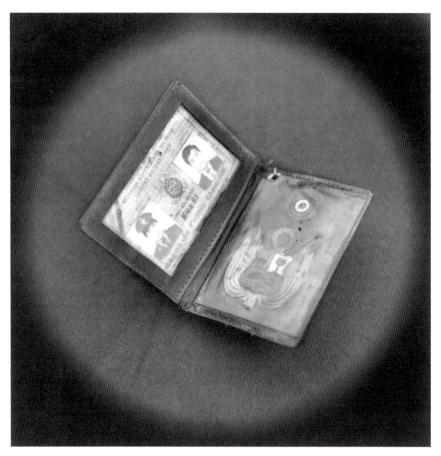

FIGURE 6.10 Milagros de la Torre, 'Fake police ID used by terrorist', from *Los pasos perdidos* [*The Lost Steps* series], 1996, toned silver gelatin print, 40 × 40 cm. Lima, Peru.

From this repository, she selected fifteen objects to photograph that capture a period of national turmoil and bloodshed just then passing into history. By 1996, when the photographs were taken, Abimael Guzmán, the leader of Shining Path, was in prison; his capture in September 1992 led to speculation about a post-war era, although further violence continued until 2000 and still erupts periodically in the present.[20] The worst of the violence, the period Peruvian historian Nelson Manrique called *manchay tiempo* [time of fear], occurred from 1983 to the end of that decade;[21] although in Lima in April 1992, after almost daily terrorist attacks, the president Alberto Fujimori closed Congress and suspended the constitution in a move described as an *auto-golpe* [self-coup], effectively establishing marital law.[22] Finally, by 1995, the war had wound down.[23] In an interview with Edward J. Sullivan, de la Torre

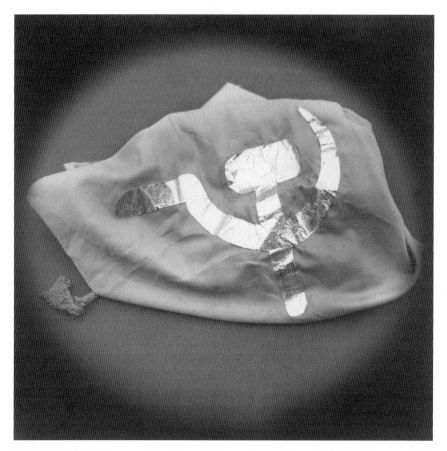

FIGURE 6.11 Milagros de la Torre, 'Flag confiscated from Shining Path terrorist', from *Los pasos perdidos* [*The Lost Steps* series], 1996, toned silver gelatin print, 40 × 40 cm. Lima, Peru.

explains that she wanted to 'cover some of the historical circumstances then, most especially the trials of crimes of passion that were happening at the time and which fascinated everyone because they distracted us from all the daily terrorist reality'.[24]

The terrorist reality unleashed by the Shining Path has been described as provoking 'one of the cruellest wars in the continent's history' and 'one of Latin America's bloodiest since the 1960s'.[25] Close to 70,000 people died; many were Quechua-speaking highlanders from the centre and south of Peru caught in the cross-fire between the Shining Path guerrillas and the government forces, often slaughtered for collusion with one or other of the combatant groups.[26] The 'bloodbath' foretold in 1980 by the Shining Path leader Abimael Guzmán had become a reality.[27]

Yet, this most bloody of Latin American wars is simultaneously described as surprising, exotic, elusive and enigmatic.[28] Steve Stern explains these characterizations as stemming from the unlikelihood of a group of hard-line Maoists emerging in Peru and in particular their obtuse use of imported symbolism in the initial phase of the conflict. For example, the announcement of the war in Lima was accompanied by dead dogs tied to lamp posts and a sign that proclaimed: 'Deng Xioaping, Son of a Bitch'. As he puts it 'as if mention of the architect of counterrevolution in China were a sufficient and relevant political explanation'.[29] Despite the allegiance to Maoism, the name 'Shining Path' had a home grown source, it was drawn from a pronouncement made by the leader of Peru's first Socialist Party, José Carlos Mariátegui: 'Marxism-Leninism will open the shining path to revolution'.[30]

The formation of this group of self-styled revolutionaries was not the result of a popular uprising as was sometimes supposed. Shining Path was founded in 1970, in the city of Ayacucho in the southern sierra of Peru by Abimael Guzmán, who taught philosophy at Ayacucho's National University of San Cristóbal de Huamanga.[31] According to Orin Starn, the core of his followers were students – high school and university students from rural communities.[32] Despite Guzmán's proclamation of a 'people's war' to overturn the old order, and his direct appeal to the revolutionary thought of Marxist-Leninism and Mao Zedong, Starn reports that the class and race divisions of the broader society were also reflected within the structure of Shining Path: 'Dark-skinned kids born in poverty filled the bottom ranks under a leadership composed mostly of light-skinned elites.'[33] Shining Path's class-based Marxism, he observes was 'notable for its lack of appeal to "indigenous" or "Andean" roots',[34] thereby radically departing from the position of Mariátegui who sought to build on Peru's Andean traditions for his form of socialism.[35] Anthropologist Enrique Mayer puts the case for Sendero's detachment from indigenous politics even more strongly; the Senderistas, he says, 'vehemently rejected Andeanism', referring to it as '*nacionalismo mágico quejumbroso* [magical-whining nationalism]'.[36]

Other reasons for surprise about the rise of Shining Path include the fact that prior to the launch of the armed insurrection in 1980, unlike other Latin American countries such as Guatemala or El Salvador, Peru had not endured what Carlos Basombrío Iglesias describes as 'a seemingly unending dictatorship', more significantly, he reports, Peru had not 'experienced grave human rights violations'.[37] Similarly, he notes that state repression never assumed a systematic pattern in Peru, as it did in other Latin American countries like Colombia, Nicaragua, El Salvador and Guatemala.[38] The total disregard for human rights is another striking and surprising feature of Shining Path thought and practice. Guzmán proclaimed: 'human rights contradict the rights of the people. . . . "Human rights" are nothing more than the rights of the bourgeois man'.[39] Again, Basombrío Iglesias underscores the divergence

from other guerrilla movements in Latin American: 'guerrilla movements in Latin America generally sought to have the cause of human rights on their side'.[40] As he explains, 'denunciations of the state as the principal violator of human rights usually have formed an important part of the political discourse of guerrilla movements'.[41] Which is not to say that the state was innocent of human rights abuses in Peru; during the 'dirty war' phase of counter-insurgency from 1983 to 1984, as Stern reports, government forces were guilty of 'indiscriminate repression'.[42]

The photographed shirt in de la Torre's series dates from this 'dirty war' period of counter insurgency. The shirt belonged to one of the eight journalists massacred with sticks, stones and axes in January 1983 by the *comuneros* (villagers) in the indigenous village of Uchuraccay, a remote Andean community in Ayacucho province, partly controlled by the Senderistas.[43] The journalists from Lima and Ayacucho (three of whom spoke Quechua) were on their way to the village of Huaychao to investigate claims that villagers had killed seven Senderistas, a practice encouraged by the counter-insurgency authorities.

Much has been written about this incident, most notably by the Nobel prize-winning Peruvian novelist Mario Vargas Llosa, who was appointed head of the commission sent by the president to investigate the massacre. The villagers had already confessed to the crime three days after it occurred when a patrol was sent to check on the whereabouts of the journalists. The villagers claimed that they thought the journalists were members of the Shining Path. The case generated an enormous amount of media attention and speculation due in large part to the fact that the victims were members of the fourth estate themselves, as well as other factors such as: the grisly nature of the deaths, the mutilated bodies, the apparently ritualistic burials, the missing body of the guide Juan Argumedo and discovered photographic records of the initial encounter between the journalists and the comuneros that contradicted the latter's unwavering, and to some, overly uniform testimony.[44] According to Vargas Llosa, the Uchuraccayans refused to give details of the murder to the Commission, but a camera belonging to one of the journalists, Willy Retto, was discovered hidden in a cave with footage of the initial confrontation, indicating that the journalists had most likely spoken to the comuneros and were not carrying a Senderista flag as had been claimed.[45]

Predictably perhaps, there was speculation about a cover-up and both Senderistas and the *sinchis* (security forces) were also blamed for the crime. Jean Franco reports that in the findings of the Peruvian *Comisión de la Verdad y Reconciliación* [Truth and Reconciliation Commission] of 2003, it finally became clear that the community had repeatedly asked authorities for protection from the Senderistas, and that these appeals had been ignored.[46] Franco also criticizes the way in which Vargos Llosa handled the case and, in particular, the alacrity with which he embraced the idea of 'primitive' violent

Andeans. At one point in his magazine article of 1983 for the *New York Times*, strangely for someone living in Peru at this time, he states: 'The violence stuns us because it is an anomaly in our ordinary lives. For the Iquichanos, that violence is the atmosphere they live in from the time they are born until the time they die.'[47] Franco wonders how he can be surprised by the violence of the murders committed by the Iquichanos 'when modern life offers daily examples from the shooting of illegal immigrants crossing borders to torture and the bombardment of the innocent'.[48]

Vargos Llosa's article consistently presents a vision of the Andean community as a veritable heart of darkness of 'isolation and primitiveness', where 'old beliefs' prevail and 'strangers take on a phantasmagoric quality, as if they were the projection of unconscious terrors'.[49] In the Andes, he says, the 'Devil merges with the image of the stranger'.[50] Franco quite rightly refuses to see this crime as indicative of a different sensibility: 'an ancient, archaic Peru', as Vargos Llosa puts it.[51] The Truth and Reconciliation Commission came to a similar conclusion pointing to the 'clear and present danger brought about by the Shining Path's tactics and the army's advice that outsiders should not be tolerated'.[52] As Franco indicates, there was nothing 'magico-religious', 'absurd' or 'atavistic' about the reaction of the villagers.[53] Caught in a war zone, where allegiances are uncertain we are all capable of projecting our unconscious terrors onto strangers. If it is atavistic to kill under such circumstances, then it is an atavism we all share. It is this same sentiment of inclusion that animates de la Torre's series; it underpins her desire to show this shameful period of Peruvian history as indicative not of dark powers, but of our dark side.

Dark enlightenment: perversion, shame, shock

The blood of the people has a rich perfume, and smells like jasmine, violets, and daisies.[54]

AYACUCHO BALLAD, UNOFFICIAL ANTHEM OF SHINING PATH

Oh!
what a frightening thirst
for vengeance
devours me.[55]

OSMÁN MOROTE, *Shining Path's second-in-command*

'Our dark side' is also a phrase used by French historian of psychoanalysis, Elisabeth Roudinesco; it is the title of her recent history of perversion in the West. Just as Ruth Leys charts the disappearance of survivor guilt as a

diagnostic category in contemporary psychiatric manuals, so too Roudinesco points to the disappearance of the term perversion and the consequent loss of capacity to explain the worst excesses of violence in our histories, such as the conflict discussed in the last section – South America's bloodiest war. While her phrasing 'our dark side' stresses the continuity of normal and pathological psychology, she also seeks to underscore the specificity of perverse acts and behaviour. For her, the key aspect of perversion is the transgression of norms; such deviance, she states, includes 'all the transgressive acts, good and bad that humanity is capable of'.[56] For her, the allure of perversion is that it encompasses both good and evil. She explains:

> Perversion fascinates us precisely because it can sometimes be sublime, and sometimes abject. . . . No matter whether the perverse are sublime because they turn to art, creation or mysticism, or abject because they surrender to their murderous impulses, they are part of us and part of our humanity because they exhibit something we always conceal: our own negativity and our dark side.[57]

Here, Roudinesco brings perversion into close dialogue with sublimation. The destructive instincts she reminds us, not the sexual instincts, are what are channelled by sublimation.[58] Violence and mayhem may occur, she implies, when there is no recourse to this defence against the socially unacceptable wishes and desires of instinctual life.

Joel Whitebook, in his study of perversion and utopia, also picks up on the Janus-faced nature of perversion, but frames it very differently: perversion can be oriented towards either utopianism or destruction. In the first instance, he locates this insight in Freud's thinking by bringing together Freud's early account of perversion with his more sociologically oriented essays such as *Civilisation and its Discontents*. From the latter essay he draws out the fact that Freud sees rebellion – that is, the 'urge to transgress the fundamental strictures of civilization' – whether utopian or destructive, as underpinned by what Freud calls 'the remains of the original personality', in other words, Whitebook argues, the perverse impulses.[59] Revolt, for Freud, is just as likely to develop civilization by opposing injustice, as to turn 'against civilization as such'.[60] In the twentieth century, such turns against civilization are represented by the crises of western modernity that Whitebook lists: 'fascism, Stalinism, total war, the Holocaust and the bomb (and later the ecological crisis)'.[61] In the more recent theory of both Herbert Marcuse and Janine Chasseguet-Smirgel, Whitebook identifies the persistent alignment of perversion with utopian rebellion as a response to these crises. He calls this alignment the 'idealization of transgression', 'the perverse-utopian wish' and 'the perverse-utopian impulse'.[62] Clearly, this impulse, and the idealization of transgression

it implies, underpins the revolutionary thinking of groups such as the Senderistas.

Most importantly, Whitebook emphasizes the importance of the disavowal of reality for Freud's later account of the perverse position, pointing out that for Freud the defence mechanism of disavowal ultimately emerges as the centre of the perversions.[63] This disavowal of things as they are also has a dual orientation: it can propel a utopian revolution and account for unspeakable destruction. Roudinesco gives a particularly vivid example of the operation of disavowal on the part of the infamous Nazi, Adolf Eichmann. According to the commandant of Auschwitz, Rudolf Hess, Eichmann wanted to check on the operation of the gas chambers to assure himself that suffering was not part of death by gassing and, despite evidence to the contrary (according to testimony of the *Sonderkommando*, bodies and faces were covered with bruises), concluded the bodies 'showed no signs of convulsion'.[64]

Eichmann must have seen but did not see what had happened to the bodies: an avowal and a disavowal of reality are held in tension. The desire to remodel reality according to inner demands is facilitated by this contradictory formulation. In other words, Eichmann's denial enables him to rewrite and reshape reality to fit his image of himself, presumably as a humane man who did not wish to inflict unnecessary suffering. The ludicrousness of this formulation, on the part of one of the principal architects of the Holocaust, shows the extraordinary revisionary power of disavowal. Such fragile compromises between inner and outer reality are ill adapted to civil society; they are part of what Chasseguet-Smirgel calls our 'perverse core' that she argues is more readily unbound or unleashed during periods of social and political upheaval.[65] At such times, Whitebook argues, 'institutions can no longer integrate it [the perverse core] into social life'.[66]

De la Torre's *The Lost Steps* Series bears witness to this unbinding. Her photographs show a world where even everyday objects like paper and broken glass (Figure 6.5) or parts of a bed (Figure 6.12) can be fashioned into a weapon and a means of assault against things as they are. Perhaps they were manufactured to defend against conditions such as defencelessness, powerlessness and vulnerability. Or, from the point of view of the one attacked, these objects might suggest that violence can come out of nowhere realized by the most ordinary parts of the environment. These are not the uses of things imagined by Martin Heidegger: the ready-to-hand object reached for in an unthinking average everyday way.[67] A perverse attitude to things is at play, where everyday belongings are turned to inventive purposes: items of clothing are used to strangle, silverware becomes part of the production of cocaine (Figure 6.13), a carpentry tool is used for forced entry (Figure 6.4), a love letter rebounds on its writer, transformed into incriminating evidence (Figure 6.14). Sustained exposure to such resourceful and inventive

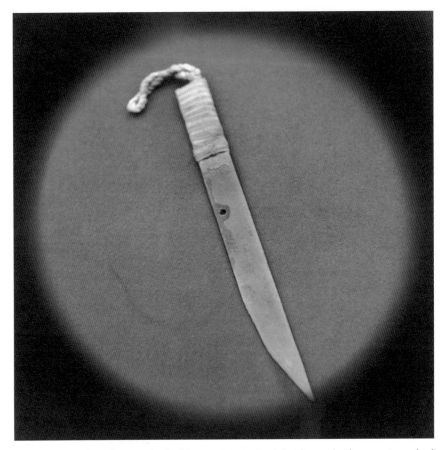

FIGURE 6.12 Milagros de la Torre, 'Improvised knife made from prison bed frame', from *Los pasos perdidos* [*The Lost Steps* series], 1996, toned silver gelatin print, 40 × 40 cm. Lima, Peru.

involvements with things creates an unstable and uncertain lifeworld where innocent objects may quite correctly elicit a startle response and hypervigilance becomes routine.

Alongside this dark vision of the unmaking of the lifeworld, there are also patches of light that are equally startling. In one photograph an erstwhile symbol of violence is disconcertingly touching (Figure 6.11). When you look closely at the confiscated Senderista flag, the crinkled metallic paper that forms the hammer and sickle suggests humble homemade manufacture, a suspicion confirmed by the hand-knitted fastening clearly visible on the left-hand side of the image. The 'extreme masculinity' Jean Franco associates with Latin American violence is strangely undercut by these poignant details of handicraft.[68] Why should these signs of the hand so unsettle the image of

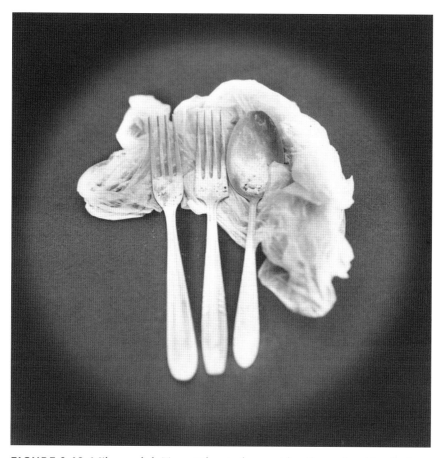

FIGURE 6.13 Milagros de la Torre, 'Chemical test to identify cocaine chlorohydrate produced in a clandestine laboratory', from *Los pasos perdidos* [*The Lost Steps* series], 1996, toned silver gelatin print, 40 × 40 cm. Lima, Peru.

the violent terrorist? Is it the suggestion, to an occidental viewer at least, of domesticity and female craft? That he (if it is indeed a he) is somebody's son, lover, brother; part of the same network of ordinary familial favours and ties that bind us all?

By bringing the viewer up close to the objects, de la Torre's series generates these kinds of questions. Some objects, however, provoke this reaction more strongly than others. For example, the rudimentary weapon of paper and glass raises questions about what crime could have been perpetrated by such poverty of means. Is it a projectile; was it prepared in advance or constructed on the run? Or looking at the belts of Mario Poggi, I cannot help thinking, why are there two belts? This duplication seems to me even more puzzling than

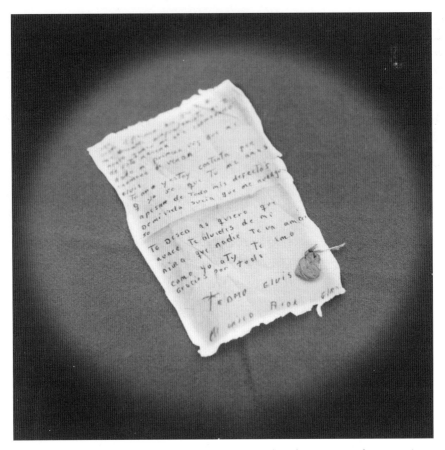

FIGURE 6.14 Milagros de la Torre, 'Incriminating love letter written by a prostitute to her lover', from *Los pasos perdidos* [*The Lost Steps* series], 1996, toned silver gelatin print, 40 × 40 cm. Lima, Peru.

the fact that he committed this crime while the suspected serial killer was in police custody. Although the location of the crime also provokes curiosity: what possessed Poggi to kill in circumstances where he could not possibly hope to get any with it, as the saying goes? But perhaps that question needs to be turned around, why didn't the reality principle of his immediate surroundings check this flamboyant character's murderous or avenging impulses? What did he refuse to see that made this action possible? This same logic of disavowal may help to explain the actions of the Uchuraccayans: seeing a party of approaching strangers and having been warned that strangers could be Senderistas, they did not see but also saw a Senderista flag. Their unflinching insistence on the presence of a flag hints at the operation of this defence.

De la Torre's series encourages these kinds of lateral connections between so-called ordinary crime and acts of war. Both types of transgression issue from our perverse core, whether it is the instinct for rebellion or the disavowal of reality (Freud's two accounts of perversion), or a combination of the two. What de la Torre calls her 'serial structure/sequence' serves this lateral movement well: each image is considered singly and in relation to the others.[69] Significantly, she also links the objects of victims and perpetrators together; in this unusual move de la Torre makes it difficult to adopt a fixed or moralizing position on the period of history on show. This intermixing is further amplified by the allusion to both victim and perpetrator in some of the photographs: some objects of victims point to perpetrators, such as the shirt of the journalist and the skirt of Maria Alpaca. Just as some perpetrator objects point to victims: the prostitute's letter to her lover, Poggi's belts to the suspected rapist, as well as at one further remove, the female victims.

Observing the series as a whole, one is moved from photographs that suggest a world coming undone for individuals and the nation – and indeed moved by them – to cases where neither the criminal nor the act is known, the only surety is that someone was tried in a court of law. This method of inclusion departs from the norms of political art propagating ideology critique. Instead of clear-cut distinctions between good and evil, we see a field of very different yet roughly concurrent events that are difficult to cleave apart in that fashion. In bringing together the silent testimony of these objects, de la Torre constructs a complex picture of life in Peru in the final two decades of the twentieth century. Shelley Rice describes her action in both universal and particular terms, at once 'drawing everyone very close into the circle of the human condition', while also acknowledging the particularity of de la Torre's world-view: 'That condition, in her world, is often violent.'[70] De la Torre's reparative method is evident in this complex balancing act that holds together the universal and the particular, the human and what we often prefer to regard as inhuman.

Bringing together victims and perpetrators for the purposes of commemoration is not without its critics in Peru. In 2007, when it was discovered that the commemorative sculpture in Lima – *El Ojo que Llora* [*The Eye that Cries*] (2005) by Dutch-born artist Lika Mutul – included all the names of the victims of the civil war (soldiers, bystanders and Senderistas), there were demands for the names of the Senderistas to be removed.[71] In turn, in the spirit of reconciliation that same year, many marched in favour of the monument, including the most affected highlanders.[72] While the desire for the removal of Senderistas is understandable, the nomenclature is perfectly correct, as Katherine Hite points out international human rights law 'defines those killed extra-judicially, including convicted criminals, as victims'.[73] Peru's

Truth and Reconciliation Commission, which encouraged the construction of memorials, of course, took the same stance.

For reconciliation to take place the sharing of victimhood must proceed in the same inclusive fashion as the sharing of shame. When the chairman of the Truth and Reconciliation Commission, Salomón Lerner, handed the final report to the president he began his speech by underscoring national shame. He said:

> The History of Peru registers more than one difficult and painful period, of authentic national prostration. But, sure enough, none of them deserves to be so deeply marked with the stamp of shame and dishonor as the period of history we are forced to tell in the pages of the report we give to the Nation today. The two final decades of the XX Century are – it is obligatory to say so plainly – a mark of horror and disgrace for Peruvian society and State.[74]

Lerner's invocation of collective shame did not mean that questions of guilt and responsibility were avoided or assuaged. However, he singled out for blame not the combatants of either side, but rather those who did nothing to stop the crisis. He described 'a double outrage: that of massive murder, disappearance and torture; and that of indolence, incompetence and indifference of those who could have stopped this humanitarian catastrophe but didn't'.[75]

In de la Torre's series, the crimes of Peru's recent history are not coloured by this tone of recrimination. Her photographs simply, and in a politically neutral fashion, bear witness to evidence of the transgression of the law. I should hasten to add that this neutrality does not connote some kind of resigned fatalism about human nature or the human condition. These photographs of objects still disturb and alarm, the spectral life they carry forth into the viewer's space does not speak of something entirely or easily consigned to the past. The objects feel very present, despite the presentation via the double framing: the circle of light, and then the dark surround. The photographs strangely hold in tension the illusion of presence and the exposure of that illusion. A photographic equivalent of disavowal is perhaps at work in this unusual and contradictory viewing experience. The photographs are at once 'theatrical' to use Michael Fried's term – addressing us as fabricated images – and yet immersive, as the objects fully absorb our attention. But perhaps this tension is the key to the operation of the images; the objects can feel very present precisely because they are doubly framed as strictly pictorial. It is far easier to consider violence and atrocity when they are contained, and where the imagination must do part of the work, allowing viewers to speculate about the objects, people and events only as far as is psychically comfortable or possible.

The Lost Steps series is thereby situated between the two poles of conflict and atrocity imagery: the afterimages, with which I began, where there is simply too little to see to generate an engaged, identificatory response; and overly explicit or shocking images where there is often too much to take in, resulting in the impulse to turn away, feelings of being overwhelmed and numbness. In both very different cases, there is nonetheless little or nothing to trigger the work of imagination that leads to prolonged inquiry.

In her book *Regarding the Pain of Others*, Susan Sontag describes turning away as the position of the coward, yet she is also critical of its polar opposite – 'voyeuristic appetites' for such images.[76] Her ambivalence is also evident when she asserts that for photographs 'to accuse, and possibly alter conduct, they must shock', yet she draws attention to the fact that we can become inured to shock.[77] As Michael Fried remarks, Sontag's book is characterized by a 'reluctance to take up a simple or consistent stance toward the difficult questions it continually raises'.[78] Indeed, Sontag moves very quickly across a range of ethical issues and challenges raised by regarding photographs of the pain of others.

I want to conclude by considering more slowly the conjunction of shock and accusation Sontag mentions in passing, as it serves to highlight the power of the middle way of de la Torre's art photography. Sontag's call for images to accuse, of course, matches the typical stance of ideology critique – the paranoid approach analysed by Eve Kosofsky Sedgwick (discussed in Chapter 1), which typically proceeds through exposure and the denunciation of the guilty. Shock, however, is what the paranoid approach seeks to guards against, paranoia functions to minimize surprise, shame and humiliation through hypervigilance.

Images that shock and images that accuse, I would argue, are highly ineffective means for art photographers to generate prolonged interest in complex political events. Shocking images have a peculiar power to imply accusation and draw accusation. In recent times, the most pertinent example of the latter phenomenon is the incredible furore generated by Georges Didi-Huberman's catalogue essay for an exhibition in Paris in 2001 titled *Mémoires des camps: Photographies des camps de concentration et d'extermination nazis (1933–1999)*. For the catalogue, Didi-Huberman analysed four images taken in Auschwitz by an anonymous member of the *Sonderkommando* in August 1944. Images he describes in the essay as 'four pieces of film snatched from hell'.[79] In his book written two years later, *Images in Spite of All: Four Photographs from Auschwitz*, two of the images are captioned: 'Cremation of gassed bodies in the open-air incineration pits in front of gas chamber of crematorium V of Auschwitz, August 1944'; the other two are captioned 'Women being pushed towards the gas chamber at crematorium V of Auschwitz, August 1944', although one image shows only details of trees.[80]

Didi-Huberman was accused of 'voyeurism' and '*jouissance* in horror'; his analysis of these sole surviving images of the death camp in action was described as 'gruesome and encouraging pernicious ways of thinking'.[81] Typical accusations of the inappropriate aestheticization of horror and suffering were also made: one critic wrote 'Auschwitz, a photogenic object? . . . This is deeply shocking.'[82] Didi-Huberman explains what he believed was the source of the controversy:

> It was the exhibition itself, as much as my own analysis – which appeared at the end of the exhibition catalogue – that 'shocked' Elisabeth Pagnoux. Consequently, she concluded that to visit the exhibition amounted to an act not only of inappropriate voyeurism but even of abject sadism: 'Unless one exults in the horror, there is reason enough not to see the exhibition.'[83]

Didi-Huberman defends his interpretation of the images, stating he was simply attempting '*to see* in order to *know better*'.[84] To know something about an image, he later extrapolates, one must spend time working on the image, to '*imagine for oneself*' what it depicts.[85] There is nothing remarkable or out of the ordinary here; the task of the art historian is to try to enter the grain of the image in order to better understand, and to render that work of imagination into language for others to evaluate – to affirm or disagree with the interpretation. So why did Didi-Huberman's analysis of these images lead to outrage and such intemperate accusations of his perversity? Why did his two chief interlocutors '*see red*', as he put it?[86]

Anger is of course a stock response to shock – a word that occurs repeatedly in the criticisms of his analysis. As neither of the two critics could direct their response to the images that they did not want to see, accusations that seem more appropriate to what is pictured are directed at Didi-Huberman. He is blamed for making them see, presumably by rendering the content of the images so well into language. It would appear that when hypervigilance fails and shock occurs, it is countered (rather than warded off) by accusation. The response to this exhibition is by no means an isolated incident; North American images of lynching provoked a similar controversy.[87]

In sum, shock is not a useful strategy for promoting prolonged viewing. For documentary photography it may be unavoidable. But if one aims to provoke seeing in order to better know, more subtle strategies are required. De la Torre's way of approaching conflict and atrocity enables seeing and knowing. Her work thereby joins with Paul Ricoeur's advocacy of 'appeased memory', where 'the evil suffered or committed' is not forgotten but is spoken of, or pictured, without accusation or anger.[88] To integrate the traumatic past into history in this fashion means that the affective load or charge it once carried has been at least partially worked through, allowing the memory to be brought

into signification where it can be seen, known, discussed and thought about. This manner of seeing, presenting and bearing witness to the past, Ricoeur indicates, speaks of forgiveness.[89] De la Torre's reparative method, then, can also be understood in these terms. She can bear to look very closely at our dark side, the evil suffered and committed, because only such scrutiny integrates traumatic experience and makes way for forgiveness.

Conclusion

The distrust of the documentary function of photography has been a thread running through this book. To conclude, I want to more explicitly indicate where I stand on this issue, as well as collecting together a few other themes that have been implicit, but not fully articulated in the preceding text, such as the artists' use of the serial method, and the importance and distinctiveness of art photography addressing shameful histories.

The focus for the first point is a recent article by Vered Maimon that I find immensely provocative, even if I largely disagree with it. I focus on this essay in particular because it exemplifies a typical diagnosis of the state of contemporary political art, namely that it rejects referentiality, documentary or realist protocols in favour of an anti-foundational account of identity and representation. In other words, Maimon's explication of new models of criticality in contemporary art repeats the theoretical emphasis on performativity that I have been intermittently tracking in this book. She aims to show how contemporary art underpinned by a performative approach to identity has surpassed art from the 1970s committed to representing reality – the traditional focus of documentary. Thus, her article is another iteration of the surface/depth model that animates the debate between Eve Kosofsky Sedgwick and Ruth Leys; only here it is laid out sequentially.

Maimon argues that political art no longer aims to 'bring back the "real"' but to follow the challenge identified by Jacques Rancière, namely, to disrupt the system he calls 'the partition of the sensible' that renders only some bodies and some things visible and sayable.[1] In other words, the aim is to make manifest or include what has been disregarded as 'noise', rather than discourse or representation; an aim this book also shares insofar as many of the historical events in this book can be described as things 'no one ever wanted to know about'.[2]

So far, so good, this sounds very similar, if not identical, to the project of identity politics: there is a dominant discourse (here the partition of the sensible), some people are assumed to be part of this discourse (it has claims to universality) yet they fail to appear or speak within it. While I have been critical of the narrow range of identity politics art in this book, I would position myself like Eve Kosofsky Sedgwick as an internal critic, entirely sympathetic to the aims, but not supportive of singular means (the dominance of 'paranoid' approaches).

In response to Maimon's refiguring of that project, for me two questions arise: Is it possible to challenge exclusions from the domain of the visible and the sayable without some claim on the real? On what grounds and according to what criteria could the claim for inclusion be discussed, disputed, argued about? Maimon asserts that there is no such ground. She writes, 'contemporary artists face different challenges, what Rancière calls the "loss of appearance": the elimination of a specific "theatrical" sphere in which subjects can enact incompatible claims with regard to what is perceived as "common"'.[3] In the two-page passage she cites from Rancière's book, *Disagreement: Politics and Philosophy*, there is very little to substantiate this claim that a sphere to enact disputes has been eliminated.[4] Certainly, the disappearance of a place to debate identity claims does not square with my knowledge, albeit limited, of Rancière's idea of politics. To cite just one contrary example, he states that politics occurs 'only when political subjects initiate a quarrel over the perceptible givens of common life'.[5] This does not speak of the end of a sphere for debate; rather it is an argument about the validity of consensus as the basis for politics. Given the importance of disagreement for Rancière, and indeed for Ruth Leys, it is immensely curious that Maimon would make this claim.

This strange wobble in an otherwise very carefully argued paper seems to be the result of a broader commitment to performativity and anti-foundational accounts of identity, which are then overlaid onto Rancière. Maimon wants to argue that the 'loss of the real' associated with the work of Jean Baudrillard has been displaced by the 'loss of appearance' (glossed above as the arena of debate). The loss of appearance is then addressed rather neatly through making an appearance – staging and performativity.[6] Using the work of New York-based Lebanese artist Walid Raad, Maimon argues that he emphasizes the 'performative rather than factual aspects of his archive'.[7] Collapsing the distinction between fact and fiction enables his work to highlight the 'imaginary' (rather than real) 'aspects of collective forms of affiliation that are enacted in appearances'.[8]

Maimon contrasts Raad with conceptual artist, Hans Haacke, whose work she characterizes as seeking to 'bring back "the real" in the form of facts'.[9] She presents institutional critique (for which Haacke's practice stands as a synecdoche in her argument) as a specific response to Baudrillard's hyperbolic claims. Namely, Baudrillard's claim that the eclipse of the real and the suspension of referentiality have resulted in the rise of the simulacrum – the copy without an original.[10] The contrast between Haacke and Raad enables a series of transpositions, displacements and recalibrations to take place here – reality becomes appearances, the factual becomes the performative, collective identity is framed as illusory or at least imaginary. In other words, Raad overcomes the ideology critique of Haacke that followed the 'paranoid'

model of political revelation.[11] Nonetheless, the aim of this new critical art is still entirely consonant with Hal Foster's ideas of advanced art on the left: it seeks to include the 'noise' of the unrepresented, the excluded, the alternative, the subaltern. In this way, Raad can be seen to continue that tradition, refiguring the inclusive project of identity politics in new (or newish) anti-foundational terms.

Is the emphasis on the performative archive and imaginary identity simply the latest ruse of critical art to evade dispute and debate? As we saw in Chapter 1, performative accounts of identity frequently produce this unintended consequence. To adapt and paraphrase Leys' key criticism of affect theory for this new configuration of essentially the same argument, we could say that a concern with disagreements over facts and reality is replaced by a concern with differences in imaginary constructions. And to reiterate the consequence of this move: We may have ideological disputes – conflicts about beliefs, and disagreements about what is true or factual – but what we imagine is generally not subject to public debate. In other words, the dispatch of referentiality, reality, truth and facts seems to function here principally to pre-empt criticism, or to make the grounds of any dispute very unstable or unclear. This is surely not an ideal model for political art, albeit it is a very familiar one.

While I share Maimon's desire to think beyond the paranoid mode, I am not convinced by the wholesale rejection of depth, identity and reality that underpins her analysis, which to my mind simply continues and entrenches in another guise the tradition Paul Ricoeur so aptly characterized as the 'hermeneutics of suspicion'. Commonly associated with the various ways in which the subject is decentred by followers of Marx, Freud and Nietzsche, it lives on in much critical theory and, most particularly, in the avoidance of essentialism, presumed to be assured by invoking performativity. In other words, Maimon's adherence to the typical tenets of postmodern suspicion – a valorization of contingency and constructedness, anti-transcendentalism and anti-foundational accounts of the subject – plunges us further into the hall of mirrors of classical postmodernism.

In this book I have tried to pursue the other arm of Paul Ricoeur's hermeneutic project that Eve Kosofsky Sedgwick identifies as 'the philological and theological "hermeneutics of recovery of meaning"'.[12] In this framework, reality is not placed under erasure, as postmodern critics would have it, rather it is subject to different, often competing, interpretations. The assumption being some kind of minimal theoretical commitment to Kantian transcendentalism is unavoidable; one might as well admit it, and conceive 'the real' in Kantian and/or Lacanian terms as the material substrata of experience we can never fully know or understand. Or, to take a more Derridean view, one might regard the opposition between reality and representation more dynamically; they are ceaselessly

inter-implicated and intertwined terms, whose involvement we ignore at our peril.

The very common view that deconstruction suspends referentiality was explicitly disputed by Derrida in an interview with Richard Kearney many decades ago. He said:

> It is totally false to suggest that deconstruction is the suspension of reference. . . . I never cease to be surprised by critics who see my work as a declaration that there is nothing beyond language, that we are imprisoned in language; it is, in fact saying the exact opposite. . . . Certainly, deconstruction tries to show that the question of reference is much more complex and problematic than traditional theories supposed. . . . But to distance oneself from the habitual structure of reference, to challenge or complicate our common assumptions about it, does not amount to saying that there is *nothing* beyond language.[13]

I stress this point here as so many of the anti-foundational arguments that circulate in art criticism are premised on poststructuralist critiques of ontology, yet they blithely ignore the complexity of those original propositions. If we insert photography into this more complex understanding of the poststructuralist framework, it is both an interpretation of reality and in a dynamic relation with it, shaping and shaped by it but not reducible to its referential function. In other words, the factual or veristic account of photography might be questioned, but the fact of the world is not in dispute.

As I hope I have shown in the preceding chapters, photographers are now as adept at this critique of the factual claims of photography as critics. All of the artists in this book view the documentary truth claims of photography with suspicion. Anne Ferran underscores that the past cannot be simply recovered photographically. She takes a strong stand against the aftermath images that are repeatedly interpreted as evincing that past by simply depicting the scene where it occurred. Similarly, Rosângela Rennó disputes the memorial function of photography, the idea that it preserves a truthful segment of time. Further, she takes a sceptical attitude towards memory, which for her is always both variable and manipulable. In her view, memory has to be manipulated to be tolerable. Manipulating memory to make it visible and tolerable unites the work of these four photographers.

Finally, both Fiona Pardington and Milagros de la Torre see photography as presenting interpretations of reality. As de la Torre puts it: 'We have come to the point where we acknowledge and realize that photography was never a trustworthy document, but rather an interpretation; it never referred to what we were actually observing in it, but it referred to our reaction and our response to its stimuli. An image has to be de-coded.'[14] The intertwining of

viewer and viewed, indicated here, shifts the emphasis from the referentiality of photography to its reception, interpretation and the generation of meaning.

Alongside the suspicion of the factual claims of photography there is nonetheless a fascination with the idea of the document and the possibilities it presents for the interpretation of significant events. These artists thus proceed very much like historians in their sceptical evaluation of evidence. Ferran attends to the meagre material remains of the female factory to consider how a forgotten history can be interpreted and represented. Pardington views historical documents (the likenesses of Oceanic life casts) as open to a different specifically Māori interpretation. Rennó sees lowly archival and media images as able to be both decontextualized and recontextualized in order to make minor histories visible. De la Torre assembles a different image of the civil war period in Peru by considering a diverse range of objects stored in the judicial archives.

To the task of the historian is added the concern of the visual artist: how to visually present the resulting interpretation. Each of the four artists in this book has made use of the grammar of the photographic series. Joel Smith notes the linkage between the artistic use of the series and language, referring to the photographic series as a kind of 'sequential grammatical art' that makes use of 'image-to-image syntax'.[15] Seriality is, of course, a key method used by minimalism and conceptual art, and in particular the conceptual uses of photography – the disinterested typology of Bernd and Hilla Becher is Smith's particular and most prominent example. Yet, in the hands of the artists in this book, the linguistic analogy is as much in evidence as the typological approach. Their interpretations of the past are assembled into something akin to narratives, where the accumulation of different yet related images might be said to illustrate a 'proposition' in the language of conceptual art, but one that is 'additive and accretive', to use Sedgwick's terms for the rich and inclusive principle of the reparative method.[16] In other words, the deadpan tautological approach that characterized conceptual art's serial method is not in evidence.

Alternatively, these articulated images might be better understood using Rancière's idea of 'the sentence-image' that he associates with the parataxis of montage.[17] His term deliberately refuses the subordination of image to word as well as their overly sharp differentiation. Hence for him the expression can equally apply to a passage of writing as to a photograph. A photograph might put into play the contrast 'between the said and the unsaid'.[18]

With the photographic series, the paratactic technique of placing images side by side is experienced in space as well as time, enabling the images to appear simultaneously, while apprehended sequentially. In this way, the filmic possibilities of montage become available to photography: conjunction and disjunction but, more importantly, a slower form of scrutiny unavailable to film – comparison, contrast and cross-referencing. Conjunction, comparison and

cross referencing enable the viewer to construct a story or history, while disjunction accentuates the singularity of each image. Bringing together these opposing actions is the work of viewers as much as the artists.

The emphasis on reception, clearly evident in the complex spectatorial positions each of the four artists configures, is also an important part of the legacy of minimalism and conceptualism. Indeed, in her review of Michael Fried's recent book on photography, Vered Maimon draws attention to his wilful occlusion of the ways in which the history of minimalism and conceptual art underpin the new 'single photographic regime' he associates with tableau photography.[19] Large-scale photographs, for him, only reinscribe the pre-eminence of painting, hence, his belief that 'photography matters as art as never before'.

He holds to this view even though the seed of his ongoing advocacy of the importance of beholding is located in his 1967 analysis of minimalism, 'Art and Objecthood'. As I have argued elsewhere, one of the principal legacies of minimalism is the entanglement of the spectator with the work of art.[20] And it was Fried who first identified one feature of this entanglement, even if he then did not approve of it. He argued that a minimalist work needs the beholder: it 'is *incomplete* without him, it *has* been waiting for him'.[21] The idea that the viewer completes the work of art is taken as a principle of production by many contemporary artists, including the four women photographers in this book. Indeed, I would suggest that close attention to beholding and what Fried calls modes of photographic address, are what distinguishes art photography from photojournalism, linking the former to the broader field of contemporary art.[22]

This kind of complex thinking about subjectivity and reception is rarely evident in the artists' statements of those photojournalists who have jumped the divide to become part of the art world. For example, while Fried cites with approval Luc Delahaye's somewhat incredible claims about his objectivity and his seemingly complete immersion in the world of things, the passage suggests to me a very peculiar, pre-critical position on the capacities of photography and photographer. Delahaye says 'I am cold and detached, sufficiently invisible because sufficiently insignificant, and that is how I arrive at the full presence of things, and a simple and direct relation to the real.'[23] The 'full presence of things' is a very strange throwback to the image of the omnipotent photographer able to completely and perfectly capture the world as it is. Delahaye seems to entirely fill up the role of the witness here, leaving the viewer to trail in his stead, or more likely be edged out by his intense communion with nature that does not admit a further bystander – the closed world appreciated by Fried in the work of Andreas Gursky.[24]

Such a view of photography cuts out the human element and the partiality that comes with recognizing the complex subject positions produced by

conflict and traumatic events: victims, perpetrators, bystanders and beneficiaries. In the work of the four photographers analysed in this book, their self-consciously subjective and partial interpretations of history navigate these positions in subtle and nuanced ways that draw the spectator into the psychological dimension of world events. The shorthand I have been using for apprehending this psychological dimension of art is witnessing: it is the prolonged attention to images that helps us to face significant and shameful events that have been effaced or ignored. For these artists, this mode of spectatorship involves identification and distancing, knowledge and feeling, misdeeds and the awakening of conscience, guilt, shame and reparation.

Their awareness of modes of address and positions of enunciation is crucial for carving out complex spaces for the viewer. In Ferran's case, looking down at the ground powerfully put us in the posture of shame and in the orbit of the mixed emotions and positions of convict woman and overseer. In Pardington's installation the self-absorption of the Oceanic sitters negates the viewer, re-enacting and reversing the power dynamic of the colonizer who possessed the gaze and the all too visible, objectified, colonized other. Rennó's volatile source imagery of the dead, the exploited and the disappeared, is subjected to a marked cooling down through a deliberate distancing of the viewer – victims gaze out at the viewer, surfaces are resistant to easy viewing, darkened or reflective. These techniques slow down the process of perception, transforming stock images and yet still unsettling the beneficiary of structural inequality. De la Torre brings things very close, but contains and frames the evidence of violence as at once pictorial and yet still disturbing. Violence is not foreign or confined to criminals or terrorists; rather it circulates between victims, perpetrators, bystanders and beneficiaries.

Complex modes of address, adept reparative interpretations of history, creative use of the paratactic sentence-image, these are just some of the innovations offered by these artists to the tactics of political art and the genre of the archival turn. If their contributions are now more clearly evident, then the principal goal of my book has been achieved.

Notes

Introduction

1 Léon Wurmser, 'Shame: The Veiled Companion of Narcissism', *The Many Faces of Shame*, ed. Donald L. Nathanson (New York: Guilford Press, 1987) 67–68.

2 Silvan Tomkins, *Affect, Imagery, Consciousness*, Vol. II The Negative Affects (New York: Springer, 1963) 118.

3 Ibid.

4 Eve Kosofsky Sedgwick, 'Shame, Theatricality, and Queer Performativity: Henry James's *The Art of the Novel*', *Touching Feeling: Affect, Pedagogy, Performativity* (Durham, NC: Duke University Press, 2003) 37.

5 Ibid., 64, 44.

6 Proponents of the anti-aesthetic tradition include most of the writers associated with the first generation of the American art journal *October* as well as subsequent generations. See, for example, specific advocates of this position: James Meyer, 'Nomads', *Site-specificity: The Ethnographic Turn*, ed. A. Coles (London: Black Dog, 2000) 10–29; and Alexander Alberro, 'Beauty Knows No Pain', *Art Journal* 63.2 (Summer 2004): 36–43. Michael Kelly provides an overview of the dominance of the anti-aesthetic stance; see *A Hunger for Aesthetics: Enacting the Demands of Art* (New York: Columbia University Press, 2012) xiii–xx, 1–2. See also James Elkins and Harper Montgomery's somewhat optimistically titled anthology, James Elkins and Harper Montgomery, eds, *Beyond the Aesthetic and the Anti-Aesthetic* (University Park: Penn State University Press, 2013).

7 See Arthur Danto, *The Abuse of Beauty: Aesthetics and the Concept of Art* (Chicago: Open Court, 2003); Elaine Scarry, *On Beauty and Being Just* (London: Duckworth, 2006); Jacques Rancière, *Aesthetics and its Discontents*, trans. S. Corcoran (Cambridge: Polity, 2009); Kelly, *A Hunger for Aesthetics*; and Robert Pippin, *After the Beautiful: Hegel and the Philosophy of Pictorial Modernism* (Chicago: Chicago University Press, 2014). See also my *Visualizing Feeling: Affect and the Feminine Avant-garde* (London: I B Tauris, 2011).

8 Julian Stallabrass argues the return to documentary is a feature of the first decade of the twenty-first century. See Stallabrass, 'Introduction/Contentious Relations: Art and Documentary', *Documentary: Documents of Contemporary Art*, ed. Julian Stallabrass (London: Whitechapel and Cambridge, MA: MIT Press, 2013) 12.

9 Hal Foster, 'The Artist as Ethnographer', *The Return of the Real* (Cambridge, MA: MIT Press, 1996) 171–203; Hal Foster, 'An Archival Impulse', *October*

110 (2004): 3–22. In 'The Artist as Ethnographer' he proposed that in the early 1990s, the artist's newly assumed role as ethnographer represented the contemporary position for advanced art on the left.

10 Foster, 'An Archival Impulse', 4.

11 Foster, 'The Artist as Ethnographer', 172.

12 Sedgwick, 'Paranoid Reading and Reparative Reading, or, You're so Paranoid, You Probably Think This Essay Is About You', *Touching Feeling*, 139.

13 See my discussion of the anti-aesthetic tradition in Best, *Visualizing Feeling*, 29–46.

14 Sedgwick, 'Paranoid Reading', 126.

15 See, for example, Heather Love, *Feeling Backward: Loss and the Politics of Queer History* (Cambridge, MA: Harvard University Press, 2007) 23.

16 See for example, Frances Guerin and Roger Hallas, eds, *The Image and the Witness: Trauma, Memory and Visual Culture* (London: Wallflower, 2007).

17 John Roberts, *Photography and its Violations* (New York: Columbia University Press, 2014) 83.

18 Jane Blocker, *Seeing Witness: Visuality and the Ethics of Testimony* (Minneapolis: Minnesota University Press, 2009).

19 Ibid., xix.

20 E. Ann Kaplan, *Trauma Culture: The Politics of Terror and Loss in Media and Literature* (New Brunswick: Rutgers University Press, 2005) 23. The pedagogical model of art is criticized by Jacques Rancière: it establishes an unequal relationship of artist as pedagogue and spectator as ignorant recipient of knowledge. See Rancière, *The Emancipated Spectator*, trans. Gregory Elliott (London: Verso, 2009) 11–15.

21 Ulrich Baer, *Spectral Evidence: The Photography of Trauma* (Cambridge, MA: MIT Press, 2002) 83.

22 Ibid.

23 Ibid., 84.

24 Mikael Levin, *War Story*, exh. cat. (Munich: Gina Kehayoff, 1997).

25 Jill Bennett, *Empathic Vision: Affect, Trauma and Contemporary Art* (Palo Alto: Stanford Universiy Press, 2005); Erika Doss, *Memorial Mania: Public Feeling in America* (Chicago: Chicago University Press, 2010).

26 See Margaret Olin, *Touching Photographs* (Chicago: Chicago Univeristy Press, 2012); Sharon Sliwinski, *Human Rights in Camera* (Chicago: Chicago University Press, 2011); Barbie Zelizer, *About to Die: How News Images Move the Public* (Oxford: Oxford University Press, 2010). Additionally, see Roberts, *Photography and its Violations*, 4–5. He argues that the 'emotional "hold"' of the photograph is linked to the truth claims of photography. The recent anthology, *Feeling Photography*, considers some art photography alongside other genres of photography: Elspeth H. Brown and Thy Phu, eds, *Feeling Photography* (Durham, NC: Duke University Press, 2014).

27 See for example, Eve Kosofsky Sedgwick and Adam Frank, eds, *Shame and Its Sisters: A Silvan Tomkins Reader* (Durham, NC: Duke University Press, 1995); Brian Massumi, *Parables for the Virtual: Movement, Affect, Sensation* (Durham, NC: Duke University Press, 2002); Sedgwick, *Touching Feeling*; Sianne Ngai, *Ugly Feelings* (Cambridge, MA: Harvard University Press, 2005); Elspeth Probyn, *Blush: Faces of Shame* (Minneapolis: Minnesota University Press, 2005); Patricia Ticineto Clough and Jean Halley eds, *The Affective Turn: Theorizing the Social* (Durham, NC: Duke University Press, 2007); Melissa Gregg and Gregory J. Seigworth, eds, *The Affect Theory Reader* (Durham, NC: Duke University Press, 2010).

28 Ariella Azoulay, *The Civil Contract of Photography* (New York: Zone, 2008) 17.

29 Ibid., 14.

30 Tomkins, *Affect, Imagery, Consciousness*, 123.

31 For the articulation of the aims of decolonial aesthetics, see the website: https://transnationaldecolonialinstitute.wordpress.com/decolonial-aesthetics/ (accessed December 2014).

32 Kader Attia, 'In Conversation: Kitty Scott and Kader Attia discuss the concept of repair', Kader Attia, *The Repair: From Occident to Extra-Occidental Cultures* (Berlin: Greenbox, 2014) 163.

33 Ngai, *Ugly Feelings*, 177.

34 There are now many catalogues of women artists' disadvantage; see, for example, Maura Reilly, 'Introduction', *Global Feminisms: New Directions in Contemporary Art*, exh. cat. (Brooklyn Museum, 2007) 18–23; Camille Morineau, 'elles@centrepompidou; Addressing Difference', *elles@ centrepompidou: Women Artists in the Collection of the Musée National d'art Moderne Centre de Création Industrielle*, exh. cat. (Pompidou Centre, Paris, 2009) 15–16.

35 See, for example, Beatrice von Bismarck, Hans-Peter Feldmann, Hans Ulrich Obrist et al., eds, *Interarchive: Archival Practices and Sites in the Contemporary Art Field* (Köln: Walter König, 2002); Okwui Enwezor, *Archive Fever: Uses of the Document in Contemporary Art*, exh. cat. (New York: International Center of Photography, 2008); Sven Spieker, *The Big Archive: Art from Bureaucracy* (Cambridge, MA: MIT Press, 2008); Krzysztof Pijarski, ed. *The Archive as Project* (Warsaw: Archeologia Fotografii, 2011); and Ernst van Alphen, *Staging the Archive: Art and Photography in the Age of Mass Media* (London: Reaktion, 2014).

36 Sedgwick, 'Shame, Theatricality, and Queer Performativity', 64–65.

37 Ruth Leys, 'Navigating the Genealogies of Trauma, Guilt, Affect', *University of Toronto Quarterly*, 79.2 (2010): 670.

38 Caroline Wake, 'Regarding the Recording: The Viewer of Video Testimony, the Complexity of Copresence and the Possibility of Tertiary Witnessing', *History and Memory* 25.1 (Spring/Summer 2013): 115.

39 Melanie Klein, 'Notes on some Schizoid Mechanisms', (1946) *Envy and Gratitude and Other Works 1946–63* (London: Virago, 1988) 14–16.

40 John Durham Peters, 'An Afterword: Torchlight Red on Sweaty Faces', *Media Witnessing: Testimony in the Age of Mass Communication*, ed. Paul Frosh and Amit Pinchevski (Houndmills: Palgrave Macmillan, 2009) 46–47.

41 Rennó in Fernando C. Boppré 'Imemorial e desidentificado: Entrevista com Rosângela Rennó' 3. http://www.fernandoboppre.net/wordpress/wp-content/uploads/2009/01/IMEMORIAL-E-DESIDENTIFICADO-ENTREVISTA-COM-ROS%C3%82NGELA-RENN%C3%93.pdf (accessed October 2014).

42 See Laurel Reuter, *Los Desaparecidos The Disappeared*, exh. cat. (Milano: Edizioni Charta; Grand Forks: North Dakota Museum of Art, 2006).

43 Susan Best, 'Review of Feeling Photography', *caareviews*, March 26, 2015 DOI: 10.3202/caa.reviews.2015.35

44 Lisa Saltzman, *Making Memory Matter: Strategies of Remembrance in Contemporary Art* (Chicago: University of Chicago Press, 2006) 20.

45 Ibid.

46 There are two versions of this video: one is 18.07 minutes in duration and the other is 14.32 minutes. See Adeline Pelletier, ed. *América Latina 1960–2013: Photographs*, exh. cat. (Paris: Fondation Cartier pour l'art contemporain; Puebla: Museo Amparo, 2013) 286; Laurel Reuter, *Juan Manuel Echavarría: Mouths of Ash, Bocas de Ceniza*, exh. cat. (Milan: Charta; Grand Forks: North Dakota Museum of Art, 2005) 168.

47 Milagros de la Torre in Edward J. Sullivan, 'Interview with Milagros de la Torre', 17 May 2011. http://www.as-coa.org/articles/interview-milagros-de-la-torre (accessed July 2011).

48 Elisabeth Roudinesco, *Our Dark Side: A History of Perversion*, trans. David Macey (London: Polity, 2009) 160.

Chapter 1

1 Tomkins, *Affect, Imagery, Consciousness*, 216.

2 Ibid., 123.

3 Silvan Tomkins, 'Shame–Humiliation and Contempt–Disgust', *Shame and its Sisters: A Silvan Tomkins Reader*, ed. Eve Kosofsky Sedgwick and Adam Frank (Durham, NC: Duke University Press, 1995) 156.

4 Sedgwick, 'Shame, Theatricality, and Queer Performativity', 37.

5 June Price Tangney and Ronda L. Dearing, *Shame and Guilt* (New York and London: Guilford Press, 2002) 25.

6 See Brian Massumi, 'The Autonomy of Affect', *Cultural Critique* 31 (Fall 1995): 83–109. He argues for a sharp distinction between emotion and affect with emotion as personal and qualified intensity as opposed to the unqualified intensity of affect. Intensity he argues is 'unassimilable', affect is 'not ownable or recognizable' (88), it is 'irreducibly bodily and autonomic' (89). The way in which affect is said to precede or outpace reason is partly based on a psychology experiment where bodily action appears to precede volition.

Massumi concludes that '"higher" functions, such as volition, are apparently being performed by autonomic, bodily reactions occurring in the brain outside consciousness, and between brain and finger, but prior to action and expression' (90). For an extended critique of this account, see Constantina Papoulias and Felicity Callard, 'Biology's Gift: Interrogating the Turn to Affect', *Body & Society* 16 (2010): 29–56.

7 Ruth Leys, 'The Turn to Affect: A Critique', *Critical Inquiry* 37.3 (Spring 2011): 434–472. See the responses to Leys from William E. Connolly, 'The Complexity of Intention', *Critical Inquiry* 37.4 (Summer 2011): 791–798; Adam Frank and Elizabeth A. Wilson, 'Like-Minded', *Critical Inquiry* 38.4 (Summer 2012): 870–877; Charles Altieri, 'Affect, Intention, and Cognition: A Response to Ruth Leys', *Critical Inquiry* 38.4 (Summer 2012): 878–881; and her responses to them: Ruth Leys, 'Affect and Intention: A Reply to William E. Connolly', *Critical Inquiry* 37.4 (Summer 2011) 799–805; Ruth Leys, 'Facts and Moods: Reply to My Critics', *Critical Inquiry* 38.4 (Summer 2012): 882–891. See also Papoulias and Callard, 'Biology's Gift', 29–56.

8 Leys, 'The Turn to Affect', 437.

9 Ibid.

10 Ibid.

11 Tomkins cited in Ibid.

12 Tomkins, 'What are Affects?' *Shame and its Sisters*, 55.

13 This insight is not limited to Tomkins' affect theory; it is also a feature of psychoanalyst André Green's interpretation of the relationship between affect and ideation. He asks why not think that: '*the profound nature of the affect is to be a psychical event linked to a movement awaiting a form*?' The active anticipatory role of affect is asserted by this provocative question: affect, as it were, seeks expression rather than being a response or accompaniment to ideational content. André Green, 'Postscript 1: Free Reflections on the Representation of Affect' (1984), *The Fabric of Affect in the Psychoanalytic Discourse*, trans. Alan Sheridan (London: Routledge, 1999) 268.

14 Sedgwick cited in Ruth Leys, *From Guilt to Shame: Auschwitz and After* (Princeton: Princeton University Press, 2007) 135. The OED defines autotelic as 'having or being an end in itself'.

15 Sedgwick and Frank, 'Shame in the Cybernetic Fold: Reading Silvan Tomkins', *Shame and its Sisters*, 16.

16 See Elizabeth Grosz, 'A Note on Essentialism and Difference', *A Reader in Feminist Knowledge*, ed. Sneja Gunew (London and New York: Routledge, 1991) 332–344; Diana Fuss, *Essentially Speaking: Feminism, Nature and Difference* (London and New York: Routledge, 1989); Spivak notes the inescapability of essentialism in an interview with Elizabeth Grosz; see Grosz, 'Criticism, Feminism and the Institution: An Interview with Gayatri Spivak', *Thesis Eleven* 10/11 (1985): 183–184.

17 Sedgwick and Frank, 'Shame in the Cybernetic Fold', 20. Sedgwick reiterates the importance of contingency in 'Paranoid Reading', 147.

18 Ibid., 2.

19 Leys, 'The Turn to Affect', 437.

20 Tomkins, *Affect, Imagery, Consciousness*, 262.

21 Freud cited in Jean Laplanche and Jean–Bertrand Pontalis, *The Language of Psycho-analysis*, trans. Donald Nicholson-Smith (London: Karnac, 1988) 323.

22 Leys, 'The Turn to Affect', 437.

23 Tomkins, 'What are Affects?', 38.

24 Ibid., 52.

25 Eve Kosofsky Sedgwick, 'Melanie Klein and the Difference Affect Makes', *South Atlantic Quarterly* 106.3 (Summer 2007) 632.

26 Tomkins, 'What are Affects?', 38.

27 Ibid., 37.

28 Sedgwick, 'Introduction', *Touching Feeling*, 18.

29 Tomkins cited in Sedgwick and Frank, 'Shame in the Cybernetic Fold', 7.

30 Ignacio Matte-Blanco, *Thinking, Feeling, and Being: Clinical Reflections on the Fundamental Antinomy of Human Beings and World* (London: Routledge, 1988) 91.

31 Ibid.

32 Ibid.

33 Leys, *From Guilt to Shame*, 148.

34 Ibid., 69.

35 Gabriele Taylor cited in Leys, *From Guilt to Shame*, 128.

36 Ruth Leys, *Trauma: A Genealogy* (Chicago: Chicago University Press, 2000) 299.

37 Leys, *From Guilt to Shame*, 150.

38 Ibid., 154–155.

39 Ibid., 155.

40 Joshua Greene, *Tribal Minds: Emotion, Reason, and the Gap Between Us and Them* (London: Penguin, 2013).

41 Leys, *From Guilt to Shame*, 155.

42 Sedgwick, 'Paranoid Reading', 139.

43 Blocker, *Seeing Witness*, xix.

44 Ibid., xx.

45 Sedgwick, 'Paranoid Reading', 136–138.

46 Ibid.

47 Sedgwick, 'Shame, Theatricality', 62.

48 Ibid., 44.

49 Tomkins, 'Shame–Humiliation', 139.

50 Leys, *From Guilt to Shame*, 151.

51 Sedgwick, 'Shame, Theatricality', 63.

52 Ibid.

53 Juliet Mitchell, 'Introduction', *The Selected Melanie Klein* (London: Penguin, 1986) 21.

54 Melanie Klein, 'Love, Guilt and Reparation', in Melanie Klein and Joan Riviere, *Love, Hate and Reparation* (New York and London: W. W. Norton, 1964) 61.

55 Melanie Klein, 'Some Theoretical Conclusions Regarding the Emotion Life of the Infant', (1952) *Envy and Gratitude and Other Works 1946–1963* (London; Virago 1988) 62.

56 Klein, 'Love, Guilt and Reparation', 61.

57 Sedgwick, 'Paranoid Reading', 128.

58 Hinshelwood cited in Sedgwick, 'Melanie Klein', 637.

59 Sedgwick, 'Melanie Klein', 637.

60 Sedgwick, 'Shame, Theatricality', 64. A 'guilty' relation to the other is briefly mentioned in 'Paranoid Reading', 137.

61 Laplanche in Cathy Caruth, 'An interview with Jean Laplanche', *Postmodern Culture* 11.2 (2001) http://muse.jhu.edu.wwwproxy0.library.unsw.edu.au/journals/postmodern_culture/v011/11.2caruth.html (accessed 16 February 2014).

62 Ibid.

63 Ibid.

64 Ibid.

65 Ibid.

66 Sedgwick, 'Paranoid Reading', 149.

67 Baer, *Spectral Evidence,* 83.

68 Lilian Alweiss, 'Collective Guilt and Responsibility: some Reflections', *European Journal of Political Theory* 2.307 (2003): 309.

69 Arendt cited in Alweiss, 'Collective Guilt', 308.

70 Ibid.

71 Alweiss, 'Collective Guilt', 313.

72 See Gillian Straker's incisive response to her critics that insists on the longevity of the position of the beneficiary. 'Beneficiaries for Evermore: Reply to Commentaries', *Psychoanalytic Dialogues* 21 (2011): 670–675. My thinking here is greatly indebted to conversations with Gill over the years on trauma.

73 Alweiss, 'Collective Guilt', 309.

Chapter 2

1 James Nachtway, *Inferno* (London: Phaidon, 1999) 471.

2 'To me, photography is the simultaneous recognition, in a fraction of a second, of the significance of an event as well as of a precise organization of forms which gives that event its proper expression.' Henri Cartier-Bresson, *The Mind's Eye* (New York: Aperture, 1999) 16.

3 The work of James Luna and Felix Gonzalez-Torres is considered under the rubric of witnessing by Jane Blocker, *Seeing Witness*. Doris Salcedo's work is discussed in these terms in Edlie L. Wong, 'Haunting Absences: Witnessing Loss in Doris Salcedo's *Atrabiliarios* and Beyond', *The Image and the Witness*, 173–188; and Charles Merewether, 'To Bear Witness', *Doris Salcedo* (Santa Fe: New Museum of Contemporary Art, 1998) 16–24. The viewer is posed as a witness to the demonstration of racism in the work of Carrie Mae Weems by Kathryn E. Delmez, '"Real Facts, by Real People": Folklore in the Early Work of Carrie Mae Weems', *Carrie Mae Weems: Three Decades of Photography and Video*, ed. Kathryn E. Delmez (Nashville: Frist Center for the Visual Arts in association with New Haven: Yale University Press, 2013) 14. A review in the *New York Times* of Weem's retrospective was titled 'Testimony of a Cleareyed Witness', *New York Times*, January 24, 2014, C 25. The work of The Atlas Group (Walid Ra'ad) is situated in relation to witnessing by Sarah Rogers, 'Forging History, Performing Memory: Walid Ra'ad's The Atlas Project', *Parachute* 108 (2002): 68. His work was included in an exhibition on this theme, *Witness: Darren Almond, Brenda L. Croft, Zhang Huan, Whitfield Lovell, the Atlas Group/Walid Raad, Fiona Tan*, exh. cat. (Sydney: Museum of Contemporary Art, 2004).

4 Guerin and Hallas, eds, *The Image and the Witness*; Dora Apel, *Memory Effects: The Holocaust and the Art of Secondary Witnessing* (New Brunswick: Rutgers University Press, 2002).

5 See also Dominick LaCapra's discussion of this incident in *Writing History: Writing Trauma* (Baltimore: Johns Hopkins University Press, 2001) 87–91.

6 Dori Laub, 'Bearing Witness or the Vicissitudes of Listening', Shoshana Felman and Dori Laub, *Testimony: Crises of Witnessing in Literature, Psychoanalysis, and History* (New York: Routledge, 1992) 60.

7 Ibid., 62.

8 Dori Laub, 'An Event without a Witness: Truth, Testimony and Survival', *Testimony: Crises of Witnessing*, 75.

9 Kelly Oliver, *Witnessing: Beyond Recognition* (Minneapolis: Minnesota University Press, 2001).

10 Shoshana Felman, 'Education and Crisis', *Testimony: Crises of Witnessing*, 21.

11 Strangeness is discussed in Felman, 'Education and Crisis', 7. These themes are woven throughout her sections of the book. She indicates that the orientation of the book was towards 'what cannot be understood, transmitted' in Felman, 'Education and Crisis', 3, fn 4.

12 Ibid. 49.

13 Ibid. 48.

14 Ibid. 52.

15 For an excellent discussion of this complex terrain, see Wake, 'Regarding the Recording', 119–124. LaCapra concedes secondary trauma could occur in *Writing History*, 102–103.

16 Dominick LaCapra, *History and Memory After Auschwitz* (Ithaca: Cornell University Press, 1998), 11.

17 Apel, *Memory Effects*, 20.

18 Ibid., 7.

19 Ibid., 93.

20 Ibid., 20.

21 Baer, *Spectral Evidence*, 76.

22 Ibid., 83.

23 Ibid., 83–84.

24 Ibid., 113.

25 Ibid.

26 Amit Pinchevski, 'The Audiovisual Unconscious: Media and Trauma in the Video Archive for Holocaust Testimonies', *Critical Inquiry* 29 (Autumn, 2012) 144.

27 John Ellis, *Seeing Things: Television in an Age of Uncertainty* (London: I B Tauris, 2000) 6. Paul Lowe also argues the photograph itself becomes a social agent, bearing witness. See Lowe, 'The Forensic Turn: Bearing Witness and the "Thingness" of the Photography', *The Violence of the Image: Photography and International Conflict*, ed. Liam Kennedy and Caitlin Patrick (London: I B Tauris, 2014) 213.

28 Paul Frosh and Amit Pinchevski, 'Introduction', *Media Witnessing*, 13.

29 Pinchevski, 'The Audiovisual Unconscious', 148.

30 Apel, *Memory Effects*, 59

31 Pinchevski, 'The Audiovisual Unconscious', 149.

32 Ibid., 156.

33 Ibid., 144.

34 Ibid., 155.

35 Ibid., 157.

36 Ibid.

37 Viktor Shklovsky, 'Art as Device' (1917), *Theory of Prose: Viktor Shklovsky*, trans. Benjamin Sher, intro. Gerald L. Bruns (Champaign and London: Dalkey Archive Press, 1990) 1–14.

38 Pinchevski, 'The Audiovisual Unconscious', 147.

39 John Durham Peters, 'Witnessing', *Media Witnessing*, 31.

40 E. Ann Kaplan, for instance, emphasizes the role of witnessing in developing an ethical consciousness and a sense of responsibility for injustice. She directs attention to the situation, rather than individuals, as the way to bring to the fore the larger political issues at stake. Kaplan, *Trauma Culture*, 23, 122–125. See also Caroline Wake's discussion of the assumption in performance studies that witnessing is ethical: 'The Accident and the Account: Towards a Taxonomy of Spectatorial Witness in Theatre and Performance Studies', *Visions and Revisions: Performance, Memory, Trauma*, ed. Caroline Wake and Bryoni Trezise (Copenhagen: Museum Tusculanum Press, 2013) 37–43.

41 On this shift in documentary practice see: T. J. Demos, *The Migrant Image: The Art and Politics of Documentary during Global Crisis* (Durham, NC: Duke University Press, 2013); Sabine Eckmann, ed., *In the Aftermath of Trauma:*

Contemporary Video Installations, exh. cat. (St Louis: Mildred Lane Kemper Art Museum, 2014); Maria Lind and Hito Steyerl, eds, *The Green Room: Reconsidering Documentary and Art* (Berlin: Sternberg, 2008) and the special issue on 'Documentary, Expanded' *Aperture* 214 (Spring 2014).

42 Wake, 'Regarding the Recording', 115.

43 See also her taxonomy: Wake 'The Accident and the Account', 33–56.

44 Peters, 'Witnessing', 31.

45 Anna Freud, 'Identification with the Aggressor', *The Ego and the Mechanisms of Defence*, trans. Cecil Baines (New York: International Universities Press, 1946) 117–131. Imitation of the aggressor is how Anna Freud understands identification with the aggressor. The book was first published in German in 1936.

46 Sándor Ferenczi, 'Confusion of the Tongues Between the Adults and the Child – (The Language of Tenderness and of Passion)', *The International Journal of Psychoanalysis* 30 (1949): 225–230. Originally delivered at the Twelfth International Psycho-Analytic Congress, Wiesbaden, September, 1932.

47 For example, Diana Fuss, *Identification Papers: Readings on Psychoanalysis, Sexuality, and Culture* (London and New York: Routledge, 1995); José Esteban Muñoz, *Disidentifactions: Queers of Color and the Performance of Politics* (Minneapolis: University of Minnesota Press, 1999); Olivier Asselin, Johanne Lamoureux and Christine Ross, eds, *Precarious Visualities: New Perspectives on Identification in Contemporary Art and Visual Culture* (Montreal: McGill-Queens University Press, 2008); Amelia Jones, *Seeing Differently: A History and Theory of Identification and the Visual Arts* (London and New York: Routledge, 2012).

48 I discuss anti-psychologism in anti-aesthetic practices in my book: Best, *Visualizing Feeling*, 40–41; 112–114; 119–121.

49 Azoulay, *The Civil Contract of Photography*, 88–89.

50 Ibid., 31–83.

51 Ibid., 17.

52 Ibid., 14.

53 Ibid., 27.

54 Ibid., 20.

55 Ibid., 17.

56 Claire Bishop, 'Antagonism and Relational Aesthetics', *October* 110 (Fall 2004) 68.

57 Ibid., 79.

58 Ibid., 73.

59 Ibid. 79.

60 Ibid., 73.

61 Ibid.

62 Ibid.

63 Ibid., 76.

64 Ibid., 75.

65 Ibid.

66 Ibid., 65. While what Bishop calls 'naturalized exclusions' from the art world might be contested by these works, this locates the contestation as the artists' gesture or intention aimed at the art world, rather than being about the actual '*quality* of relationships' in relational aesthetics, which is ostensibly the object of her analysis (65). In other words, the artists include people not normally part of the audience for contemporary art, but the relationship between those people and the audience is highly unlikely to produce contestation or conflict. The work enacts estrangement between participants, delivering to the critic in retrospect the quality of contestation.

67 Rosalyn Deutsche cited in Ibid, 65.

68 George W. Pigman argues Freud uses empathy and identification as synonyms, 'Freud and the History of Empathy', *The International Journal of Psycho-Analysis* 76 (1995): 250.

69 Sigmund Freud 'Group Psychology and the Analysis of the Ego', *Civilization, Society and Religion, Vol 12 Penguin Freud Library*, trans. James Strachey (Harmondsworth: Penguin, 1985) 134–135.

70 Ernst Van Alphen, 'Playing the Holocaust', *Mirroring Evil: Nazi Imagery/Recent Art*, ed. Norman Kleebatt, exh. cat. (New York: The Jewish Museum and New Brunswick: Rutgers University Press, 2001) 77.

71 Heinrich Racker, 'The Meanings and Uses of Countertransference' (1957) *Psychoanalytic Quarterly* 76 (2007): 734.

72 Ibid.

73 Jay Frankel, 'Exploring Ferenczi's Concept of Identification with the Aggressor: Its Role in Trauma, Everyday Life, and the Therapeutic Relationship', *Psychoanalytic Dialogues: The International Journal of Relational Perspectives* 12.1 (2002): 105.

74 Critic Peter Plagens refers to the 'lashes of guilt the show dishes out' cited in Amelia Jones, *Seeing Differently*, 122; Charles Wright refers to popular critics as perceiving the enemy as the 'straight, white, male'. Charles Wright, 'The Mythology of Difference: Vulgar Identity Politics at the Whitney Biennial', *Afterimage* 21.2 (September 1993); cited by Jones, *Seeing Differently*, 123.

75 Frankel, 'Exploring Ferenczi's Concept', 105.

76 Miguel Gutiérrez Peláez, 'Trauma Theory in Sándor Ferenczi's Writings of 1931 and 1932', *International Journal of Psychoanalysis* 90 (2009): 1221.

77 Ibid.

78 Sándor Ferenczi, 'On Shock' (1932), *Final Contributions to the Problems and Methods of Psycho-Analysis*, ed. M. Balint, trans. Mosbacher et al. (London: Hogarth, 1955) 253–4. Peláez observes that Ferenczi's term *Erschütterung* is usually translated as 'shock' or 'psychic shock' from *schütten*, to become 'unfest, unsolid'. He notes, however, the distinction between the corporeal and psychic consequences of trauma in Freud's usage: 'According to the dictionary of Roudinesco and Plon (1998), in the entry on "traumatic neuroses," Freud uses the term *Erschütterung* in *Beyond the Pleasure*

Principle (Freud, 1920) to denote the somatic character of trauma and *Schreck* [fright] for its psychic aspect.' Peláez, 'Trauma theory', 1227.

Chapter 3

1 Anne Ferran, Artist's statement for Stills Gallery, 2001, n.p.

2 Anne Ferran, 'Empty', *Photofile* 66 (September 2002) 8.

3 Kay Daniels gives the percentage as 15 per cent; some estimate as high as 20 per cent were women. See Daniels, *Convict Women* (Sydney: Allen & Unwin, 1998) 51. The number of women transported is from Joy Damousi cited in Gay Hendriksen, 'Women Transported – Myth and Reality', *Women Transported: Life in Australia's Convict Female Factories*, exh. cat. (Parramatta: Parramatta Heritage Centre, 2008) 7.

4 Caroline Leakey, *Broad Arrow: Being Passages from the History of Maida Gwynnham, A Lifer* (1859) (n.p.: Dodo Press, n.d.) 55. Significantly, this book is published by Dodo Press which specializes in rare and out of print books. The book influenced the more famous male convict novel by Marcus Clarke, which is in print as a penguin classic, *For the Term of His Natural Life,* first appearing as a serial between 1870 and 1872 and then published as a novel in 1874.

5 Assigned women convicts were returned to the factory if they became pregnant. Joy Damousi notes their punishment for becoming pregnant was 'six months imprisonment in the crime class'. Joy Damousi, *Depraved and Disorderly: Female Convicts, Sexuality and Gender in Colonial Australia* (Cambridge: Cambridge University Press, 1997) 125. In recent publications on the female factories in Tasmania, work at the Cascades factory is described as processing laundry in 'industrial quantities'. Convict Women's Research Centre, *Convict Lives: Women at the Cascades Female Factory*, 2nd ed (Hobart: Convict Women's Press, 2012) 11. At Ross, activities ranged from 'picking old rope apart to stitching ladies' night-caps'. Lucy Frost, ed., *Convict Lives at the Ross Female Factory* (Hobart: Convict Women's Press, 2011) 16.

6 Daniels, *Convict Women*, 107.

7 Ferran in Jonathon Holmes, 'An Interview with Anne Ferran', Anne Ferran, *The Ground, the Air*, exh. cat. (Hobart: Tasmanian Museum and Art Gallery, 2008) 51.

8 Very early in my career I read Judith Allen's excellent essay on how feminist concerns disrupt traditional historical methods. She pointed to the need to attend carefully to gaps and silences. This lesson has stayed with me. See Judith Allen, 'Evidence and Silence: Feminism and the Limits of History', *Feminist Challenges: Social and Political Theory*, ed. Carole Pateman and Elizabeth Gross (Sydney: Allen and Unwin, 1986) 173–189.

9 Ferran in Geoffrey Batchen, 'The Distance that Cannot be Photographed: Geoffrey Batchen Interviews Anne Ferran', *Flash: Reviews, Interviews, Comment*, http://www.ccp.org.au/flash/2009/02/anne-ferran/ (accessed 7 July 2014).

10 Damousi, *Depraved and Disorderly*; Daniels, *Convict Women*; and Deborah Oxley, *Convict Maids: The Forced Migration of Women to Australia* (Cambridge: Cambridge University Press, 1996).

11 Babette Smith, *A Cargo of Women: Susannah Watson and the Princess Royal* (1988), 2nd ed (Sydney: Allen and Unwin, 2008); Anne Summers' *Damned Whores and God's Police, the Colonisation of Women in Australia* (Melbourne: Allen Lane, 1975); and Miriam Dixon, *The Real Matilda: Women and Identity in Australia, 1788–1975* (Ringwood: Penguin, 1976).

12 Thanks to Lucy Frost for confirming this.

13 As far as I can determine there is no central database that brings together all of the images of convict women and the factories. Some images can be found on the National Library of Australia's website; others are located on the websites of the Archives of NSW and Tasmania, the two principal penal colonies.

14 Joan Kerr, 'Introduction', James Semple Kerr, *Out of Sight, Out of Mind: Australia's Places of Confinement, 1788–1988*, exh. cat. (Sydney: S. H. Ervin Gallery in association with The Australian Bicentennial Authority, 1988) 5.

15 Alison Alexander, 'Photography', *The Companion to Tasmanian History*, http://www.utas.edu.au/library/companion_to_tasmanian_history/P/Photography.htm (accessed 14 July 2014).

16 There are, of course, post-convict period photographs of the women. See the website of the Female Convicts Research Centre: http://www.femaleconvicts.org.au (accessed 16 February 2016).

17 Oxley, *Convict Maids*, 31. The image can be found on the website of the NSW state archives: http://www.records.nsw.gov.au/state-archives/today-in-history/today-in-history-images/may-margaret-greenwood/view (accessed 17 July 2014).

18 Damousi, *Depraved and Disorderly*, 93. One sketch is reproduced in Babette Smith, *Australia's Birthstain: The Startling Legacy of the Convict Era* (Sydney: Allen & Unwin, 2008) 72. Labelled circa 1800, it is not identified or discussed.

19 See Hendriksen, *Women Transported*.

20 Daniels, *Convict Women*, 243–244.

21 Ibid., 246–247.

22 Ibid., 241.

23 Ibid., 244.

24 Richard Tuffin, 'Port Arthur', *Companion of Tasmanian History*, http://www.utas.edu.au/library/companion_to_tasmanian_history/P/Port%20Arthur.htm (accessed 17 July 2014).

25 In the new introduction to the second edition of *A Cargo of Women*, Babette Smith points to the 1970s and 1980s as the decades when shame eased and family historians began to research their family trees. Smith, *A Cargo of Women*, 1–4.

26 Peter Martin, 'Could our convict past be why fewer women get ahead in Australia?', *Daily Life*, 28 June 2014 http://www.dailylife.com.au/news-and-views/could-our-convict-past-be-why-fewer-women-get-ahead-in-australia-20140629-3b18g.html (accessed 28 June 2014).

27 John Hirst, 'An Oddity From the Start: Convicts and National Character', *The Monthly*, July 2008 http://www.themonthly.com.au/issue/2008/july/1277335186/john-hirst/oddity-start (accessed 25 June 2014).

28 Ibid.

29 Janine Little, 'Talking with Ruby Langford Ginibi', *Hecate* 20.1 (1994) http://www.emsah.uq.edu.au/talkingwithruby (accessed July 2014).

30 Daniels, *Convict Women*, 101.

31 Ferran in Thierry de Duve, 'An Interview with Anne Ferran', *Anne Ferran: Shadow Land*, exh. cat. (Perth: Lawrence Wilson Art Gallery, University of Western Australia and Sydney: Power Publications, 2014) 73.

32 Of course, there are also substantial differences, the genocidal practices inflected on the indigenous population being the most obvious.

33 David Campany, 'Safety in Numbness: Some Remarks on "Late Photography"' (2003) *The Cinematic*, ed. David Campany (London: Whitechapel Gallery and Cambridge, MA: MIT Press, 2007) 188. See also John Roberts' account of late photography in Roberts, *Photography and its Violations*, 93–119.

34 Campany, 'Safety in Numbness', 188, 190.

35 Ibid., 191.

36 Ibid.

37 Ibid.

38 Ibid., 192.

39 Ibid.

40 Ibid.

41 Ibid., 192–193.

42 Ferran in de Duve, 'An Interview with Anne Ferran', 73.

43 *Ross Female Convict Station Historic Site: Conservation Plan*, Parks and Wildlife Service, Department of Environment and Land Management, April 1998, 1.

44 Baer, *Spectral Evidence*, 83.

45 Smith, *A Cargo of Women*, 3. See also Smith, *Australia's Birthstain* and in particular her account of the opening of convict archives in the 1970s (40–42), and the shaming effects of the anti-transportation movement (253).

46 Damousi, *Depraved and Disorderly*, 89.

47 Lieutenant Breton cited in Damousi, *Depraved and Disorderly*, 55.

48 Daniels, *Convict Women*, 149.

49 De Duve, 'An Interview with Anne Ferran', 73.

50 Ibid.

51 Ibid.

52 Ibid., 76.

53 Ibid.

54 Ibid.

55 Campany, 'Safety in Numbness', 187, 190.

56 Ibid., 192.

57 Ibid., 188–189.

58 Florence Jacobowitz, '*Shoah* as Cinema', *Image and Remembrance: Representation and the Holocaust*, ed. Shelley Hornstein and Florence Jacobowitz (Bloomington: Indiana University Press, 2003) 12.

59 Ferran, 'Empty', 9.

60 Ibid.

61 http://www.legacy-project.org/index.php?page=art_results&motifID=1012 (accessed 14 January 2012).

62 Ibid.

63 Ferran in Holmes, 'An Interview with Anne Ferran', 51.

64 Azoulay, *The Civil Contract of Photography*, 14.

65 Shoshana Felman, 'Education and Crisis', *Testimony: Crises of Witnessing*, 21.

Chapter 4

1 Pardington cited in Rhana Devenport, 'Foreword', *Fiona Pardington: The Pressure of Sunlight Falling*, ed. Kriselle Baker and Elizabeth Rankin (Dunedin: Otago University Press in association with Govett-Brewster Art Gallery and Two Rooms Gallery, 2011) 6.

2 Ibid., 7.

3 Walter Benjamin, 'The Author as Producer', trans. Edmund Jephcott, *Art after Modernism: Rethinking Representation*, ed. Brian Wallis (New York: New Museum of Contemporary Art, 1984) 304.

4 Suzie Linfield, *The Cruel Radiance: Photography and Political Violence* (Chicago: Chicago University Press, 2010) 5.

5 I discuss the anti-aesthetic tradition in greater detail my book, *Visualizing Feeling*.

6 Linfield, *The Cruel Radiance*, 4.

7 Ibid., 5.

8 Burgin cited in Ibid., 11.

9 Pardington cited in Kriselle Baker, 'The Truth of Lineage Time and Tā Moko', *The Pressure of Sunlight Falling*, 27.

10 This opposition is well described by Alexander Alberro, 'Beauty Knows No pain', 38.

11 Bronwen Douglas, '"Novus Orbis Australis": Oceania in the Science of Race, 1750–1850,' *Foreign Bodies: Oceania and the Science of Race 1750–1940*, ed. Bronwen Douglas and Chris Ballard (Canberra: ANU E Press, 2008) 117.

12 Roger Blackley lists three exhibitions of the casts: in 1991, when all four Māori casts were in the exhibition *New Zealand Seen by the French*, at New

Zealand's National Library; the Musée d'Orsay's *À Fleur de Peau* (2002); and the Museum of Sydney's *Lure of the Southern Seas* (2002–2003). See Blackley, 'Beauty and the Beast: Plaster Casts in a Colonial Museum', *On Display: New Essays in Cultural Studies*, ed. Anna Smith and Lydia Wevers (Wellington: Victoria University Press, 2004) 52–53.

13 *Auckland Weekly News* cited in Blackley, 'Beauty and the Beast', 51.

14 Ibid.

15 Kriselle Baker and Elizabeth Rankin note that there are seven casts in storage at the museum, 'In Search of the Present: Fiona Pardington's Āhua', *The Pressure of Sunlight Falling*, 16.

16 Roger Blackley notes that loss of detail could be due to overpainting, 'Beauty and the Beast', 57.

17 The identity of Matoua Tawai has not been established; according to Roger Blackley he may not have been a chief. See Roger Blackley, 'The Mystery of Matoua Tawai: Fiona Pardington at the Govett-Brewster', *Art New Zealand* 139 (Spring 2011): 63.

18 Susan Hunt, 'Southern Discomfort', *Lure of the Southern Seas: The Voyages of Dumont D'Urville 1826–1840*, exh. cat. (Sydney: Historic Houses Trust, 2002) 14.

19 Ibid.

20 Ibid.

21 Ibid.

22 Martin Terry, 'Encountering Dumont d'Urville', *Lure of the Southern Seas*, 25.

23 This description of his role is from Yves le Fur, 'Dumoutier's artifacts: A Distant Glimmer of Ghosts', *The Pressure of Sunlight Falling*, 79. Susan Hunt notes Dumont d'Urville's interest in physical anthropology, see Hunt, 'Southern Discomfort', 16. According to Stacy L. Kamehiro, the concentration on physical, rather than cultural or environmental, information was the French preference in the anthropology of the period. See Kamehiro, 'Documents, Specimens, Portraits: Dumoutier's Oceanic Casts', *The Pressure of Sunlight Falling*, 103.

24 Terry, 'Encountering Dumont d'Urville', 31. Kamehiro also makes this point, 'Documents, Specimens, Portraits', 103.

25 Terry, 'Encountering Dumont d'Urville', 31.

26 Kamehiro provides the estimation of over fifty casts, see Kamehiro, 'Documents, Specimens, Portraits', 10.

27 Nicholas Thomas, 'Dumont d'Urville's Anthropology', *Lure of the Southern Seas*, 62.

28 Ibid.

29 Dumont d'Urville cited in Nicholas Thomas, *In Oceania: Visions, Artifacts, Histories* (Durham, NC: Duke University Press, 1997) 145.

30 Dumont d'Urville cited in Bronwen Douglas, 'Science and the Art of Representing "Savages": Reading "Race" in Text and Image in South Seas Voyage Literature', *History and Anthropology* 11.2–3 (1999): 169.

31 Quoy and Gaimard cited in Douglas, '"Novus Orbis Australis"', 117.

32 Blackley, 'Beauty and the Beast', 53.

33 Le Fur describes the way in which the collection entered the museum, see le Fur, 'Dumoutier's Artifacts', 83.

34 Thomas, *In Oceania*, 12–13.

35 Ibid., 12, 13.

36 During cited by Thomas, *In Oceania*, 8.

37 Thomas, *In Oceania*, 13.

38 Le Fur, 'Dumoutier's Artifacts', 83.

39 Hunt, 'Southern Discomfort', 16.

40 Dumont d'Urville cited in Le Fur, 'Dumoutier's Artifacts', 83.

41 Dumoutier in Anne Salmond, '*Et la tête*: Casting in the Pacific', *The Pressure of Sunlight Falling*, 134.

42 Salmond, '*Et la tête*', 134.

43 Ibid.

44 Le Fur, 'Dumoutier's Artifacts', 83.

45 E. T. Hamy in 1918 cited in Salmond, '*Et la tête*', 134.

46 Tanya Sheehan notes before the 1880s long exposure times meant that capturing fleeting emotions was not possible. See Tanya Sheehan, 'Looking Pleasant, Feeling White: The Social Politics of the Photographic Smile', *Feeling Photography*, ed. Elspeth H. Brown and Thy Phu (Durham, NC: Duke University Press, 2014) 127.

47 Terry, 'Encountering Dumont d'Urville', 31.

48 Ibid., 32. Terry suggests they might have been coerced.

49 Dumont d'Urville cited in Douglas, '"Novus Orbis Australis"', 125. Douglas reports that Dumont d'Urville was initially 'non-committal' about polygeny but in his memoir he added a footnote in support of the singular race theory (125). In contrast, she notes Dumoutier was unequivocal, he believed in 'a single human species' (126).

50 Thomas, *In Oceania*, 16–17.

51 Michael Fried's work consistently tracks the contrast between absorption and theatricality in painting and more recently photography. The contrast first appears in his *Artforum* article of 1967 'Art and Objecthood' reprinted in *Minimal Art: A Critical Anthology*, ed. Gregory Battcock (Berkeley: University of California Press, 1968), 116–147. He concedes this point after some resistance in an interview with Jill Beaulieu, Mary Roberts and Toni Ross, 'An Interview with Michael Fried', *Refracting Vision: Essays on the Writings of Michael Fried*, ed. Jill Beaulieu, Mary Roberts and Toni Ross (Sydney: Power Publications, 2000) 389–390. The contrast is more fully elaborated in Michael Fried, *Absorption and Theatricality: Painting and Beholder in the Age of Diderot* (Berkeley: University of California Press, 1980).

52 Pardington cited in Devenport, 'Foreword', *The Pressure of Sunlight Falling*, 9.

53 Pardington cited in David Elliott, 'Embossing the Abyss: The Work of Fiona Pardington', *The Pressure of Sunlight Falling*, 25.

54 John Durham Peters, 'An Afterword: Torchlight Red on Sweaty Faces', *Media Witnessing*, 42, 46–47.

55 Ibid., 47.

56 Ibid., 46.

57 Ibid., 44.

58 Jacques Lacan, *Four Fundamental Concepts of Psycho-analysis*, trans. Alan Sheridan (Harmondsworth: Penguin, 1977) 55.

59 Laplanche in Cathy Caruth, 'An interview with Jean Laplanche'.

60 Jacques Lacan, *The Seminar of Jacques Lacan. Book II. The Ego in Freud's Theory and in the Technique of Psychoanalysis, 1954–55*, ed. Jacques-Alain Miller, trans. Sylvana Tomaselli (New York: Norton, 1991) 164. *The Stanford Encyclopedia of Philosophy* has a useful outline of the shifting meanings of the real. See http://plato.stanford.edu/entries/lacan/ (accessed 19 September 2014).

61 Diana Taylor, 'Trauma in the Archive', *Feeling Photography*, 242.

62 Baer, *Spectral Evidence*, 83.

63 Ngai, *Ugly Feelings*, 200.

64 Leo Bersani, *The Culture of Redemption* (Cambridge, MA: Harvard University Press, 1990) 14.

65 Ibid., 28.

66 Ibid., 1.

67 Ibid.

68 Ibid., 7.

69 Ibid., 28.

70 Ibid., 21.

71 Sedgwick, 'Paranoid Reading', 149.

72 See Anne Salmond, 'Nga Huarahi O Te Ao Maori: Pathways in the Maori World', *Te Maori: Maori Art from New Zealand Collections*, ed. Sidney Moko Mead, exh. cat. (Auckland: Heinemann in assoc. with The American Federation of Arts, 1984) 109–137. She states 'The alchemy of taonga was to bring about a fusion of men and ancestors and a collapse of distance in space-time' (120). She describes them as 'not artifacts, nor primitive art, but things of power' (137).

73 Fiona Pardington, 'My Paradox', *Towards a Kaupapa of Ancestral Power and Talk*, Doctor of Fine Arts, Auckland University, 2013, n.p.

74 Pardington, 'I am the Animist', *Towards a Kaupapa*, n.p.

75 Salmond, '*Et la tête*', 135.

76 Baker, 'The Truth of Lineage Time and Tā Moko', 34.

77 Pardington cited in Baker, 'The Truth of Lineage Time and Tā Moko', 27.

78 Ngai, *Ugly Feelings*, 177.

79 Room Brochure, Fiona Pardington, *The Pressure of Sunlight Falling*, Govett-Brewster Art Gallery, 11 June–28 August 2011, n.p.

Chapter 5

1 Rennó in 'Conversation between Rosângela Rennó and Hans-Michael Herzog', *La Mirada – Looking at Photography in Latin America Today, Conversations*, vol. 2, ed. Hans-Michael Herzog (Zurich: Daros Latin America Collection, Edition Oehrli, 2002) 87.

2 Rennó in Fernando C. Boppré 'Imemorial e desidentificado: Entrevista com Rosângela Rennó' 3. My translation. All translations are mine unless otherwise stated.

3 Allan Sekula, 'The Body and the Archive', *October* 39 (Winter 1986): 6, 10, 56.

4 Ibid., 56.

5 See, for example, John Tagg, *The Burden of Representation: Essays on Photographies and Histories* (Amherst, University of Massachusetts Press, 1988); Elizabeth Edwards, *Raw Histories: Photographs, Anthropology and Museums* (Oxford: Berg, 2001); Thierry de Duve, 'Art in the Face of Radical Evil', *October* 125 (Summer, 2008): 3–23; Sandra S. Phillips, ed. *Exposed: Voyeurism, Surveillance and the Camera,* exh. cat. (London: Tate Publishing, 2010).

6 Sekula, 'The Body and the Archive', 10.

7 Allan Sekula, 'Dismantling Modernism, Reinventing Documentary (Notes on the Politics of Representation)', *The Massachusetts Review* 19.4 (Winter 1978): 867.

8 Ibid., 875.

9 Lauren Berlant, 'Introduction: Compassion (and Withholding)', *Compassion: The Culture and Politics of an Emotion*, ed. Lauren Berlant (New York and London: Routledge, 2004) 10.

10 Rennó interview with Paula Alzugaray, 'Rosângela Rennó: O artista como narrador', *Rosângela Rennó* (São Paulo: Paço das Artes, 2004) 5. The phrase is 'os pequenos relatos dos oprimidos, dos vencidos'. It could also be translated as 'little stories of the oppressed and the defeated'. I have chosen the alternative translation of downtrodden, as in *Immemorial* the violence is more indiscriminate than oppression. Vanquished, in English, is a stronger word than defeated, suggesting the kind of obliteration discussed in this chapter.

11 Rennó in 'Conversation between Rosângela Rennó and Hans-Michael Herzog', 87.

12 Ibid., 86.

13 Mark Godfrey, 'Photography Found and Lost: On Tacita Dean's *Floh*', *October* 114 (Autumn, 2005): 101.

14 Martha Langford, 'Strange Bedfellows: The Vernacular and Photographic Artists', *Photography & Culture* 1.1 (July 2008): 73–94.

15 Azoulay, *The Civil Contract of Photography*, 14.

16 Ibid., 11.

17 Rennó in 'Conversation between Rosângela Rennó and Hans-Michael Herzog', 89.

18 Maria Angélica Melendi 'Arquivos do mal – mal de arquivo', *Suplemento Literário* 66 (dez. 2000) http://www.rosangelarenno.com.br/bibliografia/en (accessed October 2014).

19 Malraux cited in Alex Shoumatoff, *The Capital of Hope: Brasília and Its People*, (New York: Vintage, 1990) 55.

20 Shoumatoff, *The Capital of Hope*, 23. See also Laura Cavalcanti, 'When Brazil was Modern: From Rio de Janeiro to Brasilia', *Cruelty & Utopia: Cities and Landscapes in Latin America*, exh. cat. (Brussels: The International Centre for Urbanism, Architecture and Landscape and New York: Princeton Architectural Press, 2003) 161–170.

21 Stefan Zweig called Brazil 'a land of the future' in his book of that name. He begins the book with an epigram from an Austrian diplomat, writing in 1868 to Gobineau who was reluctant to accept an embassy post in Brazil: 'A new place, a magnificent port, distance from shabby Europe, a new political horizon, a land of the future.' Stefan Zweig, *Brazil: A Land of the Future* (1941) trans. Lowell A. Bangerter, (Riverside: Ariadne Press, 2000). See also Williams' discussion of Zweig in Richard J. Williams, *Brazil: Modern Architectures in History* (London: Reaktion, 2009) 7.

22 Nuno Crespo, 'Intensifying Images', *Strange Fruit*, exh. cat, (Lisbon: Fundaçao Calouste Gulbenkian CAM and Winterthur: Fotomuseum Winterthur, 2012) 202.

23 Tanya Sheehan investigates the genealogy of the smile in late nineteenth- and early twentieth-century American photographic portraiture in 'Looking Pleasant, Feeling White: The Social Politics of the Photographic Smile', 127–157. Lily Cho analyses the early twentieth-century Canadian convention for emotionally neutral identification photographs. 'Anticipating Citizenship: Chinese Head Tax Photographs', *Feeling Photography*, 158–180.

24 See also Ernst van Alphen, *Caught by History: Holocaust Effects in Contemporary Art, Literature and Theory* (Stanford: Stanford University Press, 1997) 93–122. His criticism is similar; he sees Boltanski's works as 'the transformation of subjects into objects'. The sameness of the faces, all enlarged, 'causes individual features to be obscured, diminished. One sees only a collection of exchangeable objects' (106).

25 One might expect this range of expressions in the identification shots of prisoners. See Suzie Linfield's discussion of prisoner identification shots from Lubyanka Prison in Moscow and Tuol Sleng Prison, Linfield, *The Cruel Radiance*, 52–60. On the Tuol Sleng photographs, see also de Duve, 'Art in the Face of Radical Evil'.

26 Zoe Leonard's description of her postcard is on the Studio Museum website: http://www.studiomuseum.org/exhibition/harlem-postcards-fallwinter-2013-14-elia-alba-malik-gaines-zoe-leonard-julie-quon (accessed October 2014).

27 This description appears in her artist's book Rosângela Rennó, *O arquivo universal e outros arquivos* [*The Universal Archive and Other Archives*] (São Paulo: Cosac & Naify, 2003) 61.

28 Rennó in 'Conversation between Rosângela Rennó and Hans-Michael Herzog', 87.

29 Rennó in Melissa Chiu, 'Rosângela Rennó Interview', Rosângela Rennó, *Vulgo* [*Alias*], ed. Melissa Chiu, exh. cat. (Kingswood: University of Western Sydney, 1999) 41.

30 Quote from the archives cited in Charles Merewether, 'Archives of the Fallen: Eugenio Dittborn, Milagros de la Torre, Rosângela Rennó', *Grand Street* 62 (Fall, 1997): 46.

31 Rennó in Melissa Chiu, 'Rosângela Rennó Interview', 42.

32 Details of the massacre from Rennó's research are cited by Herkenhoff, 'Rennó ou a beleza e o dulçor do presente', 171, fn 63. She also discusses the massacre with Melissa Chiu, 'Rosângela Rennó Interview', 41.

33 Mariana Bertelli Pagotto, 'Look Again: The influence of Vilém Flusser on Brazilian photographer Rosângela Rennó', *Flusser Studies* 12 (November 2011) 9–11.

34 Shoumatoff, *The Capital of Hope*, 48

35 Sérgio Ferro cited in Richard J. Williams, 'Brasília after Brasília', *Progress in Planning* 67.4 (May 2007): 349.

36 Williams, 'Brasília', 349.

37 Ferro cited in Williams, 'Brasília', 349.

38 Williams, 'Brasília', 349.

39 Shoumatoff, *The Capital of Hope*, 48, 49.

40 Herkenhoff, 'Rennó ou a beleza', 170. He calls it 'um trabalho de luto'.

41 Judith Butler, *Frames of War: When is Life Grievable?* (London: Verso, 2010).

42 Fisher cited in Ngai, *Ugly Feelings*, 188.

43 Kathleen Woodward, 'Calculating Compassion', *Compassion*, 67.

44 Ibid., 69.

45 Ibid., 71; Sekula cited in Rosalyn Deutsche, 'Property Values: Hans Haake, Real Estate and the Museum'. *Evictions: Art and Spatial Politics* (Cambridge, MA: MIT Press, 1996), 170.

46 Sara Ahmed, *The Cultural Politics of Emotions* (Edinburgh: Edinburgh University Press, 2004) 112–113, 119.

47 Ibid., 112.

48 Gayatri Chakravorty Spivak with Ellen Rooney, 'In a Word. *Interview*', *Differences* 1.2 (Summer 1989) 147.

49 Rennó in 'Conversation between Rosângela Rennó and Hans-Michael Herzog', 87.

50 Ibid., 86; and Rennó in Melissa Chiu, 'Rosângela Rennó Interview', 42.

51 Rennó, 'Imemorial e desidentificado', 3.

52 Merewether, 'Archives of the Fallen', 46.

53 Rennó in Chiu, 'Rosângela Rennó Interview', 41.

54 Rennó in 'Conversation between Rosângela Rennó and Hans-Michael Herzog', 86.

55 Lauren Berlant, *Cruel Optimism* (Durham, NC: Duke University Press, 2011) 10.

56 Ibid., 196.

57 Ibid., 20.

58 Rosângela Rennó, *Bibliotheca*, (Barcelona: Editorial Gustavo Gili, 2003) 34.

59 Ibid.

60 Ibid., 35.

61 Ibid.

62 Sekula, 'The Body and the Archive', 17.

63 Rennó, *O arquivo universal*, 61, 63.

64 Rennó in Chiu, 'Rosângela Rennó Interview', 41.

65 Woodward, 'Calculating Compassion', 61.

66 Leys, 'The Turn to Affect', 437.

67 Rennó, *O arquivo universal*, 61.

68 Mariana Pagotto notes that this was her first response, 'Look Again', 14.

69 Paulo Herkenhoff, 'Rosângela Rennó, a filosofia da instituiçao fotográfica', *Artes Mundi 3 2008, Wales International Visual Art Exhibition and Prize*, exh. cat. (Cardiff: Artes Mundi, 2008). http://www.rosangelarenno.com.br/uploads/File/bibliografia/PHerkenhoff08port.pdf (accessed November 2014).

70 http://news.bbc.co.uk/2/hi/americas/2532455.stm (accessed November 2014).

71 http://articles.baltimoresun.com/1990-11-25/news/1990329094_1_paulo-brazil-exhumation (accessed November 2014).

72 According to the International Center for Transitional Justice: 'Despite some efforts, Brazil has not yet sought criminal accountability or robust truth seeking for the human rights violations committed by the former dictatorship (1964–1985).' http://www.ictj.org/our-work/regions-and-countries/brazil (accessed November 2014).

73 Part of the report is published in English as *Torture in Brazil: A Shocking Report on the Pervasive Use of Torture by Brazilian Military Governments, 1964–1979, Secretly Prepared by the Archdiocese of São Paulo*, trans. Jaime Wright, ed. with a new preface by Joan Dassin (Austin: University of Texas Press, 1998). As the author credit indicates, not only was the report privately produced, it was prepared in secret. See the summary: http://www.usip.org/publications/commission-of-inquiry-brazil (accessed November 2014).

74 Ana Longoni, 'Photographs and Silhouettes: Visual Politics in the Human Rights Movement of Argentina', *Afterall* 25 (Autumn 2010): 5.

75 Ibid., 6.

76 Nelly Richard cited in Longoni, 'Photographs and Silhouettes', 7.

77 Rennó in Chiu, 'Rosângela Rennó Interview', 41.

78 Crespo, 'Intensifying Images', 202.

79 Baer, *Spectral Evidence*, 84.

80 Ibid., 83–84.

81 Rennó in 'Conversation between Rosângela Rennó and Hans-Michael Herzog', 87.

Chapter 6

1 Milagros de la Torre in Edward Ball, 'Interview: Milagros de la Torre', *Schön! Magazine*, November 23, 2013 http://schonmagazine.com/MilagrosDeLaTorre (accessed November 2014).

2 Maria Hlavajova and Jill Winder, 'Introduction', *Concerning War: A Critical Reader in Contemporary Art*, ed. Maria Hlavajova and Jill Winder (Utrecht: BAK, 2010) 12. Hlavajova and Winder cite a number of theorists (unspecified), building on the work of Giorgio Agamben, as well as Michael Hardt and Antonio Negri, as proponents of this idea of general global war. In contrast, Steven Pinker argues this is the most peaceful period in history. See *The Better Angels of Our Nature: A History of Violence and Humanity* (London: Penguin 2011).

3 William E. Ewing, Roger Mayou and Klaus Scherer, 'Preface', Nathalie Herschdorfer, *Afterwards: Contemporary Photography Confronting the Past* (London: Thames and Hudson, 2011) 11.

4 Herschdorfer, 'Introduction', *Afterwards*, 14.

5 Ibid.

6 Paul Lowe also argues empty landscapes can somehow call up the event through the tension between the title and the banality of the scene. See Lowe, 'The Forensic Turn: Bearing Witness and the "Thingness" of the Photography', 213.

7 Baer, *Spectral Evidence,* 83.

8 Michael Fried, *Why Photography Matters as Never Before* (New Haven: Yale University Press, 2008) 152.

9 Jean Franco, *Cruel Modernity* (Durham, NC: Duke University Press, 2013) 3, 11, 13.

10 Ibid., 13.

11 Milagros de la Torre in Edward J. Sullivan, 'Interview with Milagros de la Torre'.

12 Francisco Reyes Palma, 'Fetishes of Infamy. Fetishes of Light (An Interview with Milagros de la Torre)', *EXIT #1 Crimes and Misdemeanors*, February/April 2001 http://www.exitmedia.net/prueba/eng/articulo.php?id=14 (accessed December 2014).

13 A Peruvian blog, El útero de Marita, perpetuates this tabloid headline: http://utero.pe/. *El útero de Marita* has thereby become a byword for murky and sordid journalism in Peru. See the blogger Marco Sifuentes' explanation here: http://peru21.pe/noticia/52385/marco-sifuentes-utero-marita-blog-nueva-agora (accessed December 2014).

14 http://peru.com/2012/05/11/actualidad/mi-ciudad/sujeto-que-asesino-marita-alpaca-1990-aparece-haberse-hecho-muerto-noticia-63532 (accessed December 2014).

15 Poggi features in James Marrison, *The World's Most Bizarre Murders: True Stories That Will Shock and Amaze You* (London: John Blake, 2008) 178–181.

16 http://elcomercio.pe/blog/huellasdigitales/2011/02/mario-poggi-o-el-histrion-de-l (accessed December 2014).

17 http://www.larepublica.pe/20-12-2010/vuelve-el-loco-perochena-pistolero-de-los-80-reaparece-balazos-en-surco (accessed December 2014).

18 Colleen Sullivan describes it as a terrorism campaign in, 'Shining Path', *The Sage Encyclopedia of Terrorism*, ed. Gus Martin, 2nd ed (London: Sage, 2011) 541.

19 Milagros de la Torre in Sullivan, 'Interview'.

20 Orin Starn, Carlos Iván Degregori and Robin Kirk, 'The Shining Path', *The Peru Reader: History, Culture, Politics*, ed. Orin Starn, Carlos Iván Degregori and Robin Kirk (Durham, NC: Duke University Press, 2005) 321.

21 Starn, Degregori and Kirk, 'Manchay Tiempo', *The Peru Reader,* 353–355.

22 Sullivan, 'Shining Path', 542.

23 Steve J. Stern, 'Introduction to Part Five', *Shining and Other Paths: War and Society in Peru, 1980–1995*, ed. Steve J. Stern (Durham, NC: Duke University Press, 1998) 377.

24 De la Torre in Sullivan, 'Interview'.

25 Gustavo Gorriti, 'The Quota', *The Peru Reader*, 331.

26 Starn et al., 'Introduction', *The Peru Reader*, 5.

27 Guzmán cited in Gorriti, 'The Quota', 331. In an interview in 1988, Guzmán said: 'We began planning for the bloodbath in 1980 because we knew it had to come.'

28 Steve J. Stern, 'Introduction. Beyond Enigma: An Agenda for Interpreting Shining Path and Peru, 1980–1995', *Shining and Other Paths*, 1.

29 Ibid., 1.

30 Mariátegui cited in Sullivan, 'Shining Path', 541.

31 Starn et al., 'The Shining Path', *The Peru Reader*, 319.

32 Orin Starn, 'Villagers at Arms: War and Counterrevolution in the Central-South Andes', *Shining and Other Paths,* 224, 229.

33 Ibid., 229.

34 Ibid., 233.

35 See Starn et al., 'The Advent of Modern Politics', *The Peru Reader*, 229.

36 Enrique Mayer, 'Peru in Deep Trouble: Mario Vargas Llosa's "Inquest in the Andes" Reexamined', *Cultural Anthropology*, 6.4 (November 1991) 481.

37 Carlos Basombrío Iglesias, 'Sendero Luminoso and Human Rights: A Perverse Logic that Captured the Country', *Shining and Other Paths*, 427.

38 Ibid., 440.

39 Guzmán cited in Basombrío Iglesias, 'Sendero Luminoso', 431.

40 Basombrío Iglesias, 'Sendero Luminoso', 431

41 Ibid.

42 Steve J. Stern, 'Introduction to Part 2', *Shining and Other Paths*, 122.

43 Mayer describes the tools used in the massacre in Mayer, 'Peru in Deep Trouble', 466. Jean Franco reports that the territory was partly held by the Senderistas in Franco, *Cruel Modernity*, 57.

44 Mayer is suspicious of the 'unanimity of the testimony' seeing it as highly scripted. Mayer, 'Peru in Deep Trouble', 490–491.

45 Mario Vargos Llosa, 'Inquest in the Andes', trans. Edith Grossman, *The New York Times*, 31 July 1983, http://www.nytimes.com/1983/07/31/magazine/inquest-in-the-andes.html (accessed November 2011). The photographs can be viewed here: http://uchuraccay.blogspot.com.au

46 Jean Franco, 'Alien to Modernity', *A Contra corriente: A Journal of Social History and Literature in Latin America* 3.3 (Spring 2006) 9.

47 Vargas Llosa, 'Inquest in the Andes'.

48 Franco, 'Alien to Modernity', 8.

49 Vargos Llosa, 'Inquest in the Andes'.

50 Ibid.

51 Ibid.

52 Jean Franco's summary of the conclusions of the Truth and Reconciliation Commission. Franco, *Cruel Modernity*, 63.

53 Ibid., 60.

54 Cited in Starn et al., 'The Shining Path', *The Peru Reader*, 320.

55 Osmán Morote, 'A Frightening Thirst for Vengence', *The Peru Reader*, 324.

56 Roudinesco, *Our Dark Side*, 160.

57 Ibid., 4–5.

58 She cites Freud's letter to Marie Bonaparte in June 1937: 'One may regard . . . curiosity, the impulse to investigate, as a complete sublimation of the aggressive or destructive instinct.' Ibid., 71.

59 Joel Whitebook, *Perversion and Utopia: A Study in Psychoanalysis and Critical Theory*, (Cambridge, MA: MIT Press, 1995) 21.

60 Freud cited in Ibid.

61 Whitebook, *Perversion and Utopia*, 20.

62 Ibid., 218, 63.

63 Ibid., 42

64 Hoess (Hess) cited in Roudinesco, *Our Dark Side*, 110.

65 Chasseguet-Smirgel cited in Whitebook, *Perversion and Utopia*, 62.

66 Whitebook, *Perversion and Utopia*, 62

67 Martin Heidegger, *Being and Time*, trans. John Macquarrie and Edward Robinson (Oxford: Blackwell, 1962) ¶ 15, 95–102.

68 Franco, *Cruel Modernity*, 15.

69 De la Torre in Reyes Palma, 'Fetishes of Infamy'.

70 Shelley Rice, 'Observed: Milagros de la Torre', *Le Magazine Jeu de Paume*, 23 March 2012 http://lemagazine.jeudepaume.org/blogs/shelleyrice/2012/03/23/ observed-milagros-de-la-torre/ (accessed November 2014).

71 Katherine Hite, '"The Eye that Cries": The Politics of Representing Victims in Contemporary Peru', *A Contra corriente: A Journal of Social History and Literature in Latin America* 5.1 (Fall 2007): 111.

72 Ibid., 112.

73 Ibid., 113.

74 Truth and Reconciliation Commission (TRC) Press Release 226: 'TRC Final Report was made public on August 28th 2003 at noon.' http://www.cverdad. org.pe/ingles/pagina01.php (accessed November 2014).

75 Ibid.

76 Susan Sontag, *Regarding the Pain of Others* (London: Penguin, 2003) 38, 82.

77 Ibid., 72, 73.

78 Fried, *Why Photography Matters*, 32.

79 This is the title of the first section of Part 1 of the book. Part 1 is the original catalogue essay. See Georges Didi-Huberman, *Images in Spite of All: Four Photographs from Auschwitz*, trans. Shane B. Lillis (Chicago: Chicago University Press, 2008) 3–17.

80 Ibid., 12–15.

81 Critics cited in Didi-Huberman, *Images in Spite of All*, 55, 54.

82 Elisabeth Pagnoux cited in Didi-Huberman, *Images in Spite of All*, 55.

83 Didi-Huberman, *Images in Spite of All*, 66.

84 Ibid., 56–57.

85 Ibid., 119.

86 Ibid., 57.

87 See Sontag's discussion of the lynching photographs in *Regarding the Pain*, 81–83; see also Fried's commentary on her discussion, Fried, *Why Photography Matters*, 31–32. See also Dora Apel and Shawn Michelle Smith, *Lynching Photographs* (Berkeley: University of California Press, 2007).

88 Paul Ricouer, 'Memory, History, Forgiveness: A Dialogue between Paul Ricoeur and Sorin Antohi', trans. Gil Anidjar, *Janus Head* 8.1 (2005): 11.

89 Ibid.

Conclusion

1 Vered Maimon, 'The Third Citizen: On Models of Criticality in Contemporary Artistic Practices', *October* 129 (Summer 2009): 92, 96; Rancière cited in Ibid., 94.

2 Rancière cited in Ibid., 94; Baer, *Spectral Evidence*, 83.

3 Maimon, 'The Third Citizen', 86.

4 This point is attributed to a passage from Rancière that discusses public opinion as constructed by polls and also comprises a critique of Jean Baudrillard. Jacques Rancière, *Disagreement: Politics and Philosophy*, trans. Julie Rose (Minneapolis: University of Minnesota Press, 1999) 103–104.

5 Jacques Rancière, 'Introducing Disagreement', trans. Steven Corcoran, *Angelaki*, 9.3 (2004): 7.

6 Maimon, 'The Third Citizen', 96.

7 Ibid., 100.

8 Ibid.

9 Ibid., 92. John Roberts calls this model photography's violating power of 'pointing at' or 'pointing to': '*Photography violates precisely because social appearances hide, in turn, division, hierarchy, exclusion.*' Roberts, *Photography and its Violations*, 1–2.

10 See Jean Baudrillard, 'The Precession of Simulacra', *Simulations*, trans. Paul Foss et al. (New York: Semiotext(e), 1983) 1–79.

11 Raad has become the poster boy for 'good' political art for critics of many different stripes. For example, Abigail Solomon-Godeau contrasted Raad's 'good' political art (personal link to the conflict in Lebanon) and Sophie Ristelhueber's bad political art (no personal relationship to conflicts depicted), citing an ethics of representation, namely the right to represent. Abigail Solomon Godeau, 'Beautiful Suffering: The Image of Catastrophe', Lecture at University of Sydney, 25 October 2011.

12 Sedgwick, 'Paranoid Reading', 125.

13 Jacques Derrida, interview, 'Deconstruction and the Other', Richard Kearney, *Dialogues with Contemporary Continental Thinkers: The Phenomenological Heritage* (Manchester: Manchester University Press, 1984) 123–124.

14 Milagros de la Torre in Edward Ball, 'Interview: Milagros de la Torre'.

15 Joel Smith, 'More than One: Sources of Serialism', *More than One: Photographs in Sequence*, exh. cat. (Princeton: Princeton University Art Museum; New Haven: Yale University Press, 2008) 10, 14.

16 Sedgwick, 'Paranoid Reading', 149.

17 Jacques Rancière, 'Sentence, Image, History', *The Future of the Image*. trans. Gregory Elliott (London: Verso, 2007) 48.

18 Ibid., 46.

19 Fried cited in Vered Maimon, 'Michael Fried's Modernist Theory of Photography'. *History of Photography* 34.4 (2010): 387.

20 See Best, *Visualizing Feeling*, 12–28.

21 Michael Fried, 'Art and Objecthood', *Minimal Art: A Critical Anthology*, ed. Gregory Battcock (Berkeley: University of California Press, 1968) 140.

22 Fried, *Why Photography Matters as Never Before*, 152.

23 Delahaye cited in Ibid, 184.

24 Fried, *Why Photography Matters as Never Before*, 158. Fried refers to
Gursky's pictures as having 'autonomy' and 'self-sufficiency' produced by
'severing' them from the beholder. Some of Fried's interpretations of
photographs are astonishingly brilliant (chapter 7 in particular), others I find
much less convincing. This is the case with his interpretation of Delahaye
whom he argues draws the viewer in closely to peer at the images (184). In
reproduction, Delahaye's landscape images look very cold (as are many of the
photographs in Fried's book). I cannot imagine myself being drawn towards
them. However, viewed in the flesh he may be correct. The one image I have
seen of the dead Taliban soldier, *Taliban* (2001), was both fascinating and
repellant; being able to scrutinize a dead body in such detail felt invasive and
highly inappropriate.

Bibliography

Ahmed, Sara. *The Cultural Politics of Emotions*. Edinburgh: Edinburgh University Press, 2004.

Alberro, Alexander. 'Beauty Knows No Pain'. *Art Journal* 63.2 (Summer 2004): 36–43.

Alexander, Alison. 'Photography'. *The Companion to Tasmanian History*. http://www.utas.edu.au/library/companion_to_tasmanian_history/P/Photography.htm (accessed 14 July 2014).

Allen, Judith. 'Evidence and Silence: Feminism and the Limits of History'. *Feminist Challenges: Social and Political Theory*. Ed. Carole Pateman and Elizabeth Gross. Sydney: Allen and Unwin, 1986. 173–189.

Altieri, Charles. 'Affect, Intention, and Cognition: A Response to Ruth Leys'. *Critical Inquiry* 38.4 (Summer 2012): 878–881.

Alweiss, Lilian. 'Collective Guilt and Responsibility: Some Reflections'. *European Journal of Political Theory* 2.307 (2003): 307–318.

Alzugaray, Paula. 'Rosângela Rennó: O artista como narrador'. *Rosângela Rennó*, São Paulo: Paço das Artes, 2004. http://www.rosangelarenno.com.br/bibliografia/en (accessed September 2012).

Apel, Dora. *Memory Effects: The Holocaust and the Art of Secondary Witnessing*. New Brunswick: Rutgers University Press, 2002.

Apel, Dora and Shawn Michelle Smith. *Lynching Photographs*. Berkeley: University of California Press, 2007.

Asselin, Olivier, Johanne Lamoureux and Christine Ross. Eds. *Precarious Visualities: New Perspectives on Identification in Contemporary Art and Visual Culture*. Montreal: McGill-Queens University Press, 2008.

Attia, Kader. *The Repair: From Occident to Extra-Occidental Cultures*. Berlin: Greenbox, 2014.

Azoulay, Ariella. *The Civil Contract of Photography*. New York: Zone, 2008.

Baer, Ulrich. *Spectral Evidence: The Photography of Trauma*. Cambridge, MA: MIT Press, 2002.

Baker, Kriselle. 'The Truth of Lineage Time and Tā Moko'. *Fiona Pardington: The Pressure of Sunlight Falling*. Ed. Kriselle Baker and Elizabeth Rankin. Dunedin: Otago University Press in association with Govett-Brewster Art Gallery and Two Rooms Gallery, 2011. 26–34.

Baker, Simon and Shaoir Mavlian. Eds. *Conflict, Time, Photography*. Exh. cat. London: Tate, 2014.

Ball, Edward. 'Interview: Milagros de la Torre'. *Schön! Magazine* (23 November 2013). http://schonmagazine.com/MilagrosDeLaTorre (accessed November 2014).

Batchen, Geoffrey. 'The Distance that Cannot be Photographed: Geoffrey Batchen Interviews Anne Ferran'. *Flash: Reviews, Interviews, Comment*, 2009. http://www.ccp.org.au/flash/2009/02/anne-ferran/ (accessed 7 July 2014).

Batchen, Geoffrey, Mick Gidley, Nancy K. Miller, and Jay Prosser. Eds. *Picturing Atrocity: Photography in Crisis*. London: Reaktion, 2012.

Beaulieu, Jill, Mary Roberts and Toni Ross. 'An Interview with Michael Fried'. *Refracting Vision: Essays on the Writings of Michael Fried*. Ed. Jill Beaulieu, Mary Roberts and Toni Ross. Sydney: Power Publications, 2000. 377–404.

Benjamin, Walter. 'The Author as Producer'. Trans. Edmund Jephcott. *Art after Modernism: Rethinking Representation*. Ed. Brian Wallis. New York: New Museum of Contemporary Art, 1984. 297–309.

Bennett, Jill. *Empathic Vision: Affect, Trauma and Contemporary Art*. Palo Alto: Stanford University Press, 2005.

Berlant, Lauren. 'Introduction: Compassion (and Withholding)'. *Compassion: The Culture and Politics of an Emotion*. Ed. Lauren Berlant. New York and London: Routledge, 2004. 1–13.

Berlant, Lauren. *Cruel Optimism*. Durham, NC: Duke University Press, 2011.

Bersani, Leo. *The Culture of Redemption*. Cambridge, MA: Harvard University Press, 1990.

Best, Susan. *Visualizing Feeling: Affect and the Feminine Avant-garde*. London: I B Tauris, 2011.

Best, Susan. 'Review of Feeling Photography'. *caareviews* March 26, 2015 DOI: 10.3202/caa.reviews.2015.35

Bishop, Claire. 'Antagonism and Relational Aesthetics'. *October* 110 (Fall 2004): 51–79.

Blackley, Roger. 'Beauty and the Beast: Plaster Casts in a Colonial Museum'. *On Display: New Essays in Cultural Studies*. Ed. Anna Smith and Lydia Wevers. Wellington: Victoria University Press, 2004. 52–53.

Blackley, Roger. 'The Mystery of Matoua Tawai: Fiona Pardington at the Govett-Brewster', *Art New Zealand* 139 (Spring 2011): 61–63.

Blackley, Roger. 'Metamorphosis, review of Fiona Pardington: The Pressure of Sunlight Falling'. *Landfall Review Online* (September 2011). http://www. landfallreview.com/metamorphosis/ (accessed August 2015).

Blocker, Jane. *Seeing Witness: Visuality and the Ethics of Testimony*. Minneapolis: University of Minnesota Press, 2009.

Boppré, Fernando C. 'Imemorial e desidentificado: Entrevista com Rosângela Rennó'. http://www.fernandoboppre.net/wordpress/wp-content/ uploads/2009/01/IMEMORIAL-E-DESIDENTIFICADO-ENTREVISTA-COM-ROS%C3%82NGELA-RENN%C3%93.pdf (accessed October 2014).

Butler, Judith. *Precarious Life: The Powers of Mourning and Violence*. London: Verso, 2004.

Butler, Judith. *Frames of War: When is Life Grievable?* London: Verso, 2010.

Campany, David. 'Safety in Numbness: Some Remarks on "Late Photography"' (2003). *The Cinematic*. Ed. David Campany. London: Whitechapel Gallery and Cambridge, MA: MIT Press, 2007. 185–194.

Cartier-Bresson, Henri. *The Mind's Eye*. New York: Aperture, 1999.

Caruth, Cathy. 'An Interview with Jean Laplanche'. *Postmodern Culture* 11.2 (2001). http://muse.jhu.edu.wwwproxy0.library.unsw.edu.au/journals/ postmodern_culture/v011/11.2caruth.html (accessed 16 February 2014).

Cavalcanti, Laura. 'When Brazil was Modern: From Rio de Janeiro to Brasilia'. *Cruelty & Utopia: Cities and Landscapes in Latin America*. Exh. cat. Brussels:

The International Centre for Urbanism, Architecture and Landscape and New York: Princeton Architectural Press, 2003. 161–170.

Chiu, Melissa. 'Rosângela Rennó Interview'. Rosângela Rennó, *Vulgo* [Alias]. Ed. Melissa Chiu. Exh. cat. Kingswood: University of Western Sydney, 1999. 40–45.

Cho, Lily. 'Anticipating Citizenship: Chinese Head Tax Photographs'. *Feeling Photography*. Ed. Elspeth H. Brown and Thy Phu. Durham, NC: Duke University Press, 2014. 158–180.

Clough, Patricia Ticineto and Jean Halley. Eds., *The Affective Turn: Theorizing the Social*. Durham, NC: Duke University Press, 2007.

Connolly, William E. 'The Complexity of Intention'. *Critical Inquiry* 37.4 (Summer 2011): 791–798.

Convict Women's Research Centre, *Convict Lives: Women at the Cascades Female Factory*, 2nd ed. Hobart: Convict Women's Press, 2012.

Crespo, Nuno. 'Intensifying Images'. *Strange Fruit*. Exh. cat. Lisbon: Fundaçao Calouste Gulbenkian CAM and Winterthur: Fotomuseum Winterthur, 2012. 59–69.

Damousi, Joy. *Depraved and Disorderly: Female Convicts, Sexuality and Gender in Colonial Australia*. Cambridge: Cambridge University Press, 1997.

Daniels, Kay. *Convict Women*. Sydney: Allen & Unwin, 1998.

Danto, Arthur. *The Abuse of Beauty: Aesthetics and the Concept of Art*. Chicago: Open Court, 2003.

Dassin, Joan. Ed. *Torture in Brazil: A Shocking Report on the Pervasive Use of Torture by Brazilian Military Governments, 1964–1979*. Secretly Prepared by the Archdiocese of São Paulo. Trans. Jaime Wright. Austin: University of Texas Press, 1998.

De Duve, Thierry. 'Art in the Face of Radical Evil'. *October* 125 (Summer 2008): 3–23.

De Duve, Thierry. 'An Interview with Anne Ferran'. *Anne Ferran: Shadow Land*. Exh. cat. Perth: Lawrence Wilson Art Gallery, University of Western Australia and Sydney: Power Publications, 2014. 63–91.

Delmez, Kathryn E. '"Real Facts, by Real People": Folklore in the Early Work of Carrie Mae Weems'. *Carrie Mae Weems: Three Decades of Photography and Video*. Ed. Kathryn E. Delmez. Nashville: Frist Center for the Visual Arts in association with New Haven: Yale University Press, 2013. 11–19.

Demos, T. J. *The Migrant Image: The Art and Politics of Documentary during Global Crisis*. Durham, NC: Duke University Press, 2013.

Derrida, Jacques. Interview. 'Deconstruction and the Other'. Richard Kearney, *Dialogues with Contemporary Continental Thinkers: The Phenomenological Heritage*. Manchester: Manchester University Press, 1984. 107–126.

Deutsche, Rosalyn. 'Property Values: Hans Haake, Real Estate and the Museum'. *Evictions: Art and Spatial Politics*. Cambridge, MA: MIT Press, 1996, 159–192.

Devenport, Rhana. 'Fiona Pardington: Portraiture, Immanence and Empathy'. *Art and Australia* 48.3 (2011): 530–535.

Devenport, Rhana. 'Foreword', *Fiona Pardington: The Pressure of Sunlight Falling*. Ed. Kriselle Baker and Elizabeth Rankin. Dunedin: Otago University Press in association with Govett-Brewster Art Gallery and Two Rooms Gallery, 2011. 6–9.

Didi-Huberman, Georges. *Images in Spite of All: Four Photographs from Auschwitz*. Trans. Shane B. Lillis. Chicago: Chicago University Press, 2008.

Doss, Erika. *Memorial Mania: Public Feeling in America*. Chicago: Chicago
 University Press, 2010.
Douglas, Bronwen. 'Science and the Art of Representing "Savages": Reading
 "Race" in Text and Image in South Seas Voyage Literature'. *History and
 Anthropology* 11.2–3 (1999): 157–201.
Douglas, Bronwen. '"*Novus Orbis Australis*": Oceania in the Science of Race,
 1750–1850', *Foreign Bodies: Oceania and the Science of Race 1750–1940*.
 Ed. Bronwen Douglas and Chris Ballard. Canberra: ANU E Press, 2008.
 99–142.
Eckmann, Sabine. Ed. *In the Aftermath of Trauma: Contemporary Video
 Installations*. Exh. cat. St Louis: Mildred Lane Kemper Art Museum,
 2014.
Edwards, Elizabeth. *Raw Histories: Photographs, Anthropology and Museums*
 Oxford: Berg, 2001.
Elkins, James. *What Photography Is*. London: Routledge, 2011.
Elkins, James and Harper Montgomery. Eds. *Beyond the Aesthetic and the
 Anti–Aesthetic*. University Park: Penn State University Press, 2013.
Elliott, David. 'Embossing the Abyss: The Work of Fiona Pardington'. *Fiona
 Pardington: The Pressure of Sunlight Falling*. Ed. Kriselle Baker and Elizabeth
 Rankin. Dunedin: Otago University Press in association with Govett–Brewster
 Art Gallery and Two Rooms Gallery, 2011. 19–25.
Ellis, John. *Seeing Things: Television in an Age of Uncertainty*. London: I B Tauris,
 2000.
Enwezor, Okwui. *Archive Fever: Uses of the Document in Contemporary Art*.
 Exh. cat. New York: International Center of Photography, 2008.
Felman, Shoshana and Dori Laub. *Testimony: Crises of Witnessing in Literature,
 Psychoanalysis, and History*. New York: Routledge, 1992.
Ferenczi, Sándor. 'Confusion of the Tongues Between the Adults and the Child
 – (The Language of Tenderness and of Passion)'. *The International Journal of
 Psychoanalysis* 30 (1949): 225–230.
Ferenczi, Sándor. *Final Contributions to the Problems and Methods of
 Psycho-Analysis*. Trans. Eric Mosbacher and others. London: Karnac 1994.
Ferran, Anne. Artist's statement for Stills Gallery, 2001, n.p.
Ferran, Anne. 'Empty', *Photofile* 66 (September 2002): 4–9.
Foster, Hal. 'The Artist as Ethnographer'. *The Return of the Real*. Cambridge,
 MA: MIT Press, 1996. 171–203.
Foster, Hal. 'An Archival Impulse'. *October* 110 (2004): 3–22.
Franco, Jean. 'Alien to Modernity'. *A Contra corriente: A Journal of Social History
 and Literature in Latin America* 3.3 (Spring 2006): 1–16.
Franco, Jean. *Cruel Modernity*. Durham, NC: Duke University Press, 2013.
Frank, Adam and Elizabeth A. Wilson, 'Like-Minded'. *Critical Inquiry* 38.4
 (Summer 2012): 870–877.
Frankel, Jay. 'Exploring Ferenczi's Concept of Identification with the Aggressor:
 Its Role in Trauma, Everyday Life, and the Therapeutic Relationship'.
 Psychoanalytic Dialogues: The International Journal of Relational Perspectives
 12.1 (2002): 101–139.
Freud, Sigmund. 'Group Psychology and the Analysis of the Ego', *Civilization,
 Society and Religion, Vol 12 Penguin Freud Library*. Trans. James Strachey.
 Harmondsworth: Penguin, 1985. 91–178.

Freud, Anna. 'Identification with the Aggressor'. *The Ego and the Mechanisms of Defence*. Trans. Cecil Baines. New York: International Universities Press, 1946. 117–131.

Fried, Michael. 'Art and Objecthood'. *Minimal Art: A Critical Anthology*. Ed. Gregory Battcock. Berkeley: University of California Press, 1968. 116–147.

Fried, Michael. *Absorption and Theatricality: Painting and Beholder in the Age of Diderot*. Berkeley: University of California Press, 1980.

Fried, Michael. *Why Photography Matters as Never Before*. New Haven: Yale University Press, 2008.

Frosh, Paul and Amit Pinchevski. Eds. *Media Witnessing: Testimony in the Age of Mass Communication*. Houndmills: Palgrave Macmillan, 2009.

Frost, Lucy. Ed. *Convict Lives at the Ross Female Factory*. Hobart: Convict Women's Press, 2011.

Fuss, Diana. *Essentially Speaking: Feminism, Nature and Difference*. London and New York: Routledge, 1989.

Fuss, Diana. *Identification Papers: Readings on Psychoanalysis, Sexuality, and Culture*. London and New York: Routledge, 1995.

Godfrey, Mark. 'Photography Found and Lost: On Tacita Dean's *Floh*'. *October* 114 (Autumn 2005): 90–119.

Gorriti, Gustavo. 'The Quota'. *The Peru Reader: History, Culture, Politics*. Ed. Orin Starn, Carlos Iván Degregori and Robin Kirk. Durham, NC: Duke University Press, 2005. 331–342.

Green, André. *The Fabric of Affect in the Psychoanalytic Discourse*. Trans. Alan Sheridan. London: Routledge, 1999.

Greene, Joshua. *Tribal Minds: Emotion, Reason, and the Gap Between Us and Them*. London: Penguin, 2013.

Gregg, Melissa and Gregory J. Seigworth. Eds. *The Affect Theory Reader*. Durham, NC: Duke University Press, 2010.

Grosz, Elizabeth. 'Criticism, Feminism and the Institution: An Interview with Gayatri Spivak'. *Thesis Eleven* 10/11 (1985): 175–189.

Grosz, Elizabeth. 'A Note on Essentialism and Difference'. *A Reader in Feminist Knowledge*. Ed. Sneja Gunew. London and New York: Routledge, 1991. 332–344.

Guerin, Frances and Roger Hallas. Eds. *The Image and the Witness: Trauma, Memory and Visual Culture*. London: Wallflower, 2007.

Heidegger, Martin. *Being and Time*. Trans. John Macquarrie and Edward Robinson. Oxford: Blackwell, 1962.

Hendriksen, Gay. 'Women Transported – Myth and Reality'. *Women Transported: Life in Australia's Convict Female Factories*. Exh. cat. Parramatta: Parramatta Heritage Centre, 2008. 7–27.

Herkenhoff, Paulo. 'Rennó ou a beleza e o dulçor do presente', *Rosângela Rennó*. São Paulo: University of São Paulo, 1998. 115–191.

Herkenhoff, Paulo. 'Rosângela Rennó, a filosofia da instituiçao fotográfica'. *Artes Mundi 3 2008, Wales International Visual Art Exhibition and Prize*. Exh. cat. Cardiff: Artes Mundi, 2008. 76–83.

Herschdorfer, Nathalie. *Afterwards: Contemporary Photography Confronting the Past*. London: Thames and Hudson, 2011.

Herzog, Hans-Michael. 'Conversation between Rosângela Rennó and Hans-Michael Herzog'. *La Mirada – Looking at Photography in Latin America Today*,

Conversations. Vol. 2. Ed. Hans-Michael Herzog. Zurich: Daros Latin America
 Collection, Edition Oehrli, 2002. 85–90.

Hirst, John. 'An Oddity From the Start: Convicts and National Character'. *The
 Monthly*, July 2008. http://www.themonthly.com.au/issue/2008/
 july/1277335186/john-hirst/oddity-start (accessed 25 June 2014).

Hite, Katherine. '"The Eye that Cries": The Politics of Representing Victims in
 Contemporary Peru'. *A Contra corriente: A Journal of Social History and
 Literature in Latin America* 5.1 (Fall 2007): 108–134.

Hlavajova, Maria and Jill Winder. Eds. *Concerning War: A Critical Reader in
 Contemporary Art*. Utrecht: BAK, 2010.

Holmes, Jonathon. 'An Interview with Anne Ferran'. Anne Ferran, *The Ground,
 the Air*. Exh. cat. Hobart: Tasmanian Museum and Art Gallery, 2008. 50–55.

Hunt, Susan. 'Southern Discomfort'. *Lure of the Southern Seas: The Voyages of
 Dumont D'Urville 1826–1840*. Exh. cat. Sydney: Historic Houses Trust, 2002.
 11–19.

Iglesias, Carlos Basombrío. 'Sendero Luminoso and Human Rights: A Perverse
 Logic that Captured the Country'. *Shining and Other Paths: War and Society in
 Peru, 1980–1995*. Ed. Steve J. Stern. Durham, NC: Duke University Press,
 1998. 425–446.

Jacobowitz, Florence. '*Shoah* as Cinema'. *Image and Remembrance:
 Representation and the Holocaust*. Ed. Shelley Hornstein and Florence
 Jacobowitz. Bloomington: Indiana University Press, 2003. 7–21.

Jones, Amelia. *Seeing Differently: A History and Theory of Identification and the
 Visual Arts*. London and New York: Routledge, 2012.

Kamehiro, Stacy L. 'Documents, Specimens, Portraits: Dumoutier's Oceanic
 Casts', *Fiona Pardington: The Pressure of Sunlight Falling*. Ed. Kriselle Baker
 and Elizabeth Rankin. Dunedin: Otago University Press in association with
 Govett-Brewster Art Gallery and Two Rooms Gallery, 2011. 102–112.

Kaplan, E. Ann. *Trauma Culture: The Politics of Terror and Loss in Media and
 Literature*. New Brunswick: Rutgers University Press, 2005.

Kelly, Michael. *A Hunger for Aesthetics: Enacting the Demands of Art*. New York:
 Columbia University Press, 2012.

Kent, Rachel, et al. *Witness: Darren Almond, Brenda L. Croft, Zhang Huan,
 Whitfield Lovell, the Atlas Group/Walid Raad, Fiona Tan*. Exh. cat. Sydney:
 Museum of Contemporary Art, 2004.

Kerr, Joan. 'Introduction'. James Semple Kerr, *Out of Sight, Out of Mind:
 Australia's Places of Confinement, 1788–1988*. Exh. cat. Sydney: S. H. Ervin
 Gallery in association with The Australian Bicentennial Authority, 1988.
 1–10.

Klein, Melanie. 'Love, Guilt and Reparation'. (1937) Melanie Klein and Joan
 Riviere. *Love, Hate and Reparation*. New York and London: W. W. Norton,
 1964. 57–119.

Klein, Melanie. 'Notes on Some Schizoid Mechanisms'. (1946) *Envy and Gratitude
 and Other Works 1946–63*. London: Virago, 1988. 1–24.

Klein, Melanie. 'Some Theoretical Conclusions Regarding the Emotion Life of the
 Infant'. (1952) *Envy and Gratitude and Other Works 1946–1963*. London:
 Virago 1988. 61–93.

Lacan, Jacques. *Four Fundamental Concepts of Psycho-analysis*. Trans. Alan
 Sheridan. Harmondsworth: Penguin, 1977.

Lacan, Jacques. *The Seminar of Jacques Lacan. Book II. The Ego in Freud's Theory and in the Technique of Psychoanalysis, 1954–55*. Ed. Jacques-Alain Miller. Trans. Sylvana Tomaselli. New York: Norton, 1991.

LaCapra, Dominick. *History and Memory: After Auschwitz*. Ithaca: Cornell University Press, 1998.

LaCapra, Dominick. *Writing History: Writing Trauma*. Baltimore: Johns Hopkins University Press, 2001.

Langford, Martha. 'Strange Bedfellows: The Vernacular and Photographic Artists'. *Photography & Culture* 1.1 (July 2008): 73–94.

Laplanche, Jean and Jean-Bertrand Pontalis. *The Language of Psycho-analysis*. Trans. Donald Nicholson-Smith. London: Karnac, 1988.

Leakey, Caroline. *Broad Arrow: Being Passages from the History of Maida Gwynnham, A Lifer* (1859). n.p.: Dodo Press, n.d.

Le Fur, Yves. 'Dumoutier's artifacts: A Distant Glimmer of Ghosts'. *Fiona Pardington: The Pressure of Sunlight Falling*. Ed. Kriselle Baker and Elizabeth Rankin. Dunedin: Otago University Press in association with Govett-Brewster Art Gallery and Two Rooms Gallery, 2011. 78–83.

Leo, Russ. 'An Archive for Affect Theory', *Reviews in Cultural Theory*, 2.2 (August 2011). http://www.reviewsinculture.com/?r=61 (accessed October 2011).

Levin, Mikael. *War Story*. Exh. cat. Munich: Gina Kehayoff, 1997.

Leys, Ruth. *Trauma: A Genealogy*. Chicago: Chicago University Press, 2000.

Leys, Ruth. *From Guilt to Shame: Auschwitz and After*. Princeton: Princeton University Press, 2007.

Leys, Ruth. 'Navigating the Genealogies of Trauma, Guilt, Affect'. *University of Toronto Quarterly* 79.2 (2010): 656–679.

Leys, Ruth. 'The Turn to Affect: A Critique'. *Critical Inquiry* 37.3 (Spring 2011): 434–472.

Leys, Ruth. 'Affect and Intention: A Reply to William E. Connolly'. *Critical Inquiry* 37.4 (Summer 2011): 799–805.

Leys, Ruth. 'Facts and Moods: Reply to My Critics'. *Critical Inquiry* 38.4 (Summer 2012): 882–891.

Lind, Maria and Hito Steyerl. Eds. *The Green Room: Reconsidering Documentary and Art*. Berlin: Sternberg, 2008.

Linfield, Suzie. *The Cruel Radiance: Photography and Political Violence*. Chicago: Chicago University Press, 2010.

Special issue on 'Documentary Expanded'. *Aperture* 214 (Spring 2014).

Little, Janine. 'Talking with Ruby Langford Ginibi'. *Hecate: An Interdisciplinary Journal of Women's Liberation* 20.1 (1994): 100–120.

Llosa, Mario Vargos. 'Inquest in the Andes'. Trans. Edith Grossman. *The New York Times* (July 31, 1983). http://www.nytimes.com/1983/07/31/magazine/inquest-in-the-andes.html (accessed November 2011).

Longoni, Ana. 'Photographs and Silhouettes: Visual Politics in the Human Rights Movement of Argentina'. *Afterall* 25 (Autumn 2010): 5–17.

Love, Heather. *Feeling Backward: Loss and the Politics of Queer History*. Cambridge, MA: Harvard University Press, 2007.

Lowe, Paul. 'The Forensic Turn: Bearing Witness and the "Thingness" of the Photography'. *The Violence of the Image: Photography and International Conflict*. Ed. Liam Kennedy and Caitlin Patrick. London: I B Tauris 2014. 211–234.

Maimon, Vered. 'The Third Citizen: On Models of Criticality in Contemporary
 Artistic Practices'. *October* 129 (Summer 2009): 85–112.
Maimon, Vered. 'Michael Fried's Modernist Theory of Photography'. *History of
 Photography* 34.4 (2010): 387–395.
Marrison, James. *The World's Most Bizarre Murders: True Stories That Will Shock
 and Amaze You*. London: John Blake, 2008.
Martin, Peter. 'Could our convict past be why fewer women get ahead in
 Australia?', *Daily Life*, 28 June 2014. http://www.dailylife.com.au/news-and-
 views/could-our-convict-past-be-why-fewer-women-get-ahead-in-australia-
 20140629-3b18g.html (accessed 28 June 2014).
Massumi, Brian. 'The Autonomy of Affect'. *Cultural Critique* 31 (Fall 1995):
 83–109.
Massumi, Brian. *Parables for the Virtual: Movement, Affect, Sensation*. Durham,
 NC: Duke University Press, 2002.
Matte-Blanco, Ignacio. *Thinking, Feeling, and Being: Clinical Reflections on
 the Fundamental Antinomy of Human Beings and World*. London:
 Routledge, 1988.
Mayer, Enrique 'Peru in Deep Trouble: Mario Vargas Llosa's "Inquest in the
 Andes" Reexamined'. *Cultural Anthropology* 6.4 (November 1991): 466–504.
Melendi, Maria Angélica. 'Arquivos do mal – mal de arquivo', *Suplemento Literário*
 66 (dez. 2000): 22–30.
Merewether, Charles. 'Archives of the Fallen: Eugenio Dittborn, Milagros de la
 Torre, Rosângela Rennó'. *Grand Street* 62 (Fall, 1997): 36–47.
Merewether, Charles. 'To Bear Witness'. *Doris Salcedo*. Santa Fe: New Museum
 of Contemporary Art, 1998. 16–24.
Merewether, Charles. 'Violence and the Aesthetics of Redemption', *Memory and
 Oblivion: Proceedings of the XXIX International Congress of the History of Art
 held in Amsterdam, 1–7 September 1996*. Ed. Wessel Reinink and Joroen
 Stumpel. Dordecht: Kluwer, 1999. 1019–1023.
Meyer, James. 'Nomads'. *Site-specificity: The Ethnographic Turn*. Ed. A. Coles.
 London: Black Dog, 2000. 10–29.
Mitchell, Juliet. 'Introduction'. *The Selected Melanie Klein*. London: Penguin,
 1986. 9–32.
Morineau, Camille. 'elles@centrepompidou; Addressing Difference'. *elles@
 centrepompidou: Women Artists in the Collection of the Musée National d'art
 Moderne Centre de Création Industrielle*. Exh. cat. Pompidou Centre, Paris,
 2009. 14–19.
Muñoz, José Esteban. *Disidentifactions: Queers of Color and the Performance of
 Politics*. Minneapolis: University of Minnesota Press, 1999.
Nachtway, James. *Inferno*. London: Phaidon, 1999.
Ngai, Sianne. *Ugly Feelings*. Cambridge, MA: Harvard University Press,
 2005.
Olin, Margaret. *Touching Photographs*. Chicago: Chicago University Press, 2012.
Oliver, Kelly. *Witnessing: Beyond Recognition*. Minneapolis: Minnesota
 University Press, 2001.
Oxley, Deborah. *Convict Maids: The Forced Migration of Women to Australia*
 Cambridge: Cambridge University Press, 1996.
Papoulias, Constantina and Felicity Callard. 'Biology's Gift: Interrogating the Turn
 to Affect'. *Body & Society* 16 (2010): 29–56.

Pagotto, Mariana Bertelli. *Opacity and Re-enchantment: Photographic Strategies in the Work of Rosângela Rennó*. M. Art Theory. University of New South Wales, 2010.

Pagotto, Mariana Bertelli. 'Look Again: The Influence of Vilém Flusser on Brazilian Photographer Rosângela Rennó'. *Flusser Studies* 12 (November 2011): 1–20.

Palma, Francisco Reyes. 'Fetishes of Infamy. Fetishes of Light (An Interview with Milagros de la Torre)'. *EXIT #1 Crimes and Misdemeanors* (February/April 2001). http://www.exitmedia.net/prueba/eng/articulo.php?id=14 (accessed December 2014).

Pardington, Fiona. *Towards a Kaupapa of Ancestoral Power and Talk*. Doctor of Fine Arts. Auckland University, 2013.

Parks and Wildlife Service, Department of Environment and Land Management. *Ross Female Convict Station Historic Site: Conservation Plan*. April 1998.

Peláez, Miguel Gutiérrez. 'Trauma Theory in Sándor Ferenczi's Writings of 1931 and 1932'. *International Journal of Psychoanalysis* 90.6 (2009): 1217–1233.

Pelletier, Adeline. Ed. *América Latina 1960–2013: Photographs*. Exh. cat. Paris: Fondation Cartier pour l'art contemporain; Puebla: Museo Amparo, 2013.

Peters, John Durham. 'An Afterword: Torchlight Red on Sweaty Faces'. *Media Witnessing: Testimony in the Age of Mass Communication*. Ed. Paul Frosh and Amit Pinchevski. Houndmills: Palgrave Macmillan, 2009. 42–48.

Peters, John Durham. 'Witnessing'. *Media Testimony: Testimony in the Age of Mass Communication*. Ed. Paul Frosh and Amit Pinchevski. Houndmills: Palgrave Macmillan, 2009. 23–41.

Phillips, Sandra S. Ed. *Exposed: Voyeurism, Surveillance and the Camera*. Exh. cat. London: Tate Publishing, 2010.

Pigman, George W. 'Freud and the History of Empathy'. *The International Journal of Psycho-Analysis* 76 (1995): 237–254.

Pijarski, Krzysztof. Ed. *The Archive as Project*. Warsaw: Archeologia Fotografii, 2011.

Pinchevski, Amit. 'The Audiovisual Unconscious: Media and Trauma in the Video Archive for Holocaust Testimonies'. *Critical Inquiry* 29 (Autumn, 2012): 142–166.

Pinker, Steven. *The Better Angels of Our Nature: A History of Violence and Humanity*. London: Penguin, 2011.

Pippin, Robert. *After the Beautiful: Hegel and the Philosophy of Pictorial Modernism*. Chicago: Chicago University Press, 2014.

Probyn, Elspeth. *Blush: Faces of Shame*. Minneapolis: Minnesota University Press, 2005.

Racker, Heinrich. 'The Meanings and Uses of Countertransference'. (1957) *Psychoanalytic Quarterly* 76 (2007): 725–777.

Rancière, Jacques. *Disagreement: Politics and Philosophy*. Trans. Julie Rose. Minneapolis: University of Minnesota Press, 1999.

Rancière, Jacques. 'Introducing Disagreement'. Trans. Steven Corcoran. *Angelaki*, 9.3 (2004): 3–9.

Rancière, Jacques. *The Future of the Image*. Trans. Gregory Elliott. London: Verso, 2007.

Rancière, Jacques. *Aesthetics and its Discontents*. Trans. S. Corcoran. Cambridge: Polity, 2009.

Rancière, Jacques. *The Emancipated Spectator*. Trans. Gregory Elliott. London: Verso, 2009.

Reilly, Maura. 'Introduction'. *Global Feminisms: New Directions in Contemporary Art*. Exh. cat. Brooklyn Museum, 2007. 15–45.

Reinhardt, Mark, Holly Edwards and Erina Duganne. Eds. *Beautiful Suffering: Photography and the Traffic in Pain*. Exh. cat. Chicago: Williams College Museum of Art in association with University of Chicago Press, 2007.

Rennó, Rosângela. *Bibliotheca*. Barcelona: Editorial Gustavo Gili, 2003.

Rennó, Rosângela. *O arquivo universal e outros arquivos* [*The Universal Archive and Other Archives*]. São Paulo: Cosac & Naify, 2003.

Reuter, Laurel. *Juan Manuel Echavarría: Mouths of Ash, Bocas de Ceniza*. Exh. cat. Milano: Charta; Grand Forks: North Dakota Museum of Art, 2005.

Reuter, Laurel. *Los Desaparecidos The Disappeared*. Exh. cat. Milano: Edizioni Charta; Grand Forks: North Dakota Museum of Art, 2006.

Rice, Shelley. 'Observed: Milagros de la Torre'. *Le Magazine Jeu de Paume* (23 March, 2012). http://lemagazine.jeudepaume.org/blogs/shelleyrice/2012/03/23/observed-milagros-de-la-torre/ (accessed November 2014).

Ricouer, Paul. 'Memory, History, Forgiveness: A Dialogue between Paul Ricoeur and Sorin Antohi'. Trans. Gil Anidjar. *Janus Head* 8.1 (2005): 8–25.

Roberts, John. *Photography and its Violations*. New York: Columbia University Press, 2014.

Rogers, Sarah. 'Forging History, Performing Memory: Walid Ra'ad's The Atlas Project'. *Parachute* 108 (2002): 68–79.

Roudinesco, Elisabeth. *Our Dark Side: A History of Perversion*. Trans. David Macey. London: Polity, 2009.

Salmond, Anne. 'Nga Huarahi O Te Ao Maori: Pathways in the Maori World'. *Te Maori: Maori Art from New Zealand Collections*. Ed. Sidney Moko Mead. Exh. cat. Auckland: Heinemann in association. with The American Federation of Arts, 1984. 109–137.

Salmond, Anne. '*Et la tête*: Casting in the Pacific'. *Fiona Pardington: The Pressure of Sunlight Falling*. Ed. Kriselle Baker and Elizabeth Rankin. Dunedin: Otago University Press in association with Govett-Brewster Art Gallery and Two Rooms Gallery, 2011. 133–136.

Saltzman, Lisa. *Making Memory Matter: Strategies of Remembrance in Contemporary Art*. Chicago: University of Chicago Press, 2006.

Scarry, Elaine. *On Beauty and Being Just*. London: Duckworth, 2006.

Sedgwick, Eve Kosofsky and Adam Frank. 'Shame in the Cybernetic Fold: Reading Silvan Tomkins'. *Shame and its Sisters: A Silvan Tomkins Reader*. Ed. Eve Kosofsky Sedgwick and Adam Frank. Durham, NC: Duke University Press, 1995. 1–28.

Sedgwick, Eve Kosofsky. 'Shame, Theatricality, and Queer Performativity: Henry James's *The Art of the Novel*', *Touching Feeling: Affect, Pedagogy, Performativity*. Durham, NC: Duke University Press, 2003.

Sedgwick, Eve Kosofsky. *Touching, Feeling: Affect, Pedagogy, Performativity*. Durham, NC: Duke University Press, 2003.

Sedgwick, Eve Kosofsky. 'Melanie Klein and the Difference Affect Makes'. *South Atlantic Quarterly* 106.3 (Summer 2007): 625–642.

Sekula, Allan. 'Dismantling Modernism, Reinventing Documentary (Notes on the Politics of Representation)'. *The Massachusetts Review* 19.4 (Winter 1978): 859–883.

Sekula, Allan. 'The Body and the Archive'. *October* 39 (Winter 1986): 3–64.

Sheehan, Tanya. 'Looking Pleasant, Feeling White: The Social Politics of the Photographic Smile'. *Feeling Photography*. Ed. Elspeth H. Brown and Thy Phu. Durham, NC: Duke University Press, 2014. 127–157.

Shklovsky, Viktor. 'Art as Device'. (1917) *Theory of Prose: Viktor Shklovsky*. Trans. Benjamin Sher, intro. Gerald L. Bruns. Champaign and London: Dalkey Archive Press, 1990. 1–14.

Shoumatoff, Alex. *The Capital of Hope: Brasília and Its People*. New York: Vintage, 1990.

Sliwinski, Sharon. *Human Rights in Camera*. Chicago: Chicago University Press, 2011.

Smith, Babette. *A Cargo of Women: Susannah Watson and the Princess Royal* (1988). 2nd ed. Sydney: Allen and Unwin, 2008.

Smith, Babette. *Australia's Birthstain: The Startling Legacy of the Convict Era*. Sydney: Allen & Unwin, 2008.

Smith, Joel. 'More than One: Sources of Serialism'. *More than One: Photographs in Sequence*. Exh. cat. Princeton: Princeton University Art Museum; New Haven: Yale University Press, 2008. 9–29.

Sontag, Susan. *Regarding the Pain of Others*. London: Penguin, 2003.

Spieker, Sven. *The Big Archive: Art from Bureaucracy*. Cambridge, MA: MIT Press, 2008.

Spivak, Gayatri Chakravorty with Ellen Rooney. 'In a Word. *Interview'. Differences* 1.2 (Summer 1989): 124–156.

Stallabrass, Julian. Ed. *Memory of Fire: Images of War and The War of Images*. Brighton: Photoworks, 2013.

Stallabrass, Julian. Ed. *Documentary: Documents of Contemporary Art*. London and Cambridge, MA: Whitechapel Gallery and MIT Press, 2013.

Starn, Orin. 'Villagers at Arms: War and Counterrevolution in the Central–South Andes'. *Shining and Other Paths: War and Society in Peru, 1980–1995*. Ed. Steve J. Stern. Durham, NC: Duke University Press, 1998. 224–257.

Starn, Orin, Carlos Iván Degregori and Robin Kirk. Eds. *The Peru Reader: History, Culture, Politics*. Durham, NC: Duke University Press, 2005.

Stern, Steve J. Ed. *Shining and Other Paths: War and Society in Peru, 1980– 1995*. Durham, NC: Duke University Press, 1998.

Straker, Gillian. 'Beneficiaries for Evermore: Reply to Commentaries'. *Psychoanalytic Dialogues* 21 (2011): 670–675.

Sullivan, Colleen. 'Shining Path'. *The Sage Encyclopedia of Terrorism*. Ed. Gus Martin. 2nd ed. London: Sage, 2011. 541–543.

Sullivan, Edward J. 'Interview with Milagros de la Torre'. 17 May 2011. http:// www.as-coa.org/articles/interview-milagros-de-la-torre (accessed July 2011).

Summers, Anne. *Damned Whores and God's Police, the Colonisation of Women in Australia*. Melbourne: Allen Lane, 1975.

Tagg, John. *The Burden of Representation: Essays on Photographies and Histories*. Amherst: University of Massachusetts Press, 1988.

Tangney, June Price and Ronda L. Dearing. *Shame and Guilt*. New York and London: Guilford Press, 2002.

Terry, Martin. 'Encountering Dumont d'Urville'. *Lure of the Southern Seas: The Voyages of Dumont D'Urville 1826–1840*. Exh. cat. Sydney: Historic Houses Trust, 2002. 23–34.

Thomas, Nicholas. *In Oceania: Visions, Artifacts, Histories*. Durham, NC: Duke University Press, 1997.

Thomas, Nicholas. 'Dumont d'Urville's Anthropology'. *Lure of the Southern Seas: The Voyages of Dumont d'Urville 1826–1840*. Exh. cat. Sydney: Historic Houses Trust, 2002. 53–66

Tomkins, Silvan. *Affect, Imagery, Consciousness. Vol. II The Negative Affects*. New York: Springer, 1963.

Tomkins, Silvan. *Shame and its Sisters: A Silvan Tomkins Reader*. Ed. Eve Kosofsky Sedgwick and Adam Frank. Durham, NC: Duke University Press, 1995.

Tucker, Anne Wilkes, Will Michels with Natalie Zelt. *War/Photography: Images of Armed Conflict and its Aftermath*. Exh. cat. Houston: Museum of Fine Arts Houston, 2012.

Tuffin, Richard. 'Port Arthur'. *Companion of Tasmanian History*. http://www.utas.edu.au/library/companion_to_tasmanian_history/P/Port%20Arthur.htm (accessed 17 July 2014).

Van Alphen, Ernst. *Caught by History: Holocaust Effects in Contemporary Art, Literature and Theory*. Stanford: Stanford University Press, 1997.

Van Alphen, Ernst. 'Playing the Holocaust'. *Mirroring Evil: Nazi Imagery/Recent Art*. Ed. Norman Kleebatt. Exh. cat. New York: The Jewish Museum and New Brunswick: Rutgers University Press, 2001. 65–83.

Van Alphen, Ernst. *Staging the Archive: Art and Photography in the Age of Mass Media*. London: Reaktion, 2014.

Van der Stok, Frank, Frits Gierstberg and Flip Bool. Eds. *Questioning History: Imagining the Past in Contemporary Art*. Rotterdam: NAi, 2002.

Von Bismarck, Beatrice, Hans-Peter Feldmann, Hans Ulrich Obrist et al. Eds, *Interarchive: Archival Practices and Sites in the Contemporary Art Field*. Köln: Walter König, 2002.

Wake, Caroline. 'Regarding the Recording: The Viewer of Video Testimony, the Complexity of Copresence and the Possibility of Tertiary Witnessing'. *History and Memory* 25.1 (Spring/Summer 2013): 119–124.

Wake, Caroline. 'The Accident and the Account: Towards a Taxonomy of Spectatorial Witness in Theatre and Performance Studies'. *Visions and Revisions: Performance, Memory, Trauma*. Ed. Caroline Wake and Bryoni Trezise. Copenhagen: Museum Tusculanum Press, 2013. 37–43.

Whitebook, Joel. *Perversion and Utopia: A Study in Psychoanalysis and Critical Theory*. Cambridge, MA: MIT Press, 1995.

Williams, Richard J. *Brazil: Modern Architectures in History*. London: Reaktion, 2009.

Williams, Richard J. 'Brasília after Brasília'. *Progress in Planning* 67.4 (May 2007): 301–366.

Wolff, Janet. 'After Cultural Theory: The Power of Images, the Lure of Immediacy'. *Journal of Visual Culture* 11:3 (July 2012): 3–19.

Wong, Edlie L. 'Haunting Absences: Witnessing Loss in Doris Salcedo's *Atrabiliarios* and Beyond'. *The Image and the Witness: Trauma, Memory and Visual Culture*. Ed. Frances Guerin and Roger Hallas. London: Wallflower, 2007. 173–188.

Wurmser, Léon. 'Shame: The Veiled Companion of Narcissism'. *The Many Faces of Shame*. Ed. Donald L. Nathanson. New York: Guilford Press, 1987. 67–68.

Zelizer, Barbie. *About to Die: How News Images Move the Public*. Oxford: Oxford University Press, 2010.

Zweig, Stefan. *Brazil: A Land of the Future* (1941). Trans. Lowell A. Bangerter. Riverside: Ariadne Press, 2000.

Index